Christmas 2013

To

SISTER
MOT

D0615451

Noel,

The Alteri Family

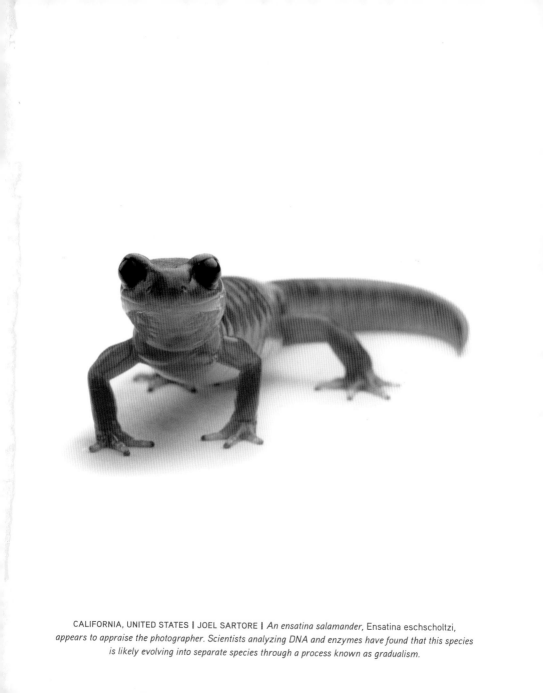

CALIFORNIA, UNITED STATES | JOEL SARTORE | *An ensatina salamander,* Ensatina eschscholtzi, *appears to appraise the photographer. Scientists analyzing DNA and enzymes have found that this species is likely evolving into separate species through a process known as gradualism.*

CHINA | *CHINA DAILY*

Workers apply a rust-resistant primer to a coal-fired power plant in Huaibei, a major industrial center. Soon they'll paint it black to add a second, waterproof coat to this 470-foot-tall (140-meter) cooling tower.

VISIONS
OF EARTH

NATIONAL GEOGRAPHIC PHOTOGRAPHS
OF BEAUTY, MAJESTY, AND WONDER

SUSAN TYLER HITCHCOCK

NATIONAL GEOGRAPHIC

WASHINGTON, D.C.

GERMANY | ROLF VENNENBERND
*Skidding from a full canter to a cloud-of-dust stop,
horse and rider display a muscular flash of Old
West skill at the 2006 World Equestrian Games
in Aachen, Germany. First prize in the individual
reining competition: $12,000.*

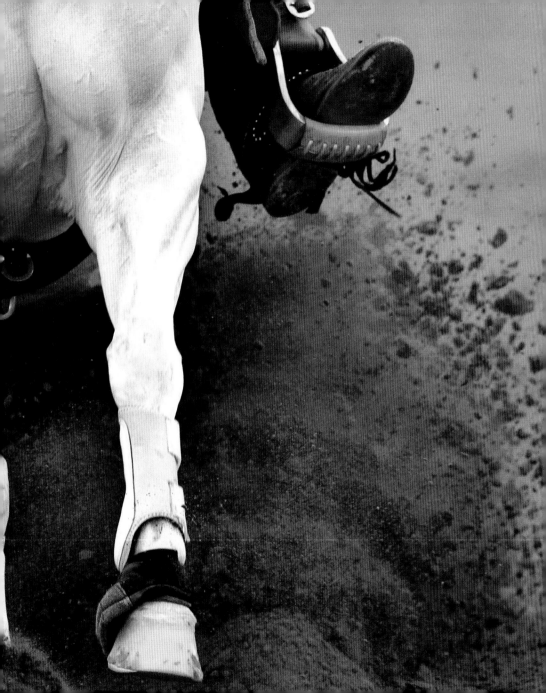

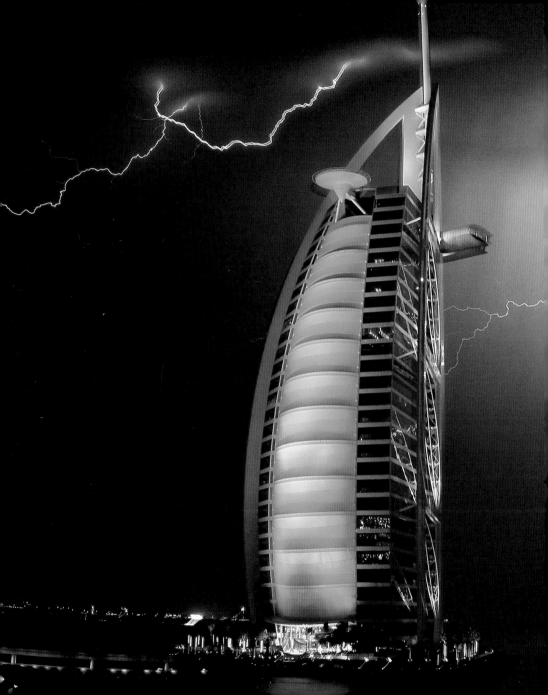

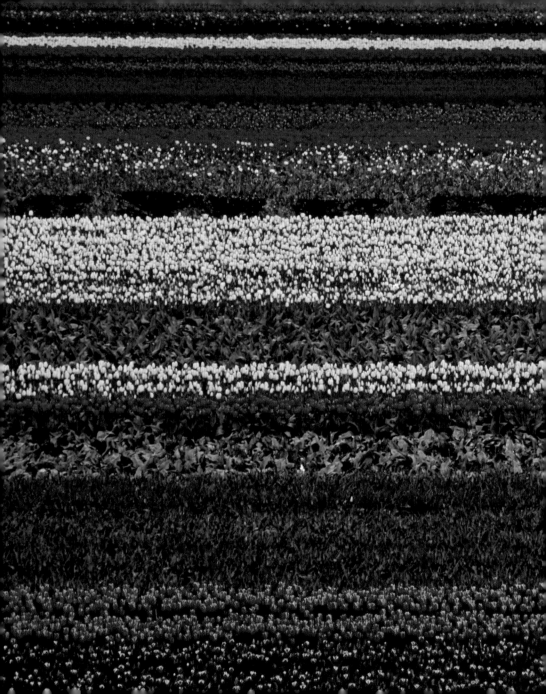

HOLLAND | SISSE BRIMBERG
*Rows of colorful tulips create a colorscape
reminiscent of a Mark Rothko painting. This field is
located next to the Keukenhof, a flower park with
4.5 million tulips in a hundred different varieties.*

FLORIDA, UNITED STATES | WES C. SKILES
A mermaid show at Weeki Wachee Springs State Park
on Florida's Gulf Coast comes complete with flips and
lip-synched songs to entertain the crowd. The clear spring
produces more than 117 million gallons (443 million liters)
of water a day, and its deep bottom has never been found.

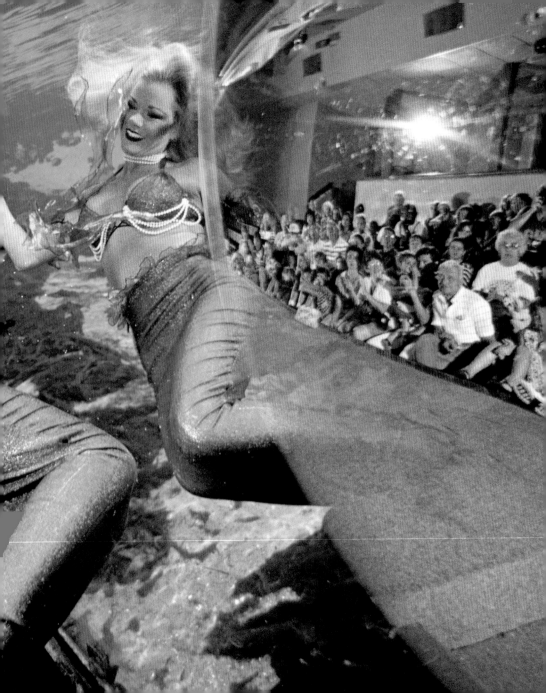

INDIA | JODI COBB
Women in Jaipur, India, create a vibrant rangoli during Diwali, the Hindu festival of lights. Colored sand or rice powder is used to make the rangoli's symmetrical designs.

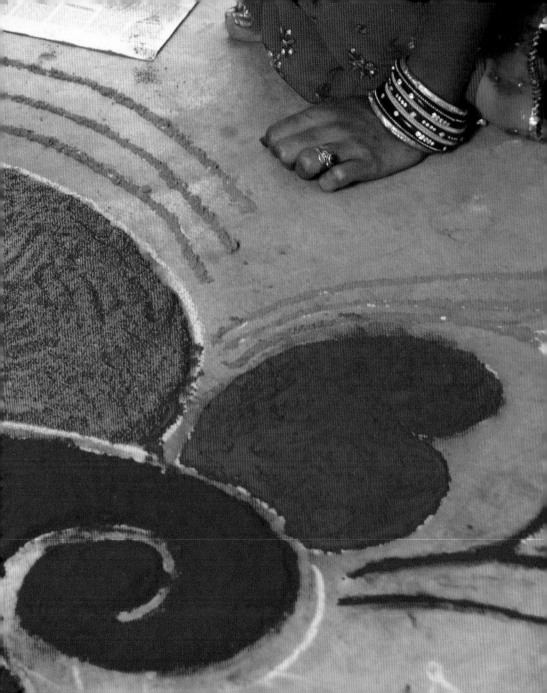

TIBET | FELIX TORKAR

Two yaks, wispy clouds, and the grand vista
of the Tibetan Plateau create a study in
timelessness on Lake Nam Co. The salt lake,
located at 15,400 feet (4,700 meters) above
sea level, is the second largest in China.

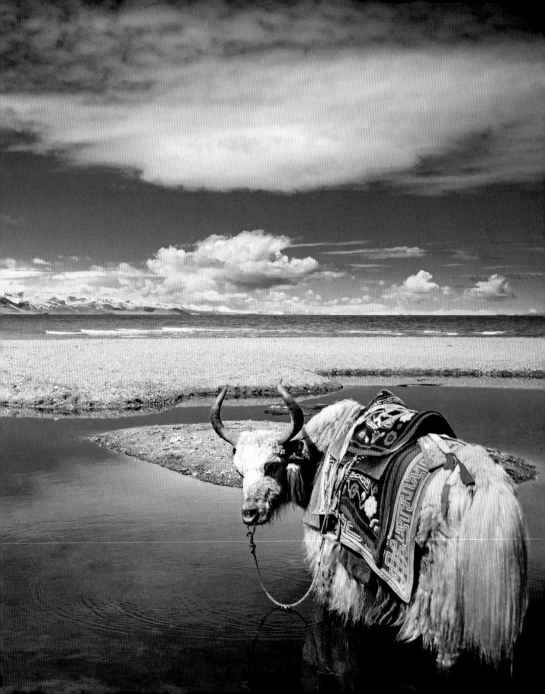

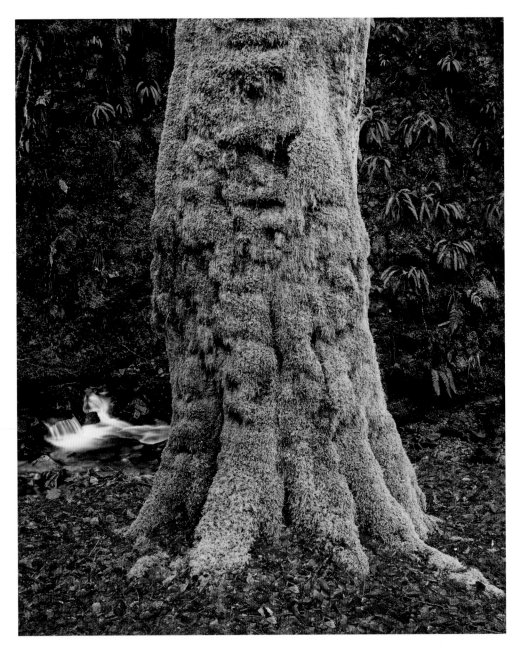

SCOTLAND | IAN CAMERON | *A moss-draped tree, fallen brown leaves, and a babbling stream create a tranquil woodland scene in the Lael Forest Garden, Scotland. Damp, humid conditions encourage such vibrant, lush growth.*

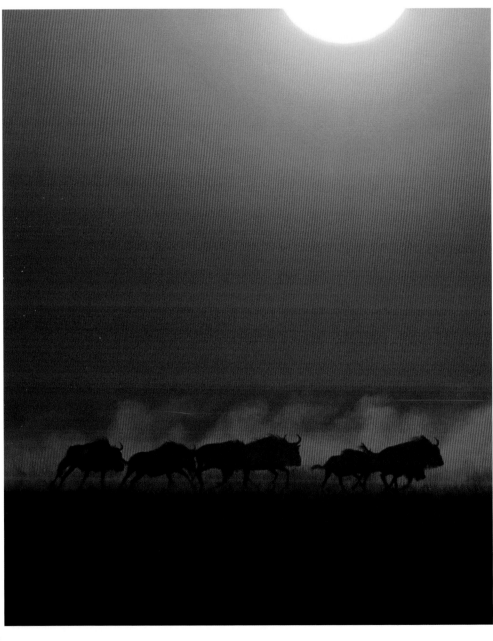

WHERE DO

ideas come from? How do they take shape? I'm convinced an idea has little to do with the clichéd bolt of lightning or switched-on lightbulb. Rather, an idea percolates. Annie Dillard, who wrote *Pilgrim at Tinker Creek,* once said that you might work and work on a paragraph and then throw it away, but you never really lose it. It comes back in different form, and so it can be with an idea.

Some years ago I had a conversation with a colleague about how to celebrate photography in *National Geographic*. We started with the thought of casting a wide net to find a singular spectacular image. It could serve, I suggested, as a kind of preface to the magazine, hinting at the excitement and wonder to follow. That was the inception of Visions of Earth—or at least the concept that was kicked around sometime in 2003.

Gradually, the idea took shape. It would not be an intellectual thing, but more gut based and emotional. The single image would be … arresting, I guess, is the best word—the kind of picture you'd want to, even need to, look at twice or more. The photograph would have to be unique, surprising, and upbeat. But *National Geographic* doesn't go for syrupy images with no substance. It had to be thoughtful. And because it would run in the front of the magazine, it had to set the tone of what followed.

It was a tall order, but we finally launched the feature in August 2004 with a picture I had taken while still working as a photographer. The image showed a stampede of wildebeests, silhouetted against a dusty sky the color of a blood orange. To make it, I journeyed across the flood-prone Zambezi Plain, one of the wildest places in Africa. At the time there were no roads and few people. It was impossibly remote, and that brings up another trademark of a Visions photograph: It has to be an image that people have never seen, perhaps never even imagined they would see.

In March 2006, overwhelmingly positive reader response convinced us we ought to expand Visions, so we went from one photograph to three. The pictures had to have some sort of connective tissue—whether it was a similar color palette, a pattern, even a quality, so subtle you might not be able to pinpoint what it was; you just sensed something that linked the three. And, I insisted, there ought to be in the mix a photograph that somehow celebrated humanity. Something deep, with soul, that spoke to who we are.

Today, Visions of Earth is consistently our top-rated department in the magazine. "Month after month you capture the wonders that the earth has to offer," wrote one reader. And that, come to think of it, is a pretty good description of the vision behind Visions.

ZAMBIA | CHRIS JOHNS | *Wildebeests run across a dusty plain on a June evening in Zambia's Liuwa Plain National Park. This remote park on the Barotse Floodplain of the Zambezi River lacks visitor services but offers unspoiled wilderness vistas.*

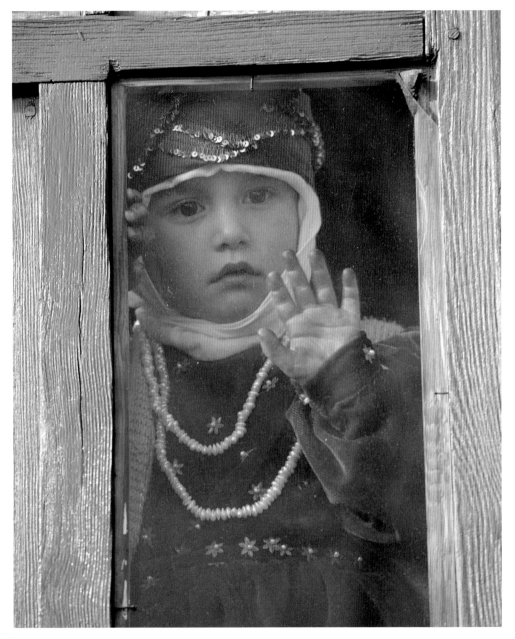

IN THE BEGINNING is the world.

A world full of shapes and patterns, colors and contrasts, rhythms and rules. We are born into it with wonder and awe, eyes wide open. We drink in the sensations without category, without censorship, without understanding. Innocent onlookers in a world full of life-forms that grow in shapes and sizes other than our own and populate landscapes where the forces of time and physics have molded water, soil, and stone into one-of-a-kind fractal shapes, some ever present and some ever changing, at least when viewed through the lens of a human lifetime.

In the beginning is the world, and there are so many good things about it. Nature takes on a multitude of identities, and even crafty disguise becomes beautiful and intrinsic to self.

Psychologist Carl Jung wrote of archetypes of the mind—universally recognized images, patterns, and relationships, oft-seen emblems of meaning through which all human beings connect, find meaning, and understand one another. For Jung those archetypes generally arose from the primeval human family: the father, the mother, the wise elder, the trickster, the maiden, the child. But what about the world in which we live and grow and learn? Might not the universe of things present to our eager minds the concrete corollaries that build and accrete into archetypes of meaning? Patterns and parallels, similarities and differences: We learn time and space, cause and effect, light and dark, joy and pain through our interactions with the world outside us. Learning, understanding, making sense of things—not to mention

TURKEY | JAMES L. STANFIELD | *Clad in traditional clothing, a young Turkish girl in Söğüt Gölü glances out her window. Her country looks both to integrate with Europe and to embrace its own rich Asian history.*

poetry, metaphor, and revelation—all happen at that balance point where the human mind meets visions of Earth in all its multitude and finds a way to bridge outward objects and inward sensations.

Early learning starts with the game of naming. To name is to know, the human mind convinces itself. On the one hand, naming confers intellectual possession: I can name it; therefore, it is a thing whose being I understand. Yet naming may carry our senses away from authentically seeing, because a named object gathers associations that may clutter the mind and blind the eye to oddities and exceptions.

To name is also to segregate and to confer a unified thingness to something we see. Edges and boundaries become lines that divide, and objects take on separate identities. An entity takes on a wholeness, but as soon as we know one thing to be a whole then we can see how that thing might be split into pieces, each belonging to the whole yet distinguishable from all the others in the company. To know a whole is to know its breaking.

Soon thereafter, we learn the space-time relationship of cause and effect. Sequence becomes influence; relationship involves dominance and power. We watch and wait and wonder as the multitude of phenomena we have learned to name and know interact. An animal hunts its prey; a forest shades the plants down under; a stream carves out a canyon. We see the relationships among all phenomena, between living beings and landscapes, and the complex human mind learns to combine memories of what was, observations of what is, and expectations of what will be.

Part of the return to true knowledge of the external world—a key component of science—is recognizing and verifying the difference between what in fact will be and what the human imagination can conjure up, the "might be's" that never will happen. Just as important in building our true knowledge of the external world is realizing the breadth

of phenomena that exist beyond the limits of human experience, the "can't be's" that are. Here is where photography, through exquisite visions of Earth, steps in to assist us. Photographers take their cameras where few of us can follow. They see, and show, the world with wonder. They return us to that open-eyed amazement based not on our presumptions but on the true observation of all that is in the world, nature and culture and all meeting points in between—visions of Earth that promise moments of enlightenment, marvel, amusement, sorrow, and joy.

We cannot all be scientists or photographers, but in some way, every one of us, as a thinking human being in this physical world, performs both functions intellectually. We seek to distinguish truth from our fantasies, to know things as they really are and not as we imagine them to be, and we do so by testing the world and seeing it as it really is. We make meaning by connecting the sensations coming into us with the feelings and passions that dwell within—the work of an artist, using the raw materials presented by the universe of things outside of our bodies and creating meaningful combinations with the thoughts and feelings within. To make sense of it all is to find the echoes and harmonies between the kaleidoscopic world outside and the interior world within.

Photographers re-create those primeval moments, before our eyes and minds have become so accustomed to what we drink in that we no longer see. They provide us with reminders of the shapes and patterns, colors and contrasts, rhythms and rules that exist in the world we see—so that, refreshed in our vision, we may make sense of the world of thought and feeling, intention and plans. Nature photographers are the unacknowledged scientists of the world today: the objective eye, the unbiased observer, holding before us clear visions of the world around us, so very different from the human mind and yet so much what has made us who and what we are.

BEGIN

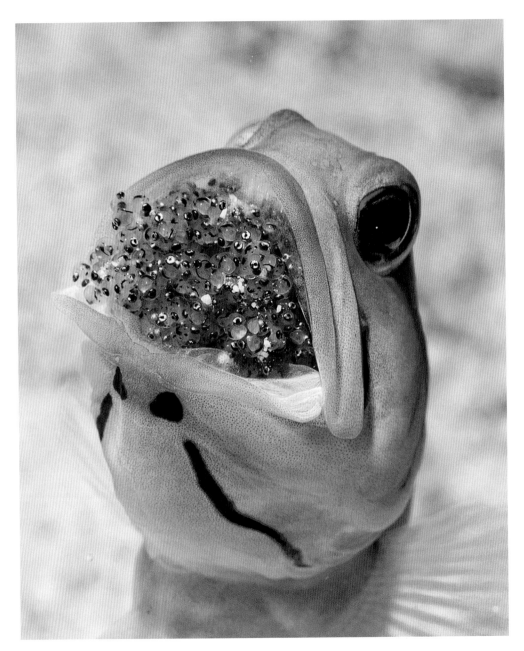

ONE BECOMES two, then four, then sixteen.

Beginnings multiply into beings in the blink of an eye. We pause and want to stay here at the start, so pleasant it is to dwell in the moment in which little is certain, everything is possible, and all is unhindered growth and enthusiasm.

A fuzzy bud bulges, balancing precariously atop a slender stalk. One more morning's sunshine, and a bright orange poppy brightens the world—a new beginning. A shiny pupa dangles, shades of black and brown as if old wood with layers of varnish. Spring winds caress it, and something starts to move within. Threadlike legs push out; head and body emerge; wings unfold and pulse in the sun—a new beginning.

A human infant, a newborn mammal, a hatching egg, a sprouting seed: In each of nature's new beginnings, we recognize that genetic destiny already has an upper hand, but it is so enticing to imagine, in those early tender times, that anything could happen. Or, rather, that only the best will happen, and all the potential enfolded in that tiny shape will open up, take shape, and blossom into reality.

We cherish new life, at once so tender and unprotected yet so quintessentially endowed with spirit. The mass of life has not yet taken over. An excess of matter does not yet burden the impulse to grow and thrive; the weight of the world has not landed.

CAYMAN ISLANDS | JIM CHAMBERS | *With a mouthful of eggs, a male jawfish incubates his progeny off Little Cayman Island. Known as mouth brooding, this reproductive technique allows the parent to keep the eggs close by for protection and transportation.*

At a hospital in Tarin Kowt, a midwife weighs
a newborn boy. Afghan babies are kept tightly
swaddled for a year. Local tradition holds that the
practice promotes good posture.

RUSSIA | MARK THIESSEN

The jump is just the beginning for this Russian smoke jumper. Once on the ground in Siberia, he'll work to contain wildfires in the world's largest coniferous forest.

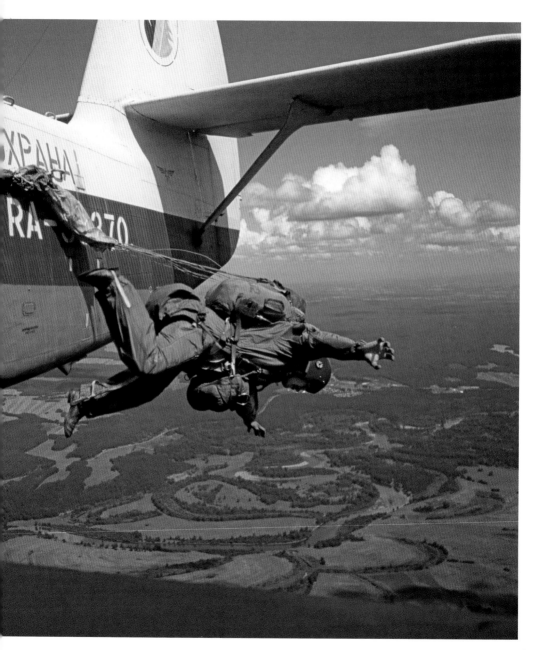

BANGLADESH
MUSTAFIZ MAMUN
Boys and girls splash each other during the Rakhain water festival, held each year during the New Year celebrations. The act symbolically washes away the sorrows and sins of the past year.

FRANCE | SISSE BRIMBERG
The animals on the calcite walls of Lascaux Cave
appear to move in time and space. Created by
Paleolithic humans some 20,000 years ago,
the more than 600 paintings here continue to
inspire and transcend.

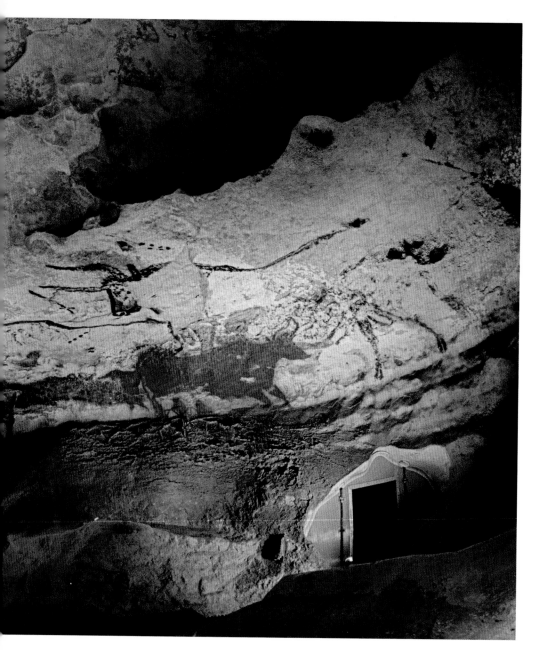

Because their eyes can detect ULTRA-VIOLET LIGHT, butterflies can see more colors than humans can. But in the human world they would be considered visually impaired, because they cannot see fine details.

TRINIDAD I M. WILLIAMS WOODBRIDGE I *Blood begins to flow into a butterfly's wings as it emerges from its chrysalis. After a few hours, the veins stiffen and the butterfly can fly away.*

36

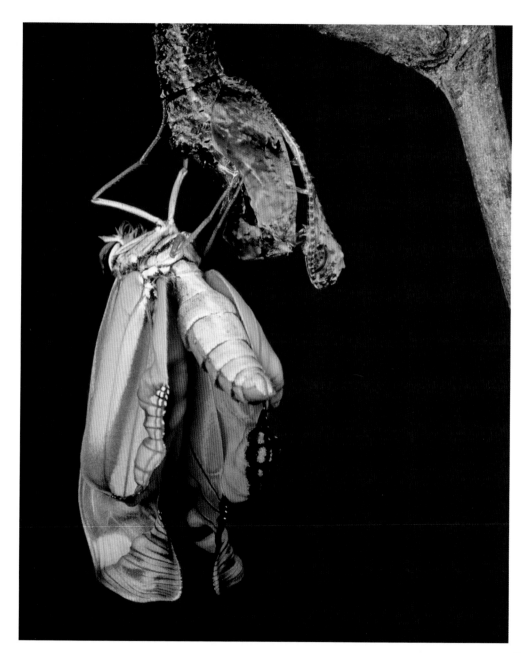

CHINA | RANDY OLSON
Newlywed couples at a mass wedding ceremony
in Shanghai celebrate the beginning of their lives
together. Some 70 couples married in 2007 in the
annual October event.

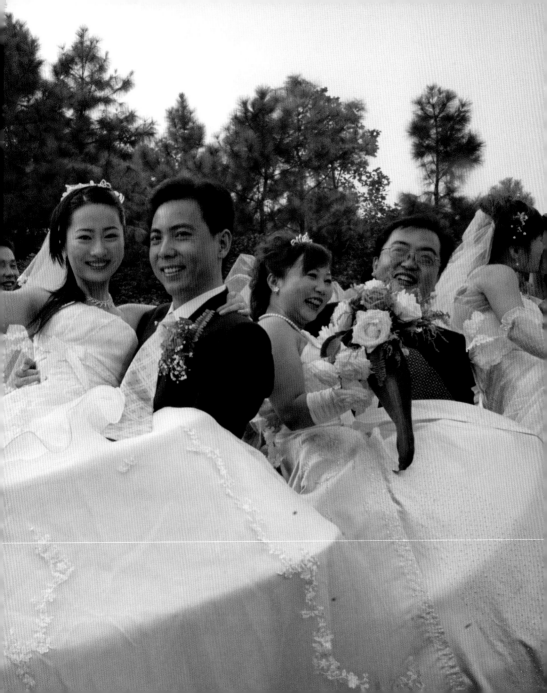

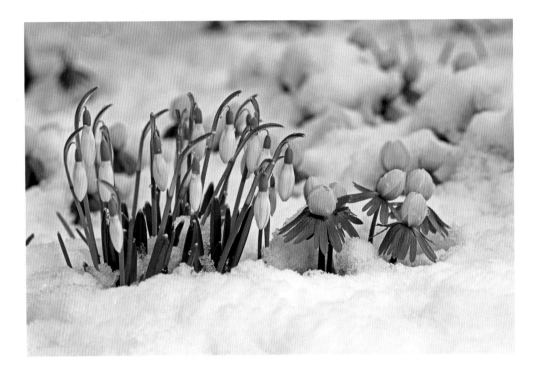

GERMANY | KONRAD WOTHE

The arrival of these white snowdrops and yellow winter
aconite helps to signify the coming spring. Although these
hardy plants look beautiful in the snow, winter aconite is
poisonous, and the snowdrop bulb is mildly toxic.

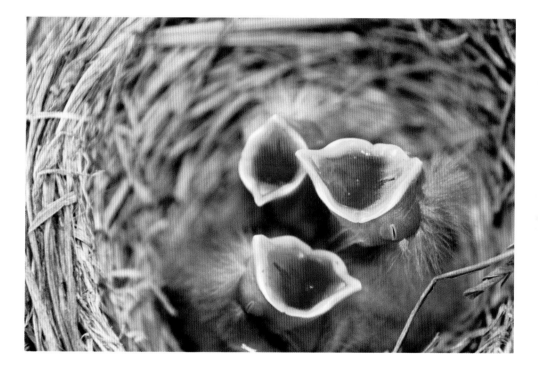

IOWA, UNITED STATES | DARCI DUEY

With mouths opening like hungry flowers, these day-old robins eagerly wait for food. The baby robins, whose nest was located in a backyard fort, fledged in a few weeks.

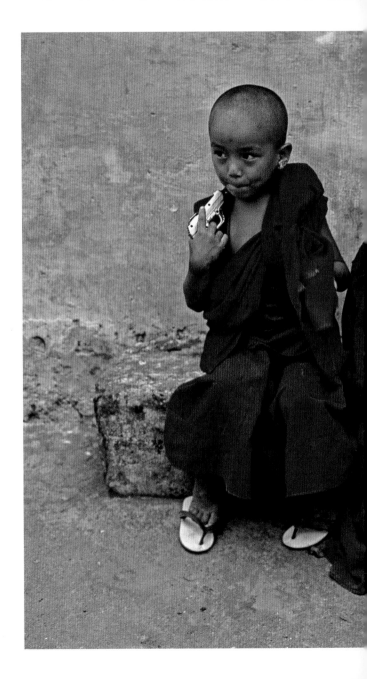

INDIA | STEVE MCCURRY

*The red robes of these young
Buddhist monks evoke meditation,
but the handheld games show off
their playful side. Some 100,000
Buddhists fled Tibet in 1959, and
yet the faith continues to flourish.*

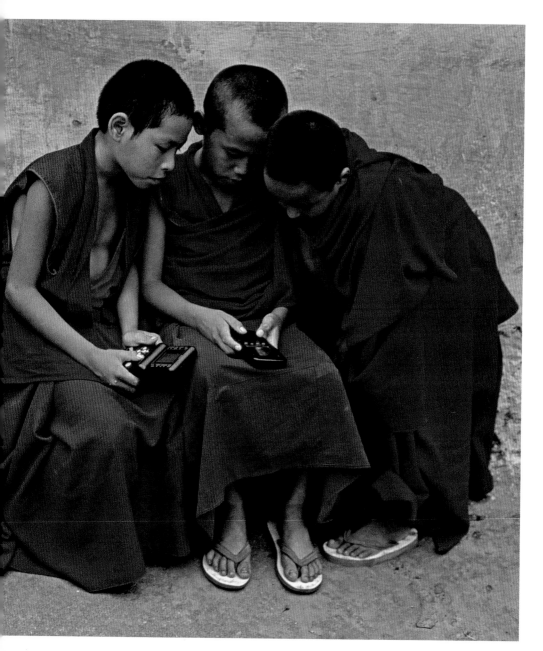

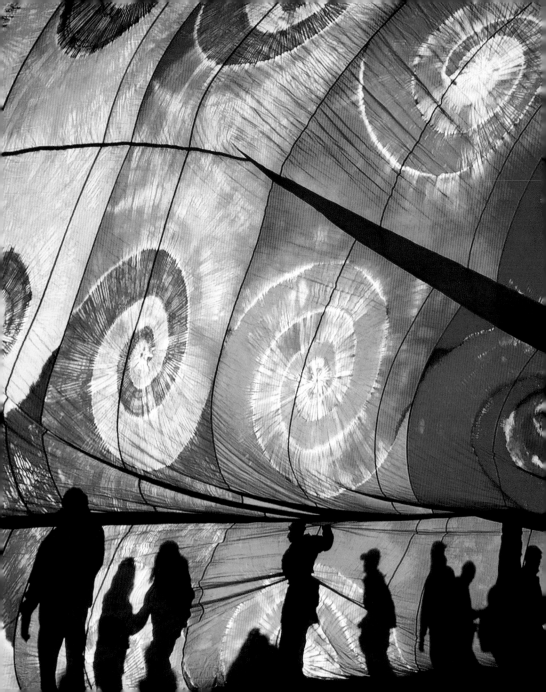

As colorful as a butterfly wing, this balloon at the
Albuquerque International Balloon Fiesta provides
a shimmering backdrop for silhouetted visitors.
Five hundred balloons from 39 states and 17 countries
thrilled visitors at the 2010 festival.

MARYLAND, UNITED STATES
STACY GOLD
*With focused determination, a high school
athlete dives into a pool to begin his race.
He'll leave more than a splash in his wake,
as student athletes are more likely to attend
college and have lower dropout rates.*

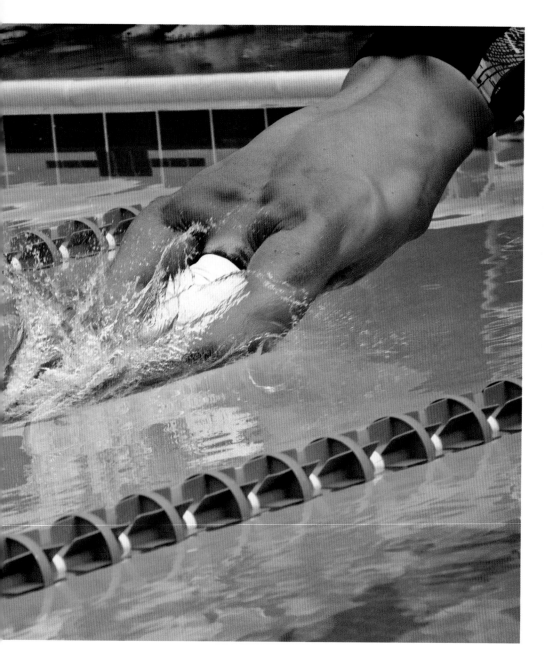

SCOTLAND | JIM RICHARDSON
On the eve of the Beltane Fire Festival, these
costumed participants help celebrate the beginning
of summer growing season. The pagan festival,
which has roots in Celtic fertility rituals, also
features drummers and acrobats.

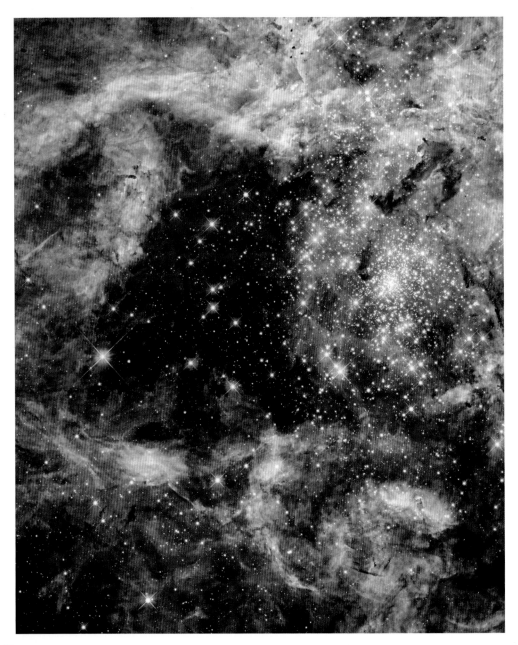

THE MILKY WAY is made up of some 100,000,000,000 stars. So it should come as no surprise that there are more stars in the universe than there are grains of sand on the entire planet Earth.

SPACE | HUBBLE TELESCOPE | *The hottest stars burn blue, and they shine like jewels in this Hubble Telescope image of our galactic neighborhood. This star grouping, called R136, resides in a satellite galaxy near the Milky Way and spans about a hundred light-years.*

51

Neither a bird nor a plane, Jetman—aka
adventurer Yves Rossy—soars above the Alps
on jet-propelled wings during a five-minute,
186-mile-an-hour (200-kilometer-an-hour) flight.
He has since flown over the English Channel.

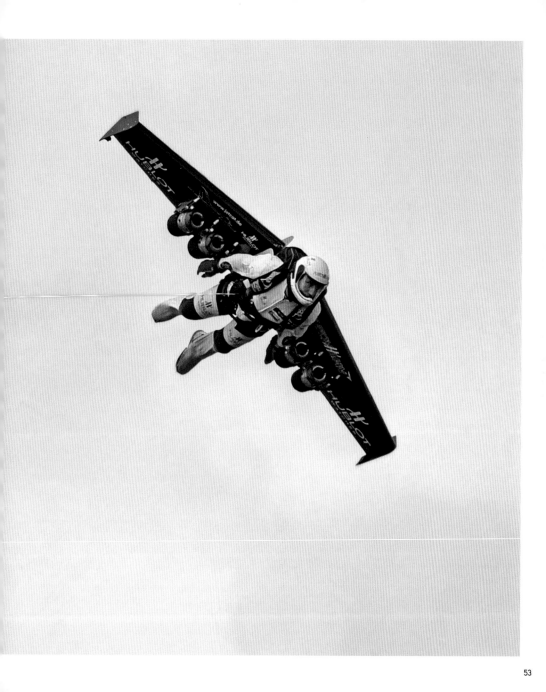

TRINIDAD | BRIAN SKERRY

Following its instinct, a leatherback turtle heads out to sea. If this hatchling makes it past both land and water predators, it has longevity on its side—leatherbacks have been around for 100 million years.

CUR

NATURE

abhors a straight line. Instead, it curves. The reach of a tree branch, the soft slopes of its leaves. An anthill path, in and out and over and under the mounds of leaf mold. The delicate outline of a butterfly's wings, its sensitive antennae. The shared swoop of a flock of blackbirds, dipping in unison, winging as one in an autumn sky. The graceful S-curve of a snake, sashaying to move forward. The loving sweep of a mother lion's paws, pulling in cubs toward her, claws relaxing into soft leather pads. Every embrace is a curve, arms enfolding. Every curve is an embrace.

Time turns straight lines into curves. Fractured rocks, worn by running water, lose their angles and assume curves. The stone steps of an ancient cathedral, pathway to serenity for centuries, likewise lose sharp edges, soften and curve with time.

Every curve is a piece of a circle, bending around, its ends destined to meet. The circle of life, the circle of story, a circle of friends around a campfire. Even the horizon—that feature of our landscape that seems so straight its name denotes a mathematical axis—is, in fact, a curve. To test this observation, which has provoked high-court battles and lost men their lives, one need only sail a boat into open water or, better yet, pilot a craft into outer space, where the known horizon becomes the curving circumference of our spherical blue planet.

INDONESIA | JAMES L. STANFIELD | *An arched entryway of Banda Aceh's Baiturrahim Mosque mirrors its black domes. The mosque, rebuilt by the Dutch in the late 19th century as a way to win favor with the local population, stood as a powerful example of faith after the disastrous 2004 tsunami ravaged the area.*

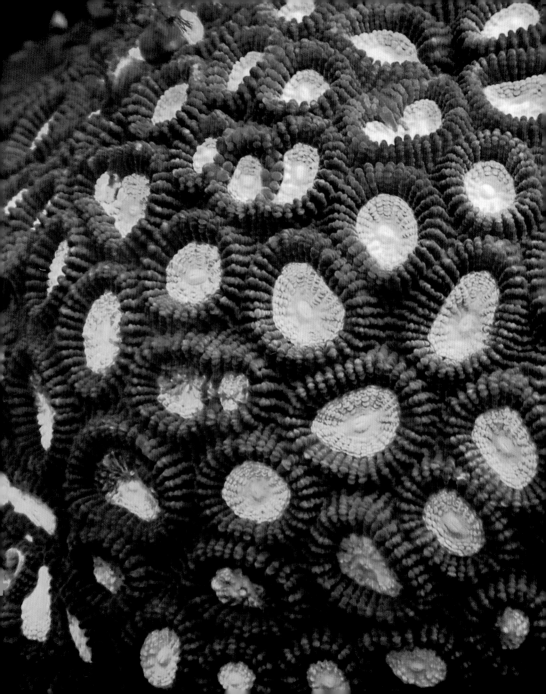

INDONESIA
MARK PICKFORD
In waters off the Raja Ampat Islands, a honeycomb coral glows green. The archipelago is a hot spot of coral diversity—some 75 percent of all known coral species can be found there.

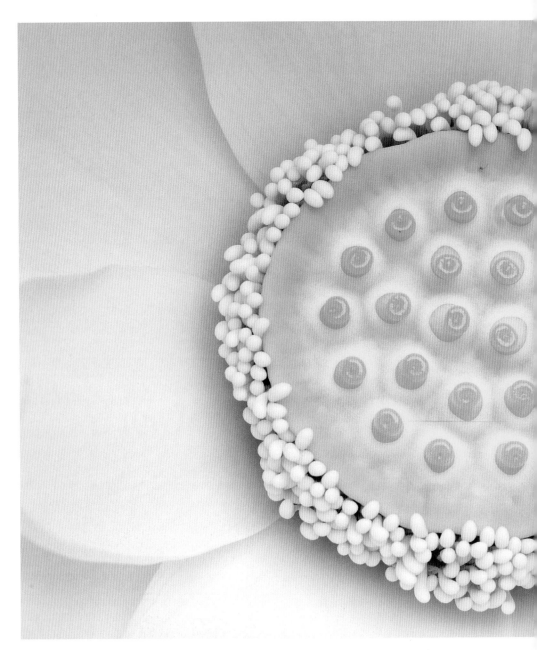

MARYLAND, UNITED STATES
STEPHANIE LANE

*Looking like a lemon torte on a plate
of petals, a lotus blooms in a Maryland
garden pool. The chartreuse circle, three
inches (eight centimeters) in diameter,
is dotted with 23 seed holders and
ringed by immature pollen sacs.*

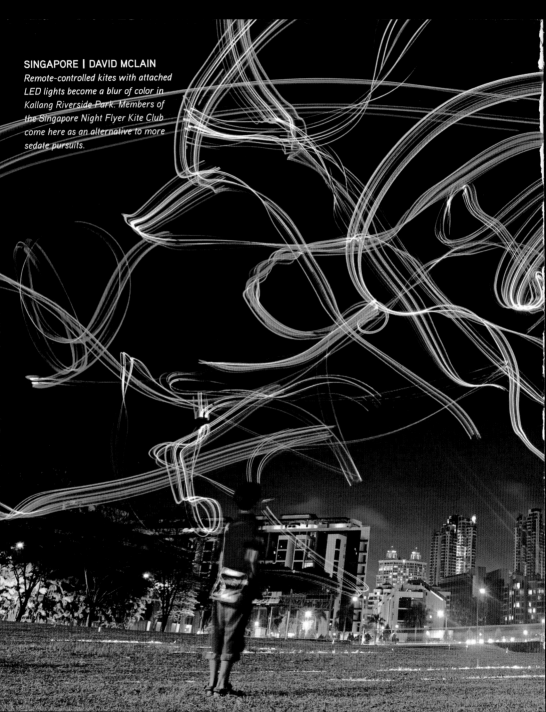

SINGAPORE | DAVID MCLAIN

Remote-controlled kites with attached LED lights become a blur of color in Kallang Riverside Park. Members of the Singapore Night Flyer Kite Club come here as an alternative to more sedate pursuits.

LIGHT as a feather:
In many birds, the cumulative
weight of their feathers exceeds the
weight of their bones. Feathers provide
birds both insulation and protection from
ultraviolet light.

NEW YORK, UNITED STATES I JULIUS DIAZ I *Do you see me now? The striking red eyes and white-tipped crest (used to attract mates) of this male Victoria crowned pigeon serve to highlight its serious side.*

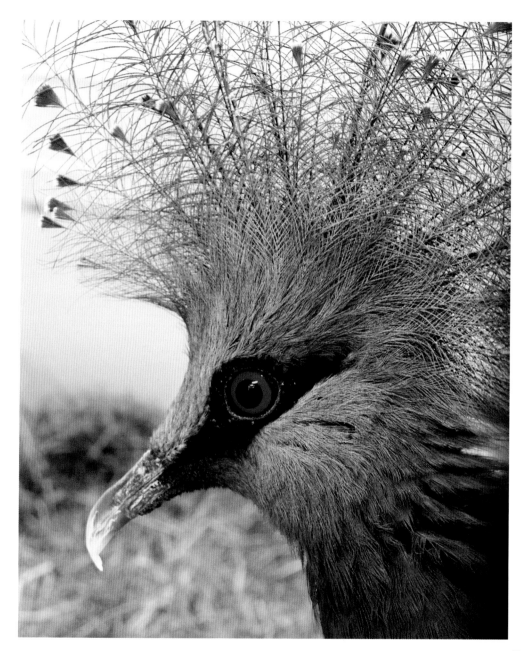

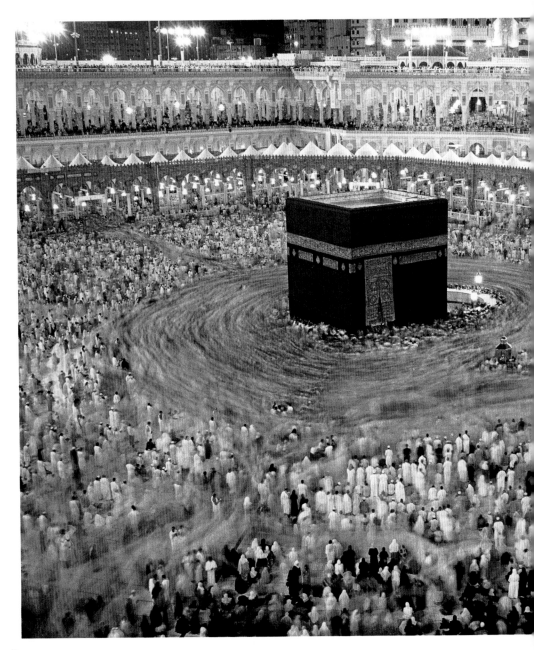

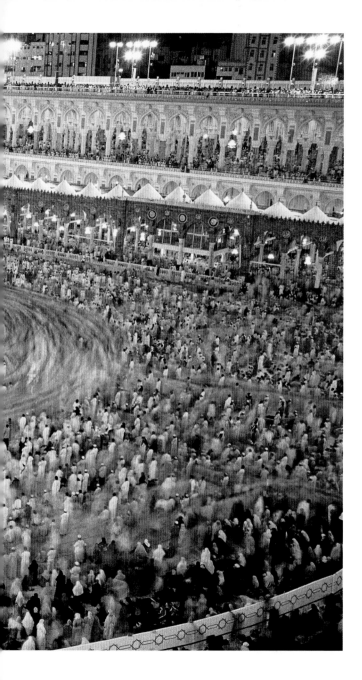

SAUDI ARABIA | REZA

*Muslims in Mecca become a blur
of faith in this long exposure.
During the annual hajj, pilgrims
walk seven times around the
Kaaba in the Grand Mosque—a
ritual performed at least twice.*

CHINA | HUANG XIAOBANG
*Gleaming with mouthwatering perfection,
a "banquet" of stones resembling food adorns
a table at the sixth International Rare Stone Festival
in Liuzhou. About 3,000 specimens were on show.*

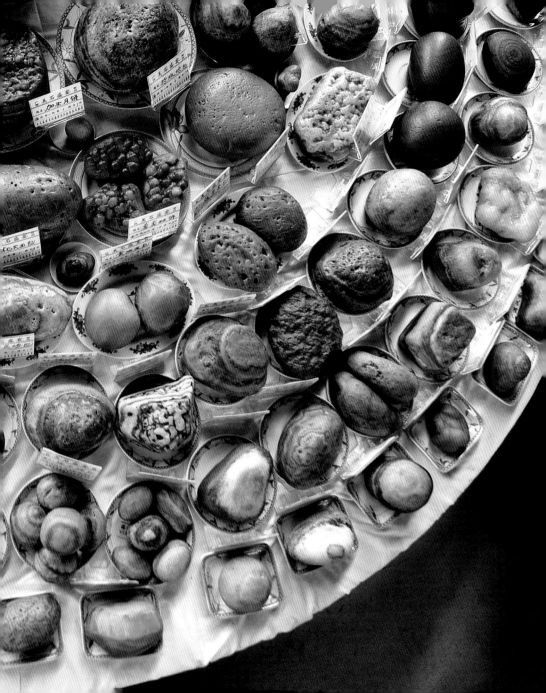

MALAYSIA | INGO ARNDT
Spikes at the center of the Rafflesia kerrii *flower*
may help disperse its odor—the stench of rotting
meat—throughout its jungle habitat, thus attracting
the carrion flies that pollinate the platter-size bloom.

MISSOURI, UNITED STATES | BRUCE DALE

Stargazers seated around a projector appear as specks in a giant eye at the McDonnell Planetarium in St. Louis, Missouri. The projector can be programmed to show the celestial sky as seen from any place on Earth.

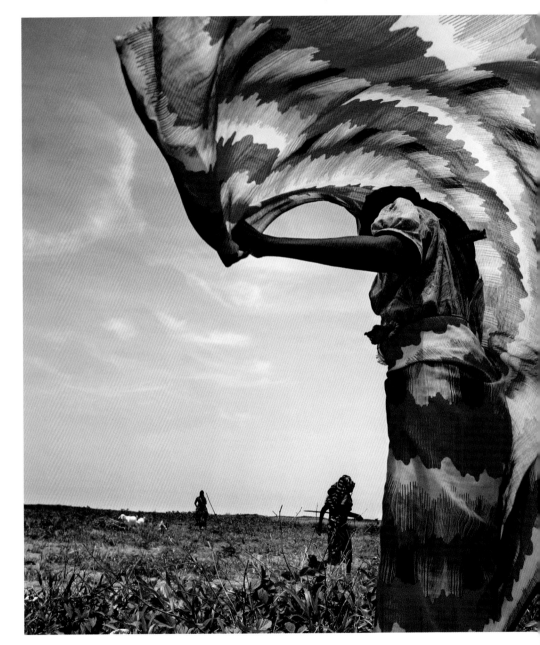

SUDAN | J CARRIER

*Women walk miles from their West
Darfur refugee camp—and risk assault
by roving militiamen—to gather wood
and grass for fuel. A full sack earns
some 50 cents in their camp, home to
about 15,000 people.*

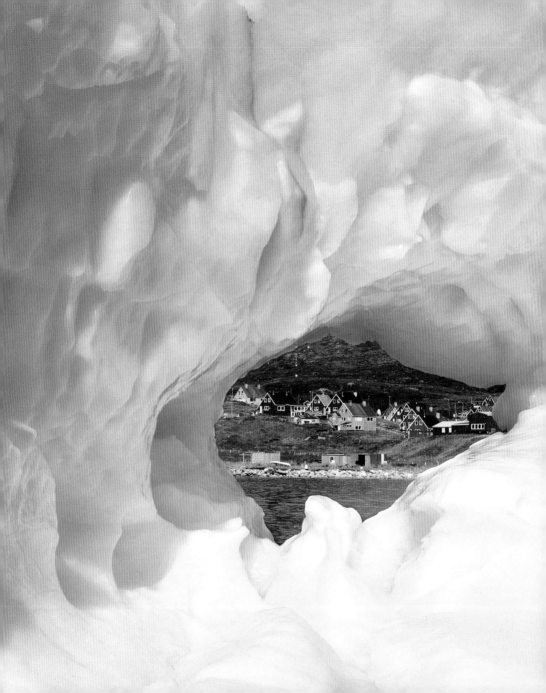

THE SUN | NASA

NASA's new Solar Dynamics Observatory reveals an erupting plasma plume—aka a solar prominence—looping into the atmosphere along a magnetic field line. Ten Earths could be stacked inside the twisting ring.

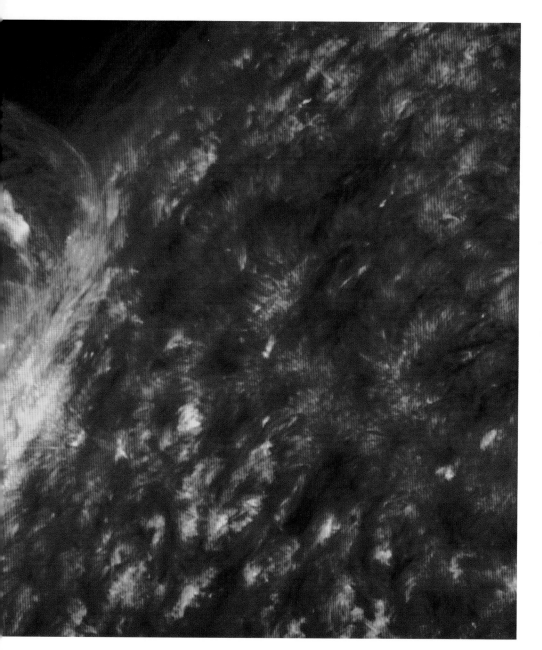

AFGHANISTAN | TOMAS MUNITA
*Good luck and centripetal force help driver
Mohammed Jawed keep circling the shud-
dering wood-plank Wall of Death during his
traveling stunt show's stop in Kabul.*

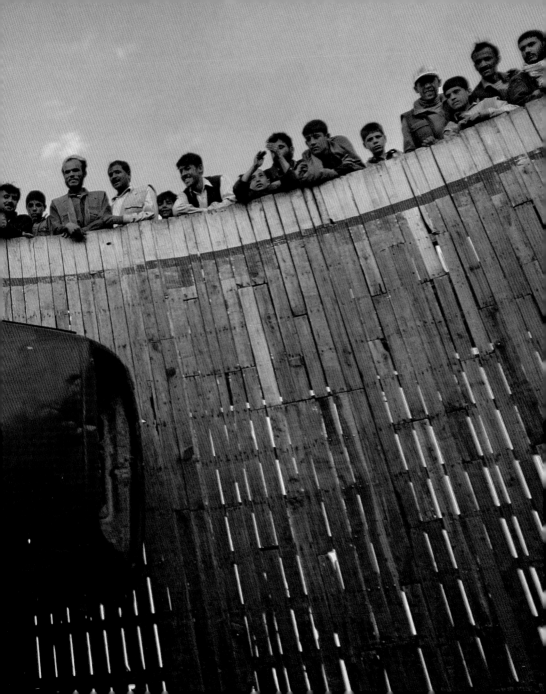

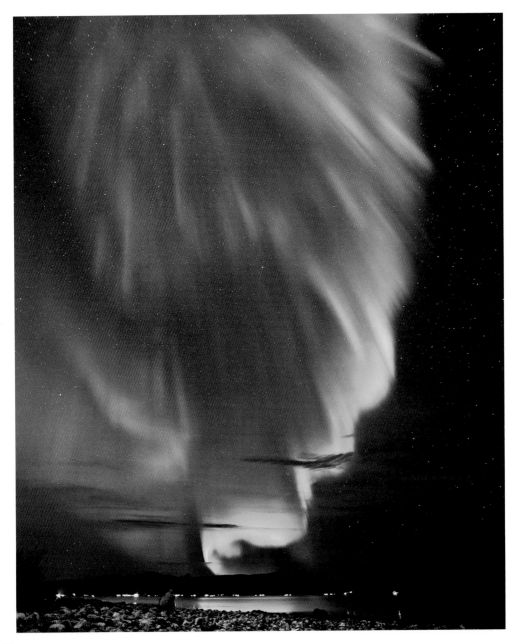

MAGNETIC STORMS

associated with an unusually large aurora in 1989 caused a flurry of problems in Canada: The power grid in the province of Quebec collapsed, compass readings became unreliable, radio transmissions were disrupted, and there were even reports of automatic garage doors opening and closing on their own.

NORWAY | OLE CHRISTIAN SALOMONSEN | *The aurora borealis casts ethereal shapes in the night sky of northern Norway. Such magnificent displays occur as electrons, driven by the solar wind, hit the particles in Earth's upper atmosphere.*

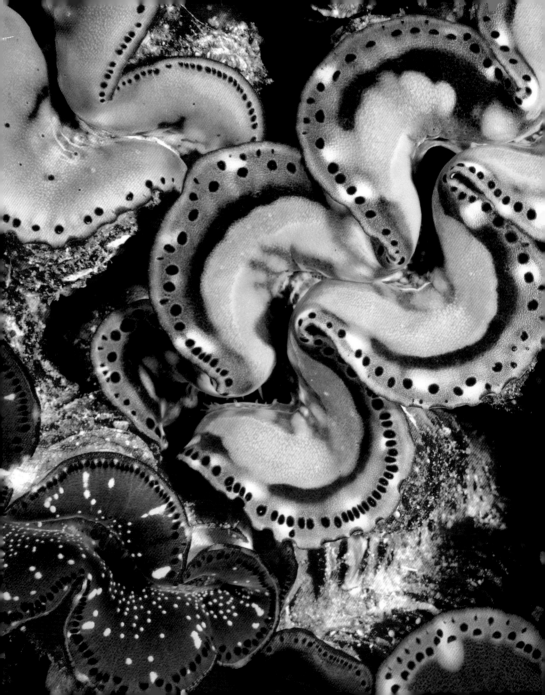

KINGMAN REEF, PACIFIC OCEAN
BRIAN SKERRY
*Creating a kaleidoscope of color, the
mantles of these giant clams in the Pacific
Ocean's Kingman Reef are the lucky ones.
They inhabit an unspoiled lagoon the size of
Manhattan Island located some 1,000 miles
(1,600 kilometers) south of Hawaii.*

SURF

ACES

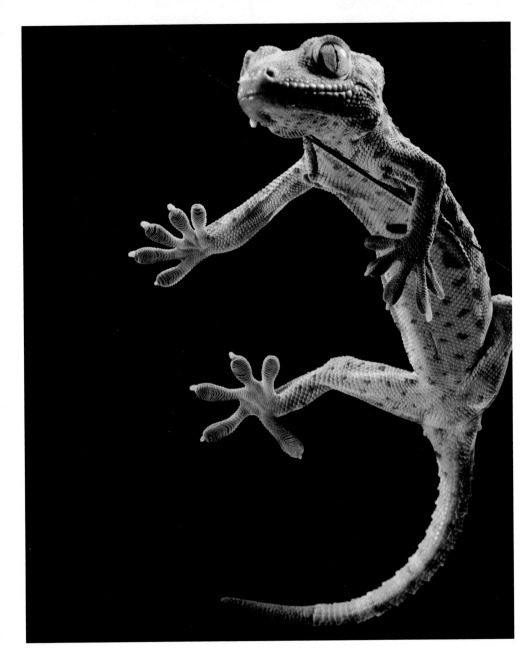

SURFACE IS real in the world of nature. At the surface, inner being meets outer surround.

Smooth or mottled, waxy or velveteen, surfaces delight our senses, not only because of the intricacy of pattern, a feast for the eyes, but also because we imagine how they might feel if we touched them. Any array of surfaces evokes the sense of touch, the one all-body sensation. A surface can feel soft, gentle, and pleasing, or it can feel jagged, dangerous, and cruel. A photograph that brings our attention to a surface is likely to create a body-feel experience of the mind.

See a downy nestling, a day-old Canada goose all yellow-green fuzz, and fancy caressing it with your fingertips. Behold a sheet of cold stream water shimmering over a smooth rock, and imagine entering that cool, eternal flow with the flat of your hand. Enjoy a picture-postcard portrayal of a sunbaked beach of white, white sand with nobody on it, and you're bound to imagine the soles of your feet sinking into the surface. Peer into the feathery details of a fern frond unfolding; feel it tickle the soft skin of your upper lip and cheek.

In the world of humans, we are given the warning that appearances can be deceiving. But in the world of nature, surfaces do not lie. Yes, there may be dark ocean depths under the surface of the water, but those dimples, ripples, and waves are every bit as authentic as the dark fathoms below.

NEW YORK, UNITED STATES | ROBERT CLARK | *A tokay gecko shows off its staying power. More than six million microscopic hairs on each of the gecko's toes hold the secret to the reptile's ability to climb walls and ceilings.*

RHODE ISLAND, UNITED STATES
GEORGE STEINMETZ
A palette of orange surrounds the Odyssey submersible in an anechoic (non-echoing) chamber while it undergoes acoustic tests at the Newport Naval Undersea Warfare Center. The Odyssey probe can dive to depths of 19,700 feet (6,000 meters) to collect salinity and temperature data.

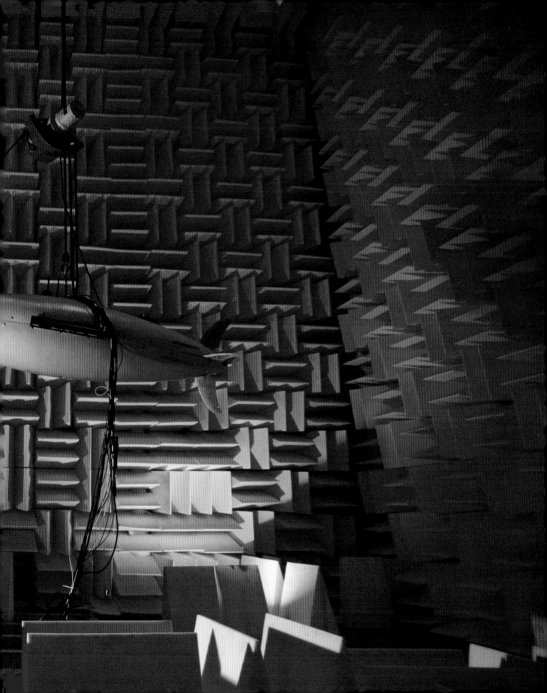

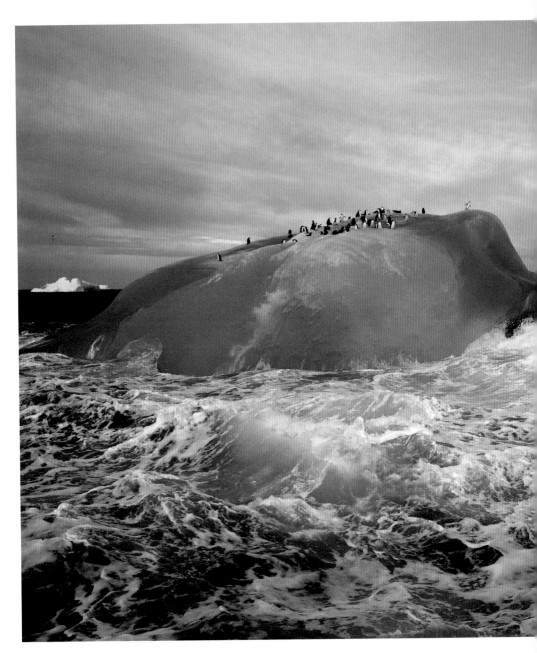

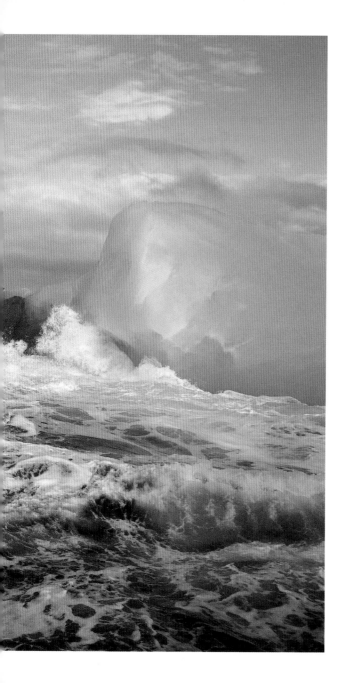

ANTARCTICA | MARIA STENZEL

Riding on top of a blue iceberg, chinstrap penguins near Candlemas Island in Antarctica use this eroded iceberg as a temporary resting spot. For most of the year pack ice keeps the South Sandwich Islands in place, but for about four months during the austral summer a brief thaw occurs.

PHILIPPINES
ALFONSO LIZARES
An earth-colored participant at the Mambukal Mudpack Festival appears as if coming from another time. The festival is held at the height of the monsoon season and celebrates our connection to the natural world.

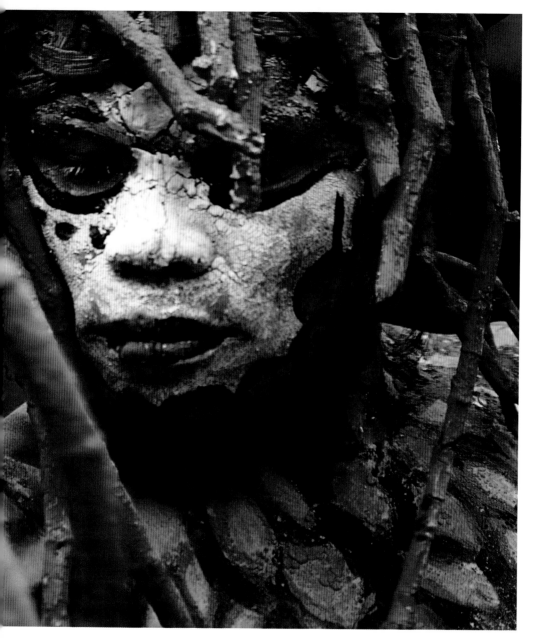

GEORGIA, UNITED STATES | BULENT EREL

A nearly translucent green gem of a grasshopper climbs on a flower petal. North American grasshoppers range in size from the minuscule to the largest, which can measure three inches (eight centimeters) long.

DISTANCES between objects in space are vast, and light from stars and galaxies takes a long time to reach Earth. So when we see these things through our telescopes, we are actually seeing them as they appeared long ago, when their light first started its journey. In essence, we are looking back in time.

ARIZONA, UNITED STATES | JOE MCNALLY | *A technician inspects the surface of the 28-foot (9-meter) Large Synoptic Survey Telescope mirror in search of major flaws. The glass will then be polished to the precise concave shape required for the telescope, which scientists will use to survey our universe.*

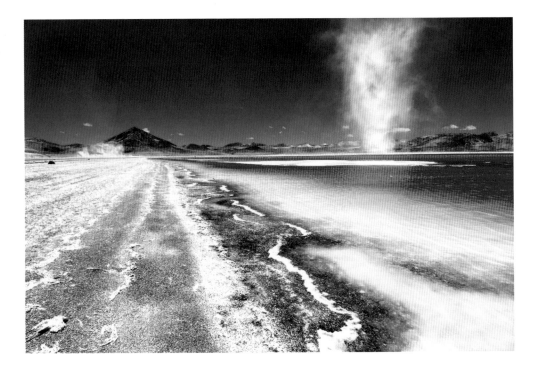

BOLIVIA | DORDO BRNOBIC
The Altiplano shows its otherworldly appeal in South America's high Andes. The red waters of Laguna Colorada, tinted by algae, take their place among jagged mountains, mud volcanoes, and salt flats.

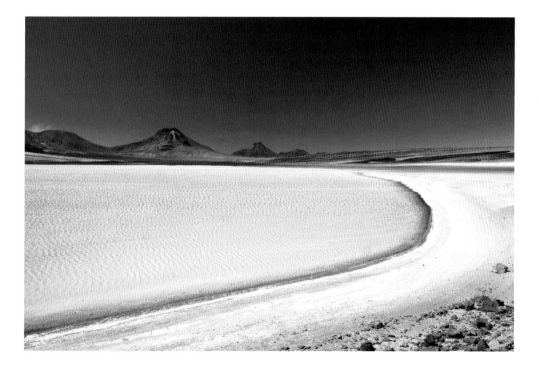

CHILE | DORDO BRNOBIC

The yellow-tinted waters of Laguna Lejía wash up against not white sand but salt flats in the Chilean Altiplano. Extinct volcanoes surrounding the lake lend a stunning backdrop for the vista.

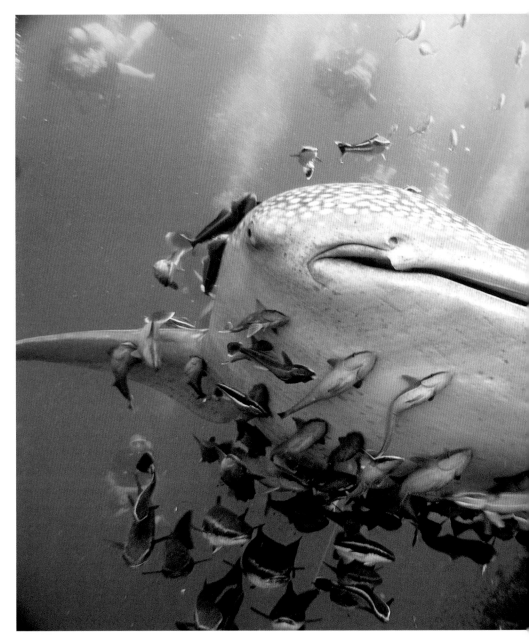

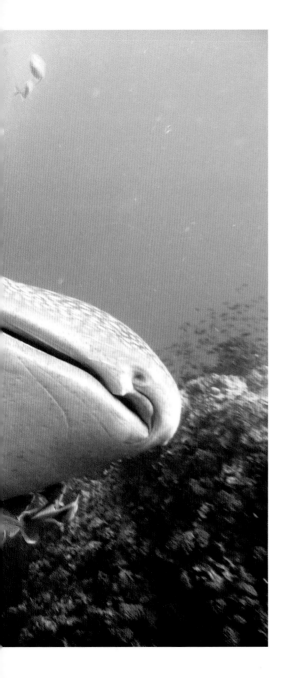

GALÁPAGOS ISLANDS | COLIN PARKER
Hitchhikers come along for the ride on a whale shark.
They don't have much to fear since this fish,
the largest one in the ocean, feeds nonaggressively
by filtering water through its formidable mouth.

TANZANIA | GEORGE STEINMETZ
*An airplane casts a shadow over the red
waters of Lake Natron in Tanzania, part
of the East African Rift Valley. The water's
red hue is due to algae that live on salts
spewed from nearby volcanoes.*

HAWAII, UNITED STATES | LAUREN HOGAN
A textured mouthful, this baby squid perches on a kid's tongue. This mouth is not the first to taste squid, a popular dish around the world, whether deep-fried, dried, or grilled.

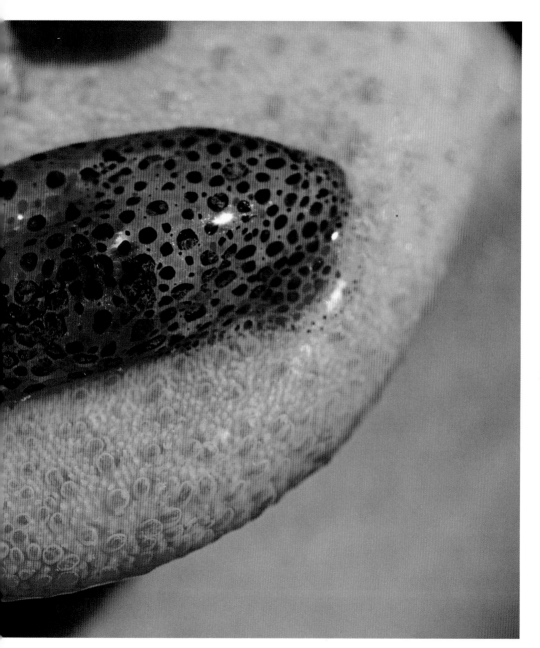

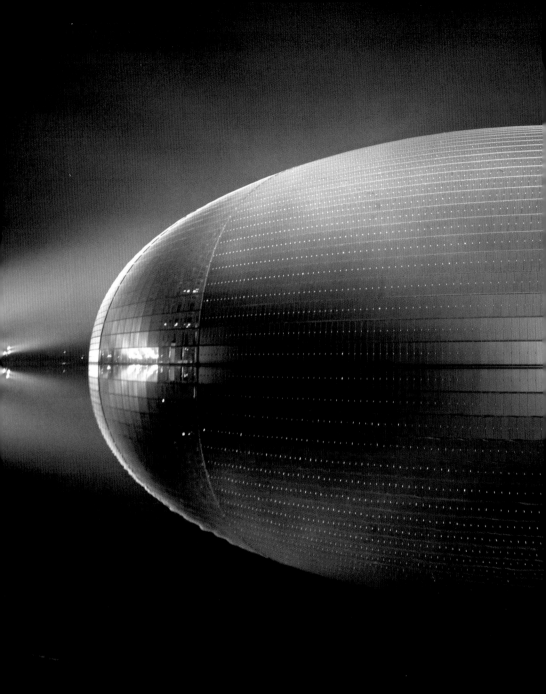

CHINA | JASON LEE

Like a gleaming egg adrift in ink, Beijing's glass-and-titanium National Center for the Performing Arts is reflected in the pool that surrounds it. The four-year-old, $336-million dome seats 5,452 people in three halls.

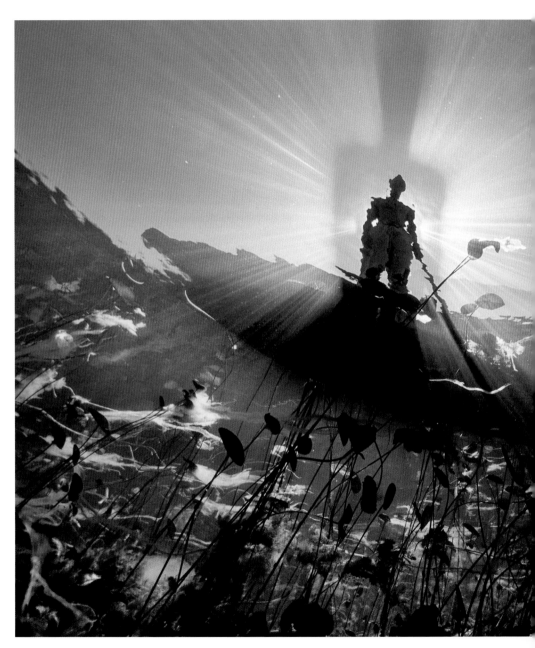

BOTSWANA | DAVID DOUBILET
*Sunlight and shadows highlight a river
Bushman in a canoe in the Okavango River.
When the river swells and floods, it creates
an alluvial fan of more than 10,000 square
miles (26,000 square kilometers).*

TEXAS, UNITED STATES
SMILEY N. POOL
Limned by Hurricane Ike, an abstract
expressionist expanse of oil-sheened
floodwater surrounds a pump jack—
a mechanical device used to extract
oil—near High Island, Texas.

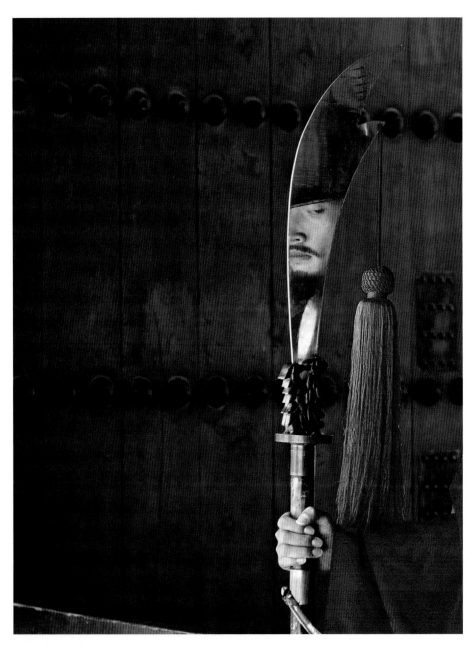

In Turkey,
6,000-YEAR-OLD MIRRORS
made of obsidian have been discovered;
the ancient Egyptians made theirs
from polished copper.
Modern mirrors, made of metal-backed
glass, were first produced
during Roman times.

SOUTH KOREA | JOE SIM CHOU HUNG | *The sword of a Gyeongbokgung Palace guard captures his intense concentration. The palace, originally built in the 14th century, offers visitors both a respite and a glimpse into the past of Korea's Joseon dynasty.*

ITALY | TERRY BRIDGES
Like colored dots in an abstract painting, umbrellas create a masterpiece in the small fishing village of Vernazza. This village and four others are located within the boundaries of Italy's Cinque Terre National Park.

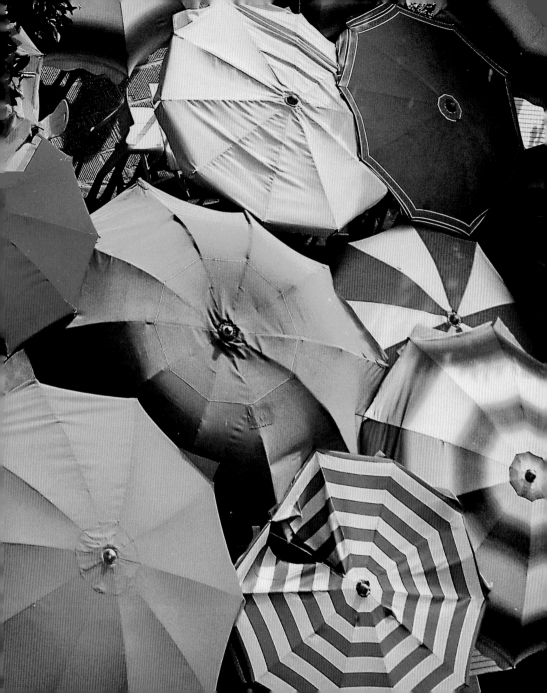

PATT

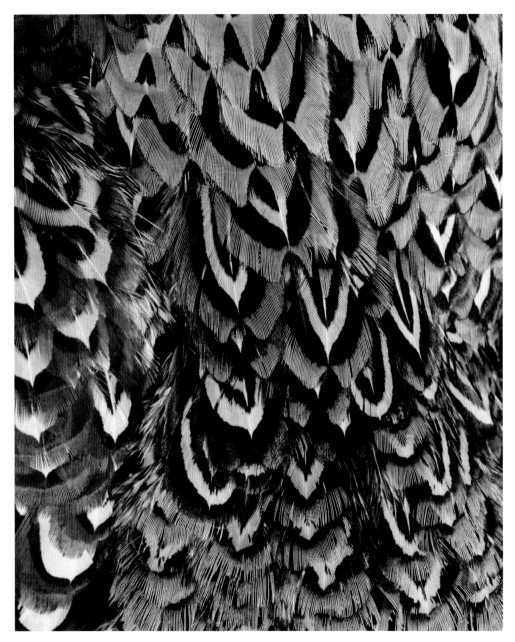

ROVING EYES seek pattern just as the mind seeks

meaning in the chaos of things. It's a human impulse, driven by the comfort that expectability brings and satisfied by the relationships that repetition and meeting points confer. Perfectly concentric circles pulsing out from where a pebble dropped into a pond. A fringe of icicles dripping motionlessly off a fence line. A snowflake's hexagon. Diamonds and stripes in earth tones, the natural geometry of snakeskin. Black veins outlining brilliant orange panels in the monarch butterfly wing, nature's stained-glass window, ornamental grace notes to the already pleasing symmetry of two antennae, head, thorax, abdomen, six legs, four wings.

Pattern makes the unknown feel familiar. Half a world away, rain forest orchids blossom in the dappled light of tropical undergrowth. We have seen this pattern before—petals, sepals, lip, lobes; blooms alternating up a stalk stretching up out of the crown of moist green leaves. Leaves, stalk, flowers, buds: a familiar pattern, and yet the photographer trekked hours, far from any known road or shelter, to capture this particular iteration of it.

In the human world, we revel in pattern as well. We find or we impose it. Buildings, neighborhoods, landscapes, farmlands: each repeating square as if part of a patchwork quilt, oddities within each piece but a regularizing pattern overall. Notes in a scale, beads on a string, flowers in a circle, chairs in a row. There is safety, there is beauty in pattern.

LOCATION UNKNOWN | PHOTODISC | *The bold markings of feathers from a male ring-necked pheasant create a dynamic cascade of color. The striking design of pheasant feathers often has been used for hats, from a vintage pillbox to Bavarian hunting caps.*

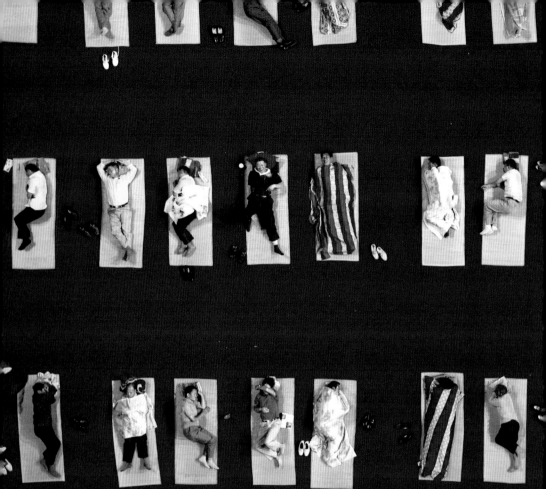

CHINA | REUTERS

Sleeping mats dot the floor of a university building in Hubei Province—kindergarten-style accommodation for hundreds of parents eager to make sure the college year starts out right for their children.

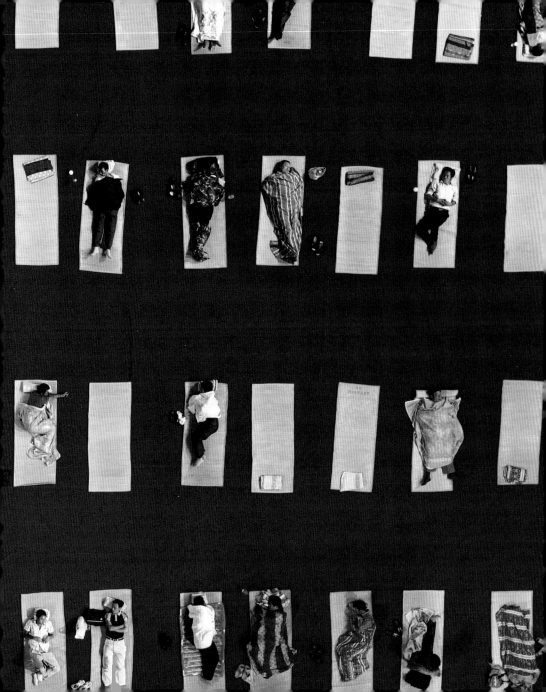

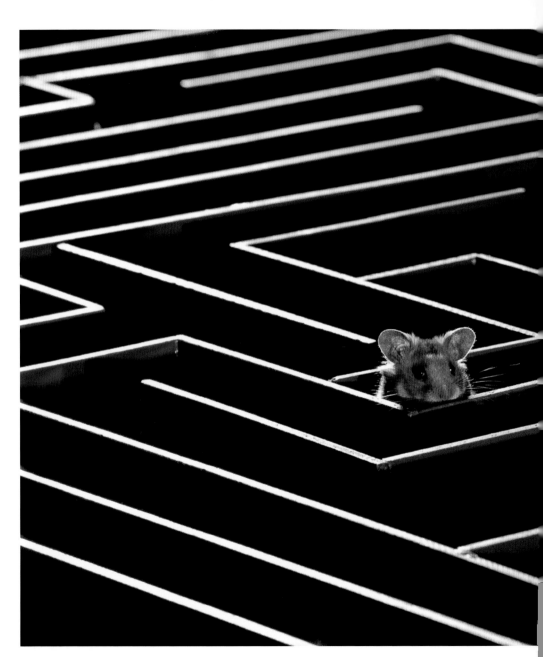

GERMANY
HEIDI AND HANS-JÜRGEN KOCH
Seemingly stuck inside a labyrinth, this golden hamster appears to be considering another way out. Golden hamsters at Martin Luther University, Halle-Wittenberg, take about a week to learn how to navigate out of this 4-foot-by-5-foot (1.2-meter-by-1.5-meter) maze.

IRAQ | JULIE ADNAN

Some 160 miles (257 kilometers) northeast of Baghdad, in a Sulaymaniyah music hall ravaged by war, looting, and neglect, a violin-playing boy sounds a note of hope. His teacher, Azad Maaruf, lives there and instructs scores of students.

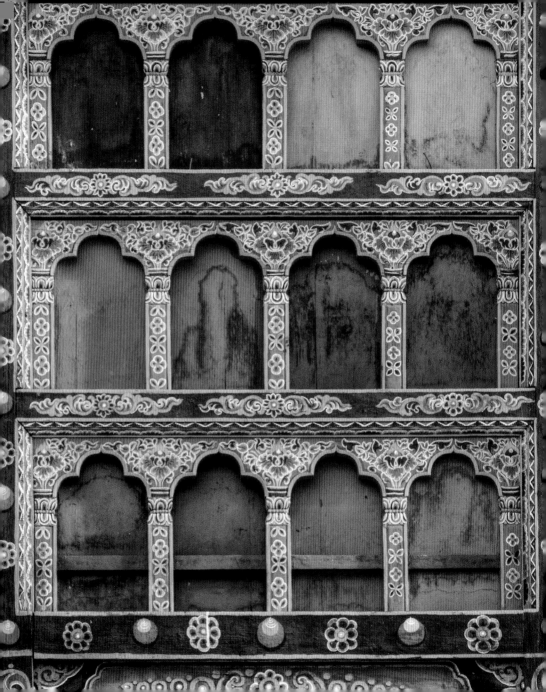

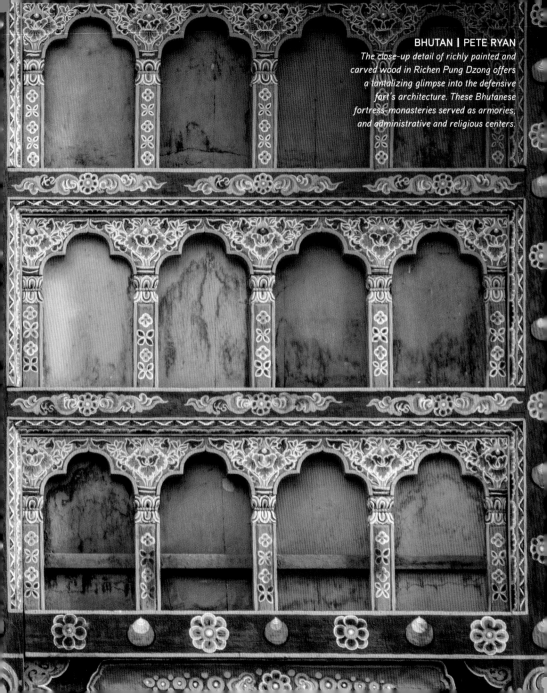

PRAIRIE DOGS

are not dogs at all; they are rodents.
Their name comes from the sound of
their warning call, which sounds
somewhat like a dog's bark.

MASSACHUSETTS, UNITED STATES | JOEL SARTORE | *This Dalmatian's owner's coat makes her easy to find. Dalmatians, whose spots range in size from a dime to a half-dollar, trace their ancestry to dogs that appeared in Africa, Asia, and Europe.*

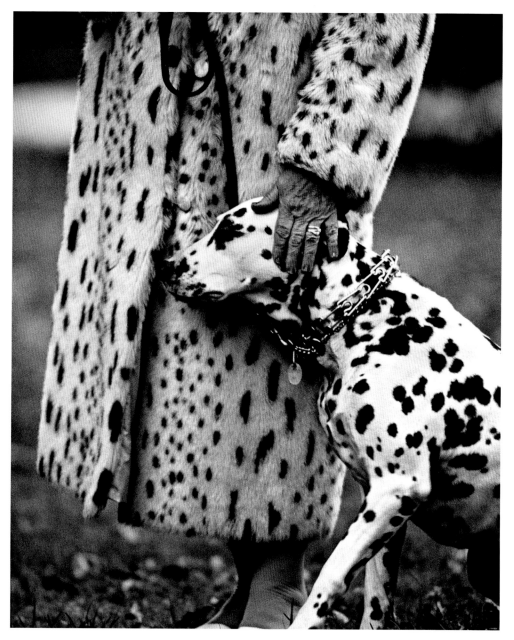

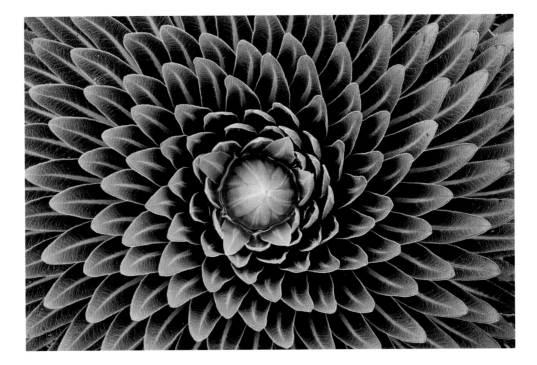

TANZANIA | GEORGE F. MOBLEY
The deep green whorls of the giant lobelia, Lobelia telekii,
grace rocky alpine slopes with good drainage in East Africa.
The plant, which can grow to ten feet tall (three meters),
can take as long as 50 years to reproduce.

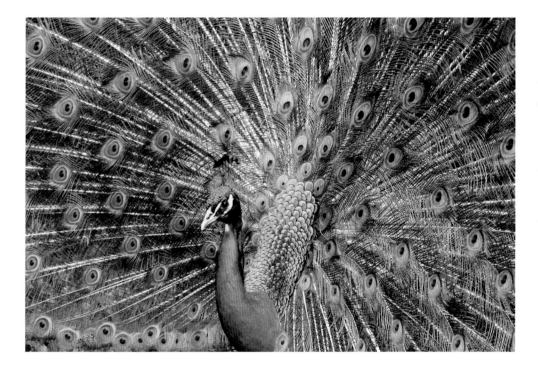

Showing off its iridescent eyespots, this Indian peafowl,
Pavo cristatus, *will molt and lose its elaborate plumage
each year. It's the tail, though, that encouraged Charles
Darwin to formulate his theory of sexual selection.*

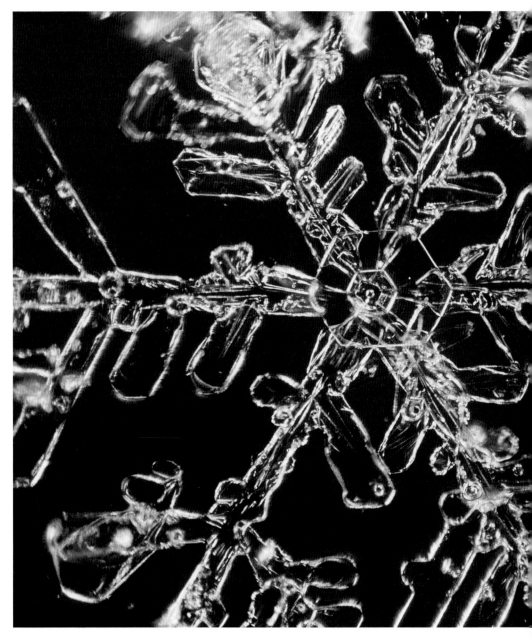

VIRGINIA, UNITED STATES | ROBERT SISSON

Polyvinyl resin preserves the unique shape of this snowflake. The levels of moisture and air temperature help determine a snowflake's pattern, and snowflake-watchers describe the shapes as columns, needles, plates, and dendrites.

INDIA | FRANS LANTING
Colorful golden headdresses adorn elephants waiting in line during the Thrissur Pooram elephant festival. Thirty elephants and their human riders, carrying giant handcrafted umbrellas, take part in the 36-hour festival.

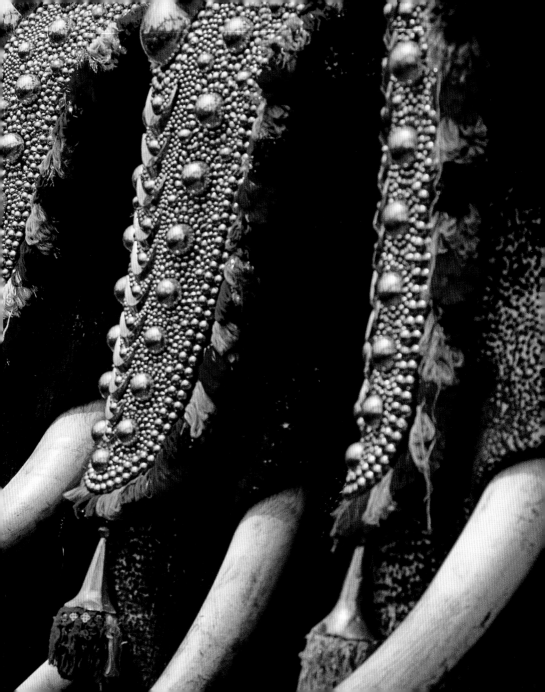

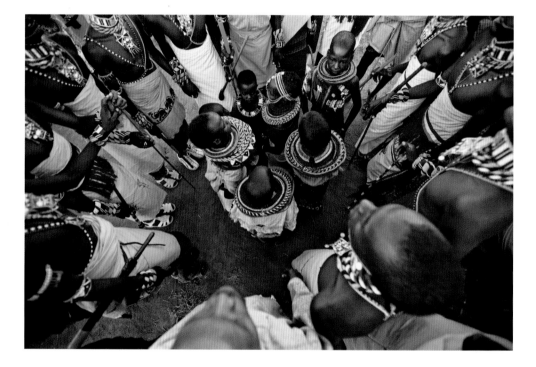

KENYA | MICHAEL NICHOLS
The Samburu people express their pastoral traditions during a three-day wedding ceremony. Samburu women make the elaborate beaded bracelets and necklaces worn by both men and women.

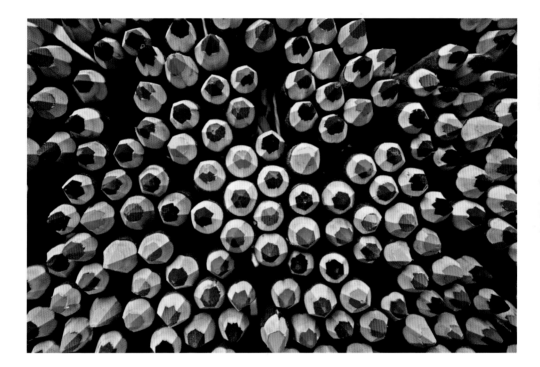

ARGENTINA | JASON EDWARDS

Shoppers can choose any color of pencil in this street
market in Buenos Aires. The city thrives on its streets,
where you can buy just about anything, watch an
impromptu tango, or breathe in the local art.

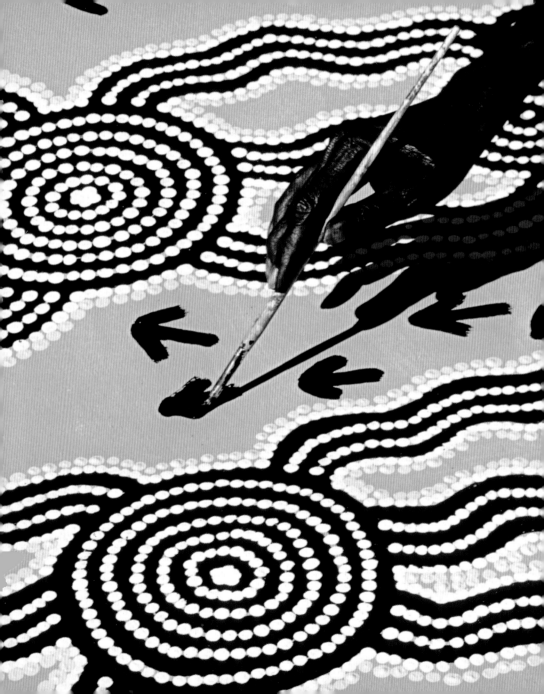

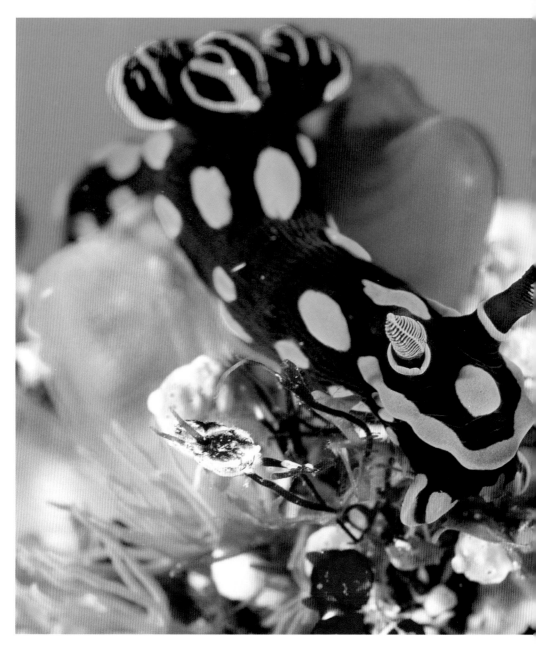

WESTERN PACIFIC OCEAN
DAVID DOUBILET

With its bright colors warning predators to stay
away, this green-spot nudibranch, Nembrotha
kubaryana, *glides over strawberry ascidians.*
Nudibranchs can secrete the poisons of their
prey as a defense.

BRAZIL | GEORGE STEINMETZ

Ribbons of dunes trap water from rains in Lençóis Maranhenses on Brazil's northeastern coast. The dunes form when ocean currents push sand, carried by two nearby rivers, to the shore; strong winds then blow the sand inland.

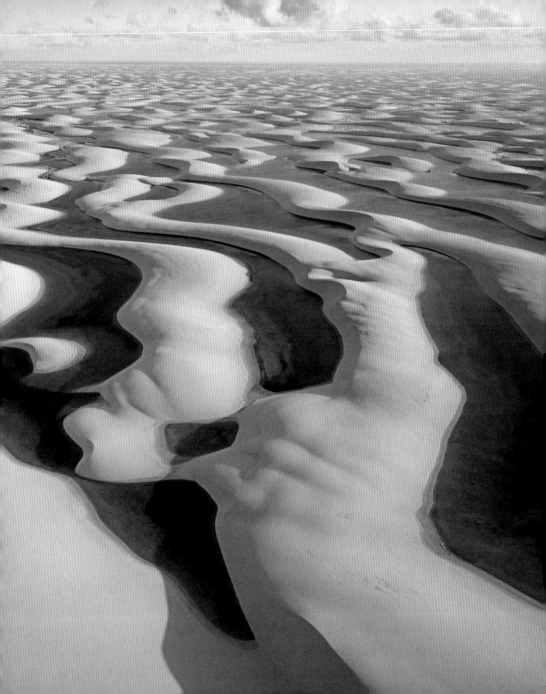

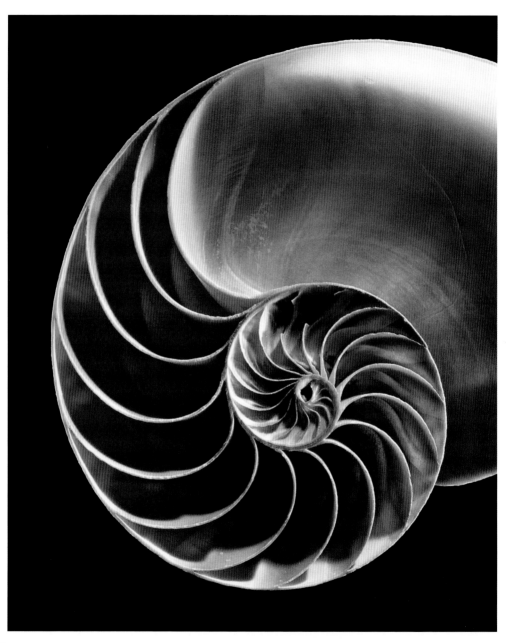

CEPHALOPODA,
the class of marine creatures including
nautiluses, squid, octopuses, and
cuttlefish, share several traits. They usually
have three hearts and blue blood
and are able to expel an inky substance
to cloud the water when threatened.

UNITED STATES | VICTOR R. BOSWELL | *A cutaway of a chambered nautilus,* Nautilus pompilius, *shows its intricate design. This deep-sea mollusk has existed in the same form for more than 400 million years.*

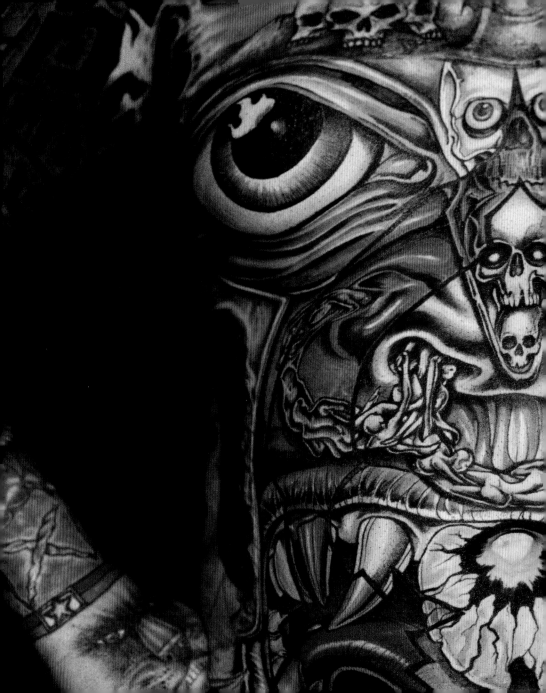

PENNSYLVANIA, UNITED STATES
JODI COBB
This contestant in a tattoo competition in Pittsburgh shows off his full-body tattoo backstage. The practice of tattooing dates to at least the Copper Age—scientists found charcoal tattoos on a mummy known as Ötzi who lived some 5,300 years ago.

EMAN

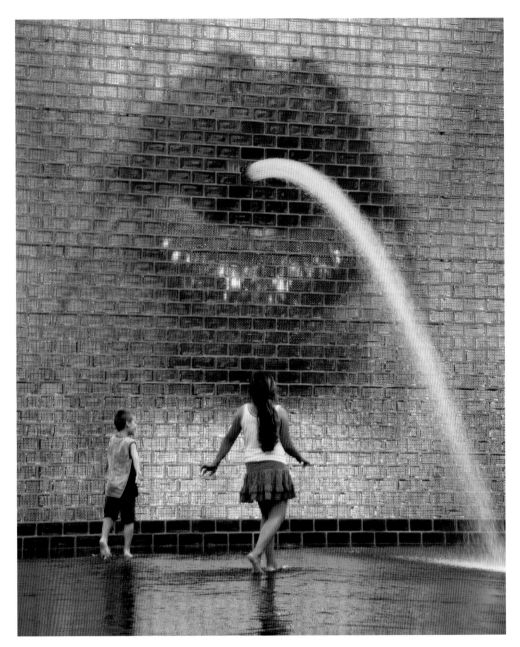

PHYSICISTS

explain to us that all this stuff, everything we see around us, started off with one big bang. From a tight and secret center of void and silence broke forth light, life, and energy—all the particles and particulars of our universe. No one saw that first big bang, but we can all imagine. We have seen it before, we see it every day, in the nature that surrounds us, in our visions of Earth.

The perfect pouf of a dandelion going to seed: a firm center surrounded by a sphere of feather-winged seeds, delicately congregating, a wispy aura where just yesterday there was a thick yellow bloom. Touched by the slightest wind, the emanation disperses and sends tiny slivers of dandelion being out into the world to propagate their kind.

The burst of life that took centuries to build, revealed in an old tree trunk's cross section. At its center, material memories of the sapling that this tree once was. Year after year it grew by accretion, adding successive layers of the interplay of xylem and phloem, water in and water out, sap traveling up and down, transporting complexities under the corky protection of callous bark. If we could read the code of this great being, we would hear tales of drought summers or deep winter snows melting into spring overflow. The history of a life much longer than any human's tells its tale in concentric rings.

ILLINOIS, UNITED STATES | ANNIE GRIFFITHS | *Chicago's Crown Fountain provides a watery hello at Millennium Park. Designed by Spanish artist Jaume Plensa, LED displays on two 50-foot (15-meter) towers show changing images, while the fountains offer respite from the heat.*

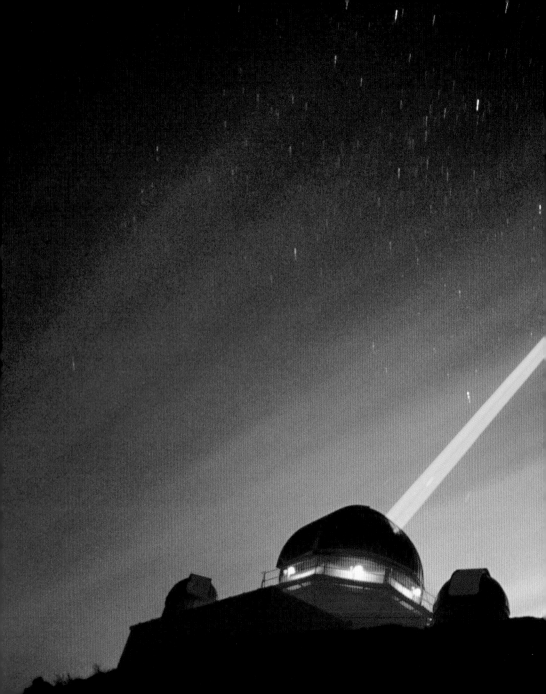

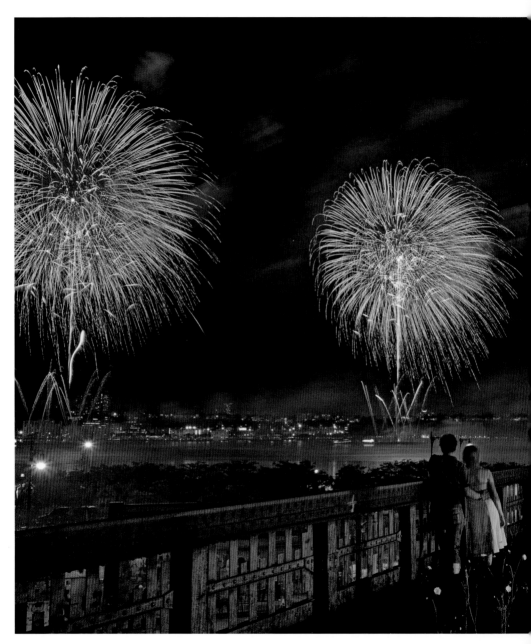

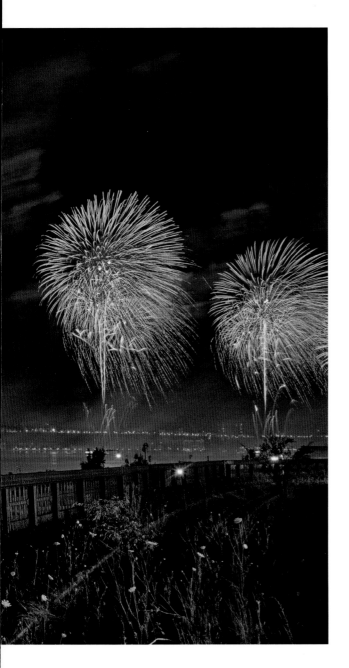

NEW YORK, UNITED STATES
DIANE COOK AND LEN JENSHEL
A couple watches Fourth of July fire-
works bloom over the Hudson River in
the Chelsea section of New York City. The
different bursts of color require careful
control of the chemistry and temperature.

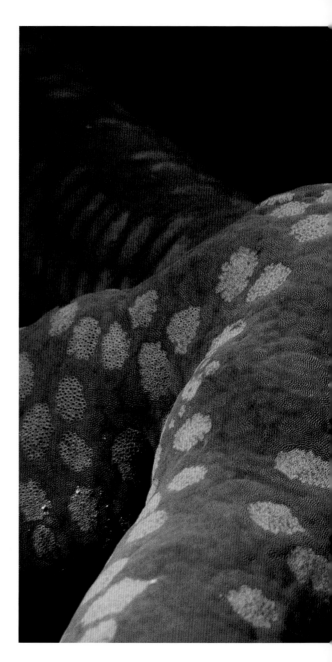

SOLOMON ISLANDS | BIRGITTE WILMS

Like a pale brooch atop royal velvet, a brittle star—barely as big as a nickel—crawls across the arm of an 18-inch-wide (46-centimeter) blue sea star. The smaller creature took just seconds to traverse the larger.

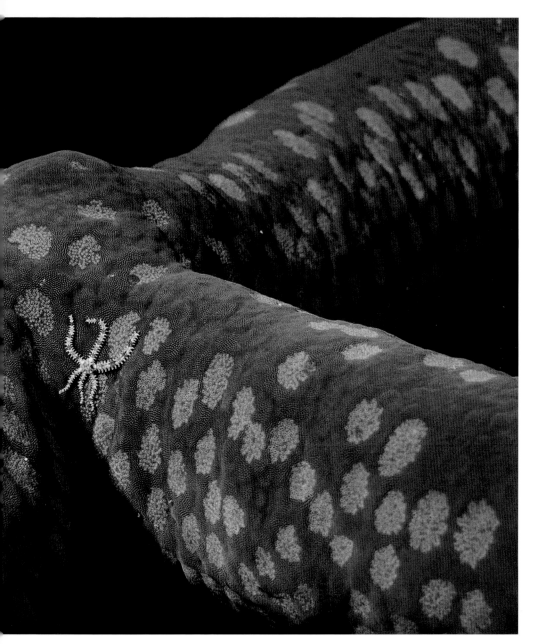

TANZANIA | OLIVIER GRUNEWALD

A camera's long nighttime exposure reveals the red glow of lava spilling from Mount Ol Doinyo Lengai in Tanzania's Rift Valley. The volcano's lava, which appears brown to the naked eye, has the consistency of olive oil.

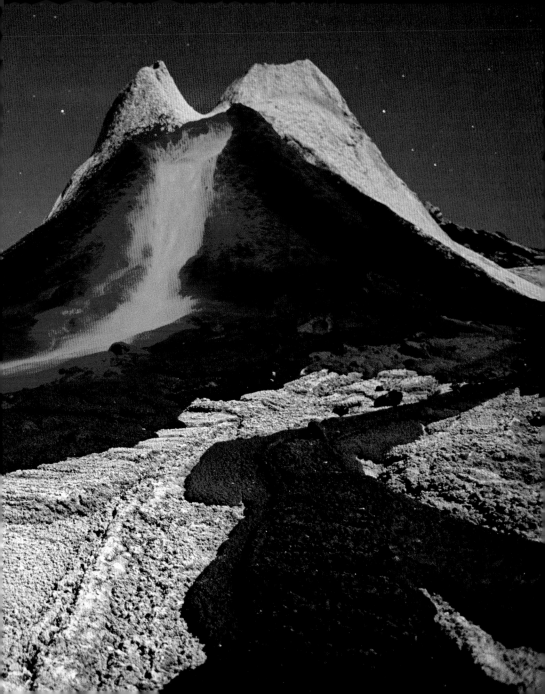

ELECTRIC EELS

can produce strong electric shocks
of around 500 volts.
They use this ability both for hunting
and self-defense.

WASHINGTON, D.C., UNITED STATES | TYRONE TURNER | *A thermal image of a compact fluorescent light and an LED lightbulb turns them into postmodern flowers. The energy efficiency of the CFL, which lasts up to ten times as long and uses only 25 percent of the energy of an LED, is clearly shown by the lack of dead blue space.*

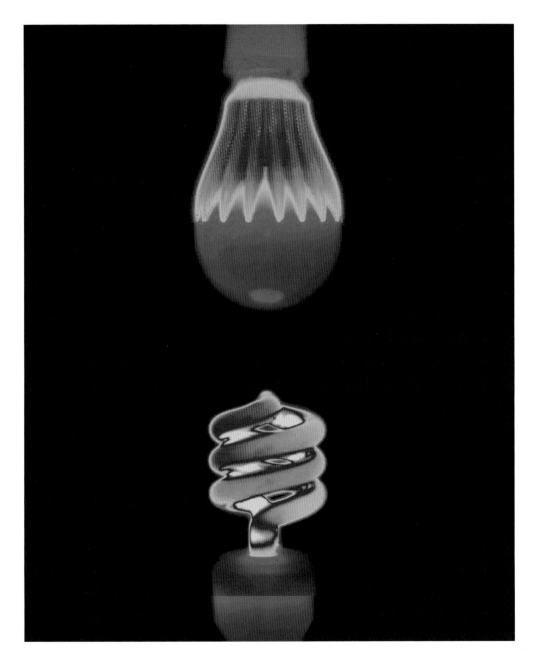

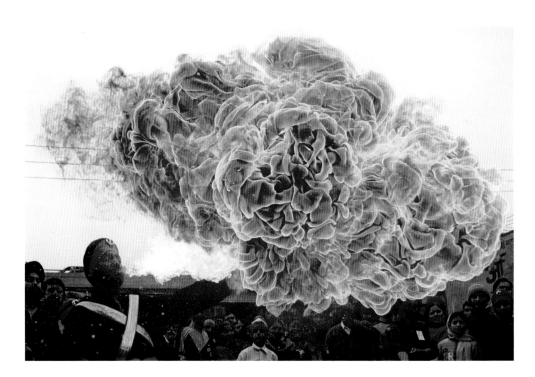

INDIA | JAIPAL SINGH

In Jammu, a flower of flame blooms from a man's
kerosene-filled mouth. Devotees of Sikhism, the world's
fifth largest organized religion, were marking the 342nd
birthday of Guru Gobind Singh, a founder of the faith.

CANARY ISLANDS | MANUEL M. ALMEIDA
Bright yellow pollen adds a golden, beelike tinge
to this weevil's body. These small beetles might
be considered pests in the home, but they are
intrinsically important for plant fertilization.

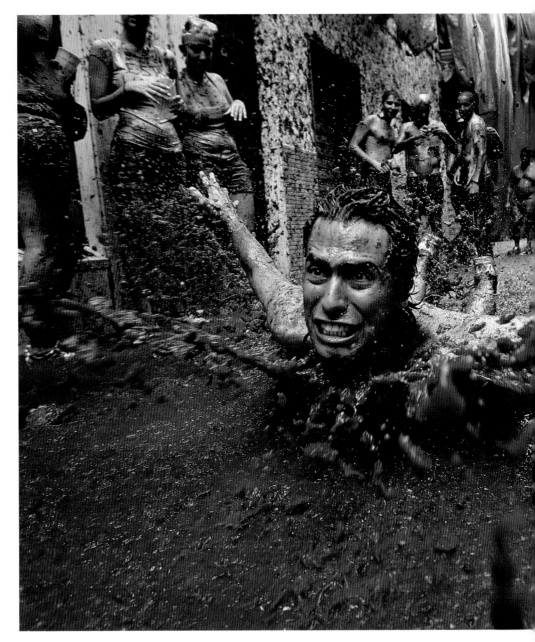

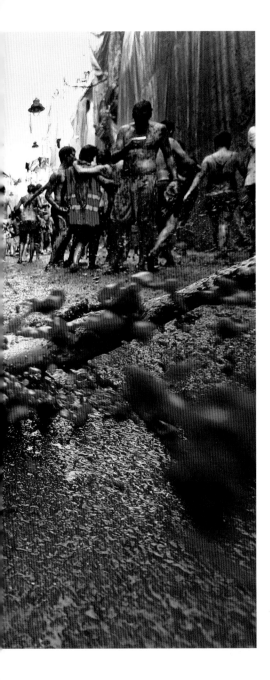

SPAIN | BIEL ALINO

Sliding headlong through a tomato-juice torrent, a young man celebrates La Tomatina in Buñol on August 26, 2009. The event is a one-hour food fight that can use up to 275,000 pounds (125,000 kilograms) of tomatoes.

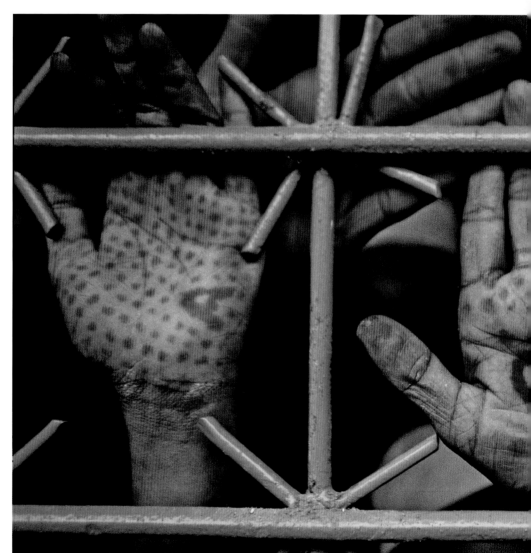

BANGLADESH | ALEXANDRA BOULAT
Behind a window at a Koranic school in Jessore,
children show off their henna-stained hands.
Girls and women decorate their hands for religious
holidays, weddings, and other celebrations.

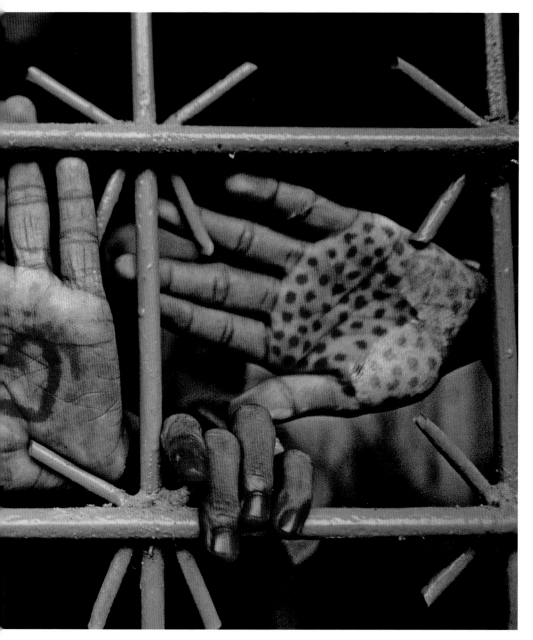

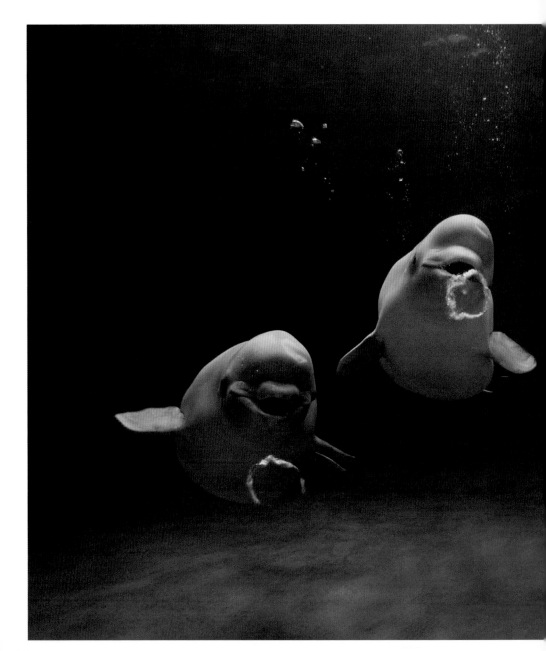

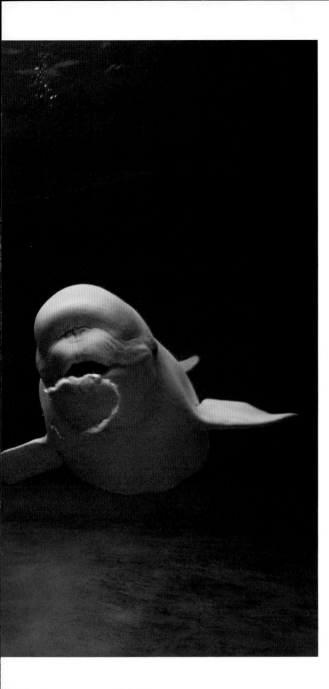

JAPAN | HIROYA MINAKUCHI

*Bubble-blowing beluga whales in Iwami
Seaside Park's Shimane Aquarium appear
to be choreographed. Beluga (which means
"the white one" in Russian) whales not
only play but also make and mimic a wide
variety of sounds.*

WASHINGTON, D.C., UNITED STATES | VICTOR BOSWELL

Magnified sugar crystals take on the look of a cathedral window.
Sugar water started to evaporate on a microscope slide,
thus allowing crystals to form and to spread outward.

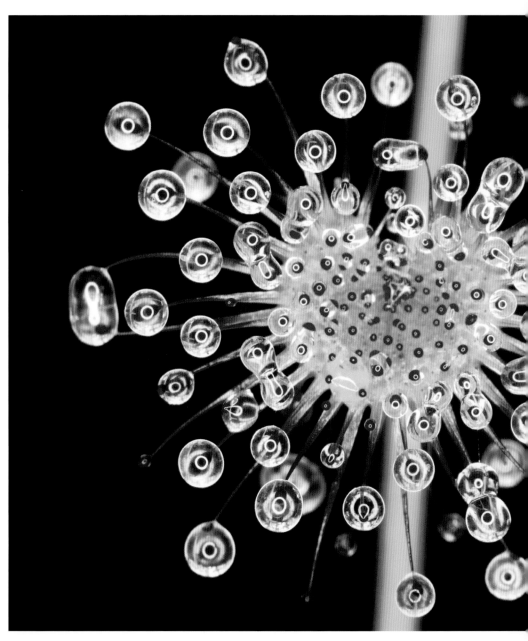

GERMANY | HELENE SCHMITZ

What look like dewdrops on an Australian sundew
(Drosera stolonifera) *act as lures for thirsty insects.*
Drawn to the carnivorous plant, they find themselves
entangled in its sticky tentacles.

CHINA | YU ANDY
Hidden behind hats and exploding firecrackers,
these revelers at a dragon-boat festival in
Guangzhou, China, appear to be playing it safe.
Fireworks, invented in ancient China from
explosive military rockets or missiles, are
a mainstay at many festivals.

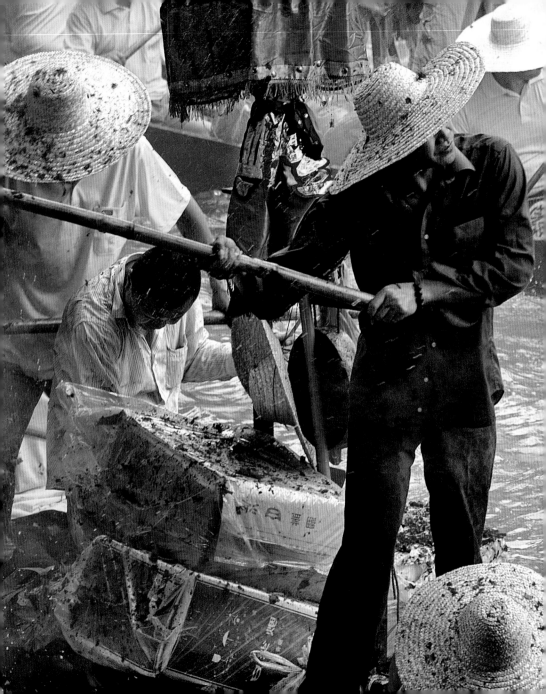

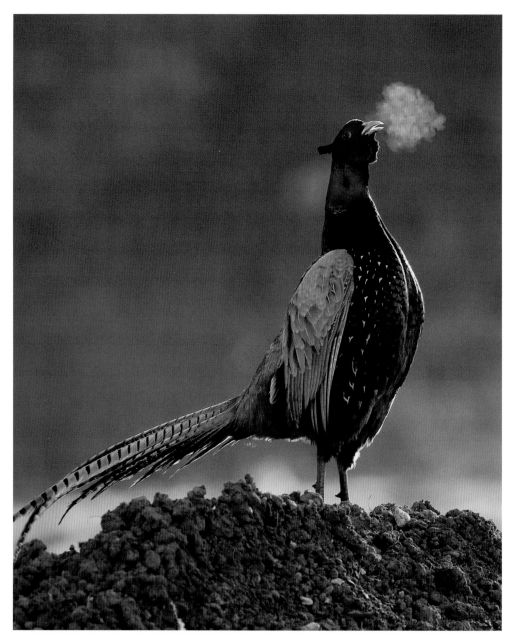

The average person takes about
25,000 breaths
every day. That's about 2,000
gallons (8,000 L) of air.

ENGLAND | DAMIAN WATERS | *This male pheasant is not just blowing smoke. It also uses a hoarse call to start off the day.*

179

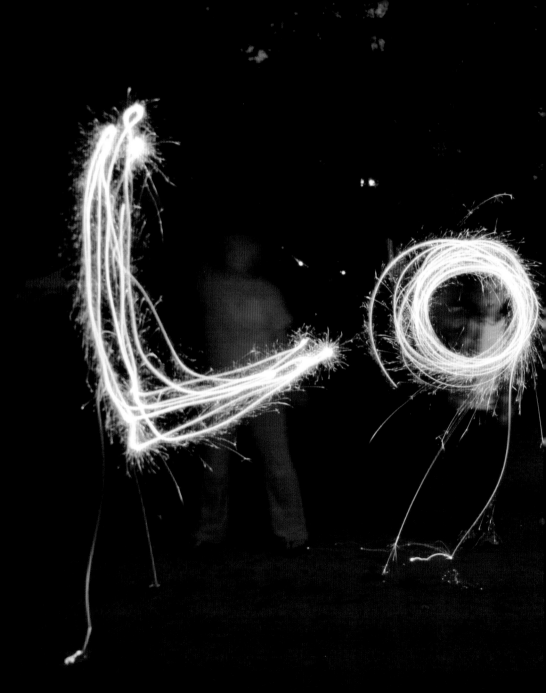

LOUISIANA, UNITED STATES
STEVE SCHINDLER

Five kids, some sparklers, and a long exposure spell out a lovely message during New Year festivities. Celebrated throughout the world, with a written record from 4,000 years ago in Mesopotamia, the new year has traditionally been seen as a time for rebirth and love.

AGGRE

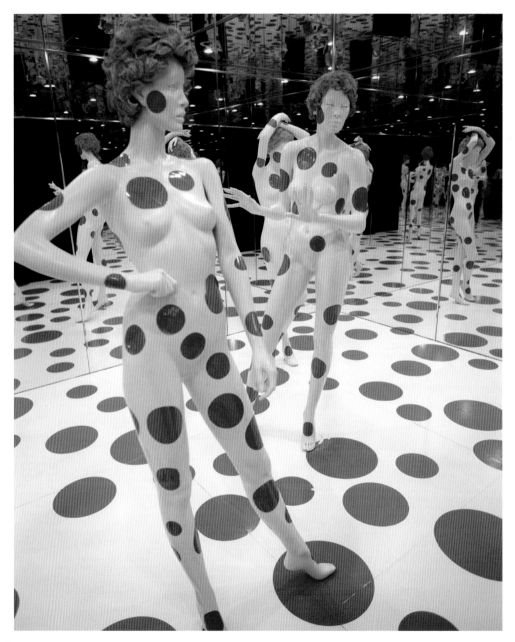

THERE IS A safety in numbers, a sense of plenitude approaching delight. To know that there are many confirms our sense of permanence and the persistence of life.

Some things naturally come in aggregations. A viscous mass of frog eggs, nearly liquid in itself and yet solid enough to resist dissolving, hundreds of tiny orbs, each holding a living and growing amphibian life. The spring hatch of a praying mantis egg case, wintering over as a bit of dried-out foam but becoming the birthplace of as many as hundreds of miniature mantids, perfectly engineered, emerge and enter the weedy world. Snowy egrets by the dozens, gathering in the mangroves as the sun goes down, clucking quietly as they jostle each other to find just the right perch for a nighttime roost.

We humans so enjoy natural aggregations that we have amassed an entire vocabulary of words to name them: swarm, pack, smack, pride, brace, flock, warren, bevy, brood, exaltation. Each multitude of creatures seems to assume a different personality; each aggregation becomes a new kind of one. And indeed that is the fascination of these natural gatherings. Blackbirds swirl through autumn skies, and it seems so likely that centrifugal force will fling them out in all directions. But no: They fly as one. Minnows pulse through ocean shallows, but do they dart hither and yon? No: They swim as one.

The one made of many, a symbol of synchronicity and wordless coordination.

PENNSYLVANIA, UNITED STATES | RICHARD NOWITZ | *The dots go on forever in Yayoi Kusama's "Infinity Dots Mirrored Room" at Pittsburgh's Mattress Factory Art Museum. Kusama explains that for her, "A mirror is a device which obliterates everything including myself and others."*

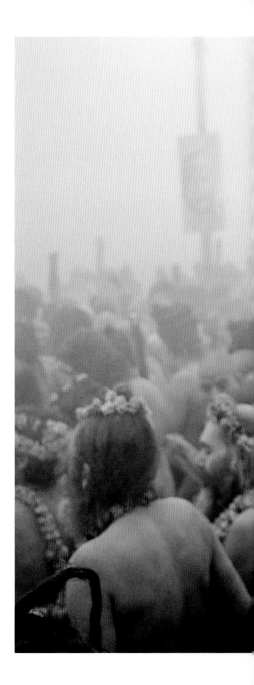

INDIA | GREG VORE

A Hindu boy bedecked in flowers looks out from a sea of people during the Kumbh Mela festival in Allahabad, India. Millions of Hindus travel to the confluence of the Yamuna and Ganges Rivers to take part in the most auspicious of sacred baths.

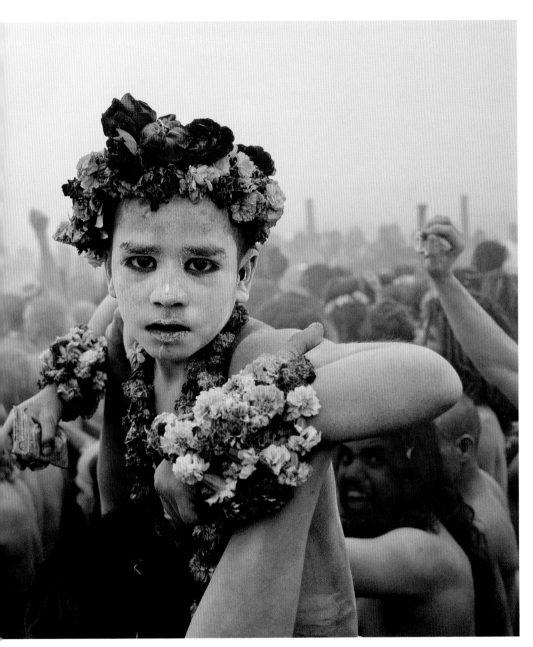

INDONESIA | JAMES NACHTWEY
Muslims in prayer appear as cells in a vibrant organism at Jakarta's Istiqlal Mosque, the largest mosque in Southeast Asia. More than 100,000 people can worship here, which is appropriate since Indonesia is home to the largest Muslim population in the world.

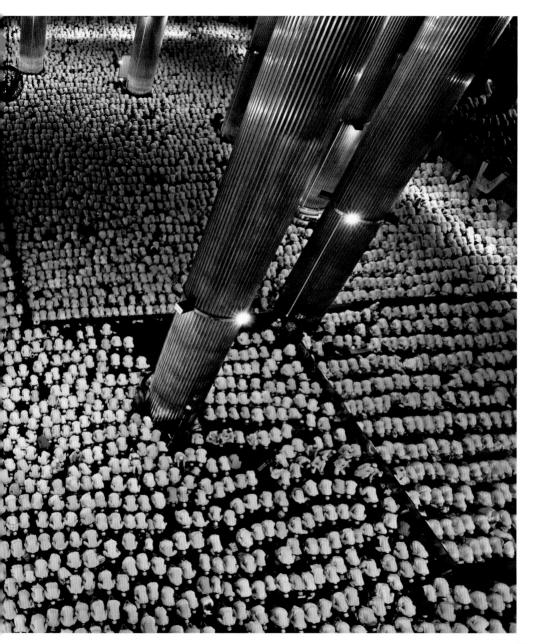

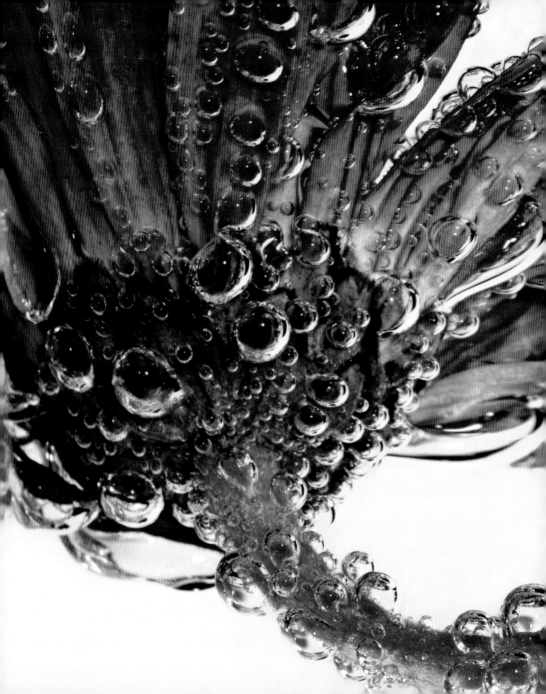

FLORIDA, UNITED STATES | CHERYL MOLENNOR
Seeming to defy the laws of gravity, raindrops cling to a Gerbera *daisy. This genus, which contains some 30 different wild species, was named for an 18th-century German doctor, Traugott Gerber.*

WASHINGTON, UNITED STATES
JORDAN SIEMENS

*Over the past 17 years, a decidedly sticky sit-
uation has developed in Seattle's Post Alley,
where countless colorful wads—pressed
down with coins or used to spell out names
and places—form the gum wall.*

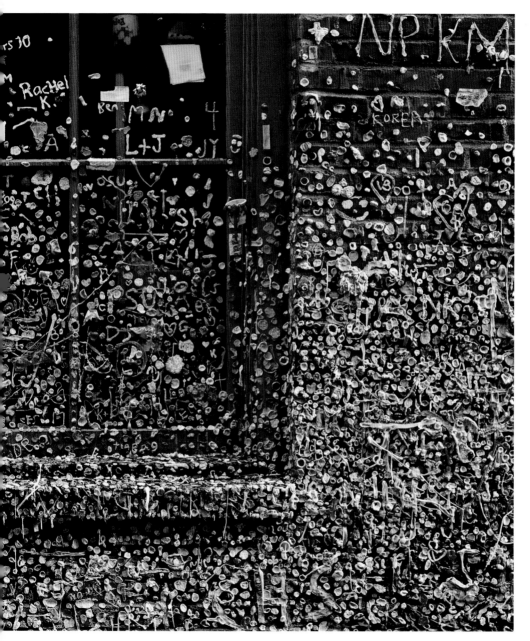

The number of people on
PLANET EARTH is projected to reach
seven billion by the end of 2011.
With more than 1.3 billion people,
China is the most populous country,
followed by India and
then the United States.

ISRAEL | CHRIS ANDERSON | *Nestled in soft bedding, these Baby Jesus statues look out on the world
with beatific expressions. Visitors to Bethlehem's Church of the Nativity, which marks the traditional birthplace
of Jesus Christ, can purchase one to take home.*

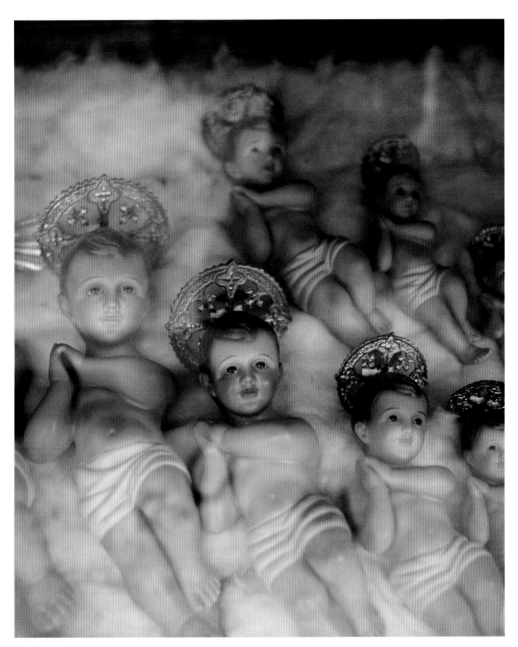

PENNSYLVANIA, UNITED STATES | JODI COBB
A raft of plastic ducks bobs on the water at the Big Butler Fair in western Pennsylvania. This county fair features midway games such as this one, as well as a school-bus demolition derby, Fourth of July fireworks, and sea lions.

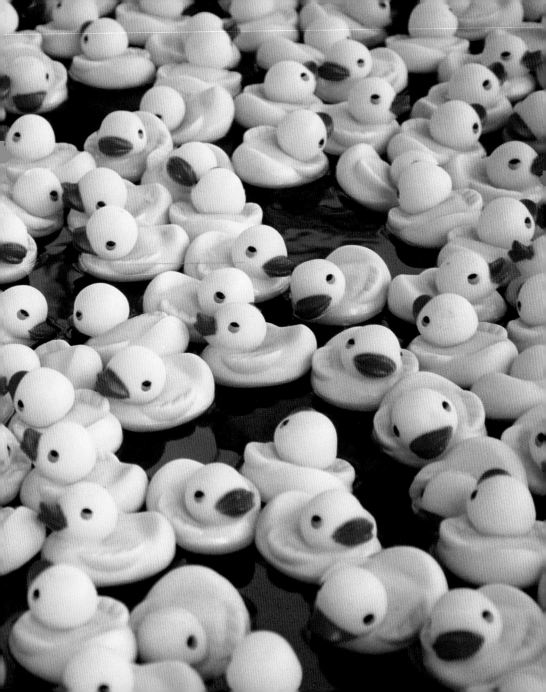

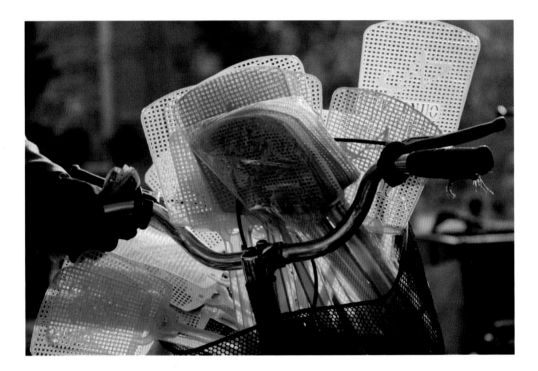

CHINA | DAVID EVANS

*The pastel hues of fly swatters create a plastic bouquet in
this bike basket in Xining, China. In the markets here you
may be able to find anything you'd like, including caterpillar
fungus used in traditional medicine.*

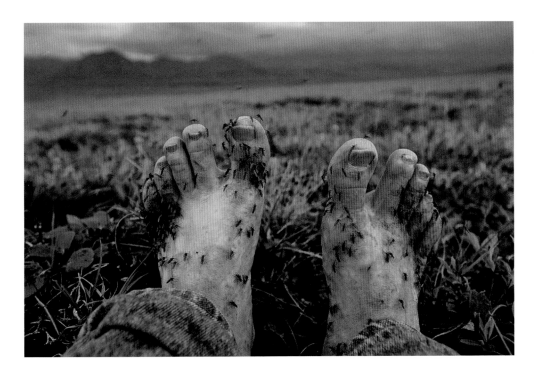

ALASKA, UNITED STATES | JOEL SARTORE

This photographer sacrifices his feet to tenacious mosquitoes on Alaska's North Slope. But there was a price to pay for his art: "I scratched the bites for hours afterward."

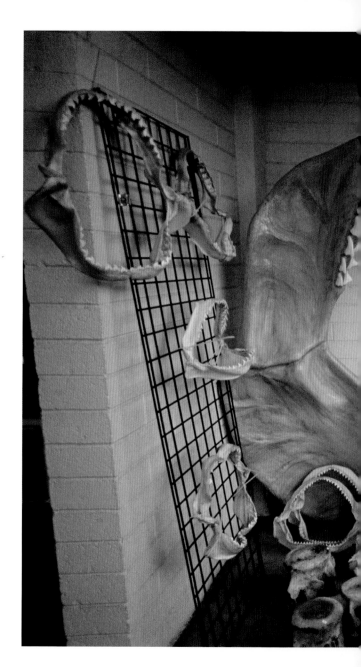

ARIZONA, UNITED STATES
LYNN JOHNSON

This jaw and teeth beckon fossil collectors instead of guarding against thieves at a hotel room in Tucson, Arizona, home to a popular gem and mineral show. The lucrative fossil trade forces museum curators, paleontologists, and private collectors to jockey for the best specimens.

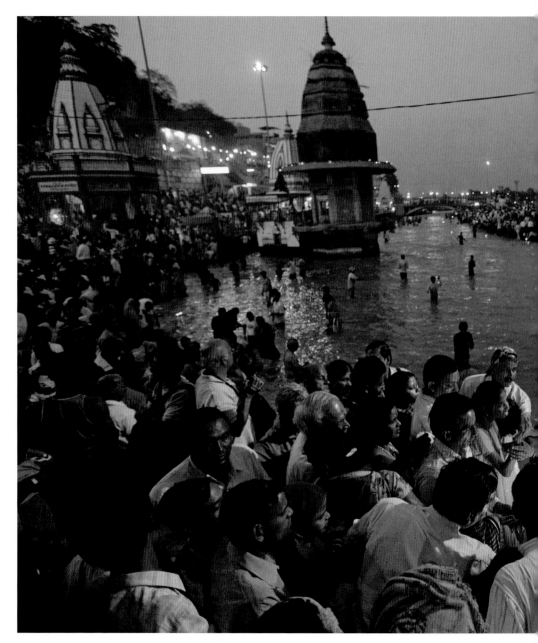

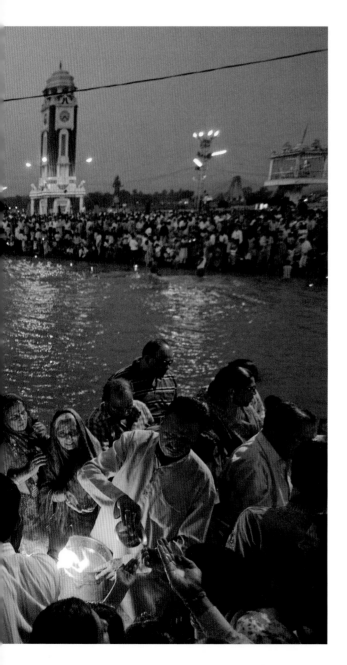

INDIA | JOHN STANMEYER
Hindus perform aarti, *an offering of lamps*
to the sacred Ganges in Haridwar, India.
Here, they believe, the power of Mother
Ganga to wash away sins is strong.

FRENCH POLYNESIA | DAVID LIITTSCHWAGER
All this sea life passed through a 12-inch (30-centimeter)
metal cube on Temae Reef off Moorea Island in French
Polynesia. The myriad colors, shapes, and sizes represent
a small ecosystem—and vividly demonstrate the richness
of life on Earth.

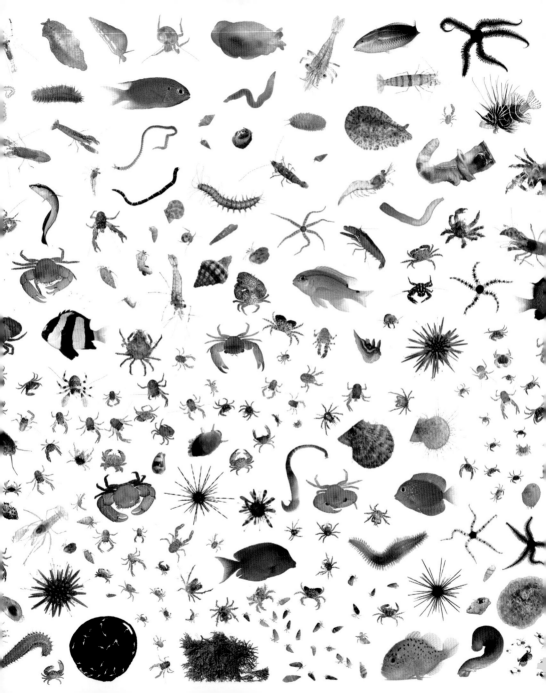

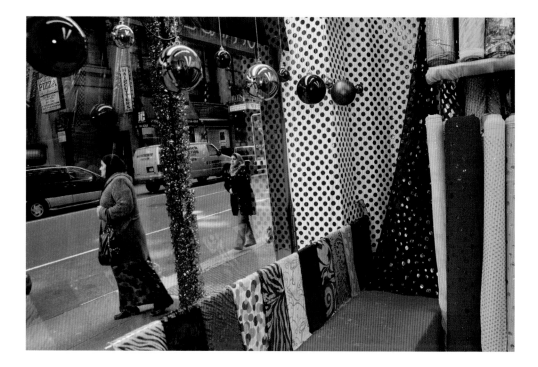

NEW YORK, UNITED STATES | WILLIAM ALBERT ALLARD
Passersby don't seem to notice the bright rows of fabric in
a shop window in New York City's Garment District. Fashion
designers appreciate the close proximity of materials, but
manufacturing doesn't always take place here, as it has shifted
to outlying locations and other countries.

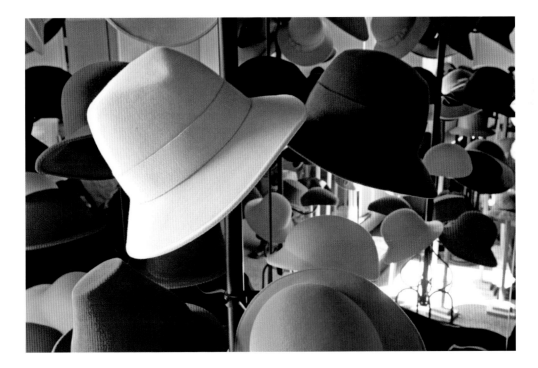

NEW YORK, UNITED STATES | WILLIAM ALBERT ALLARD

*Like gumdrops in a candy store, these hats in a milliner's showroom
in New York City's Garment District may be destined for a designer's
fashion show. One designer showcase requires intense effort but is
usually over in less than 20 minutes.*

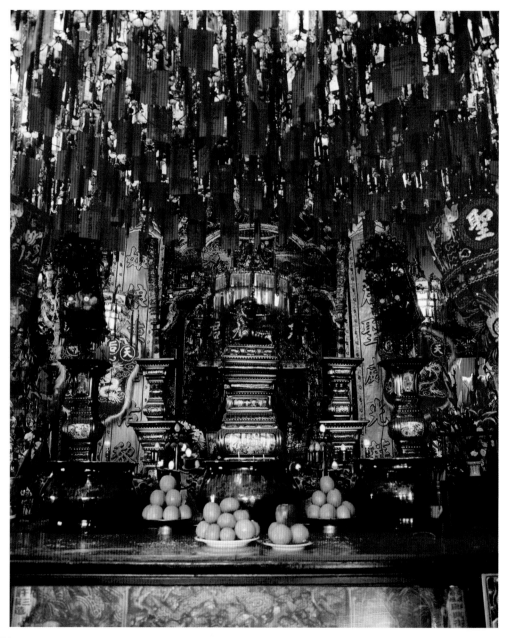

IN CHINA, the color red symbolizes good fortune and joy. Yellow and gold represent heavenly glory.

CALIFORNIA, UNITED STATES | SUSAN SEUBERT | *The Tien Hau Temple in San Francisco's Chinatown provides a bright respite from the busy streets below. The altar, located on the top floor of a building that survived the 1906 earthquake, is dedicated to the goddess of heaven.*

RUSSIA | RANDY OLSON

Finding their natal waters in order to spawn, these salmon in the Ozernaya River are just one of six Pacific salmon species that return to the rugged Kamchatka Peninsula. Unlike Atlantic salmon, once a Pacific salmon has bred, it dies.

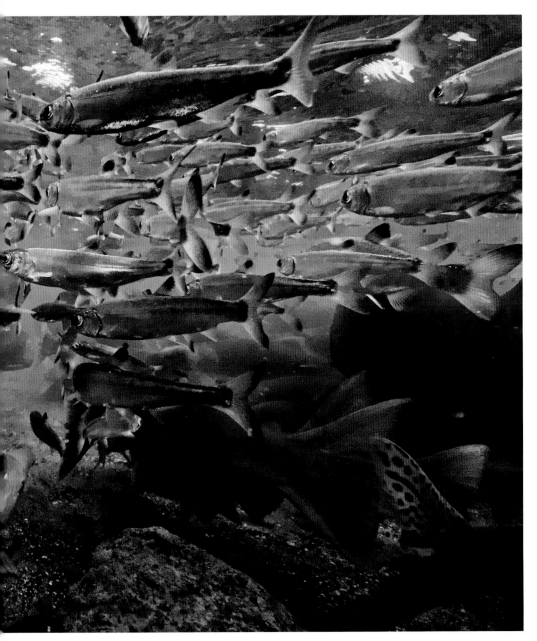

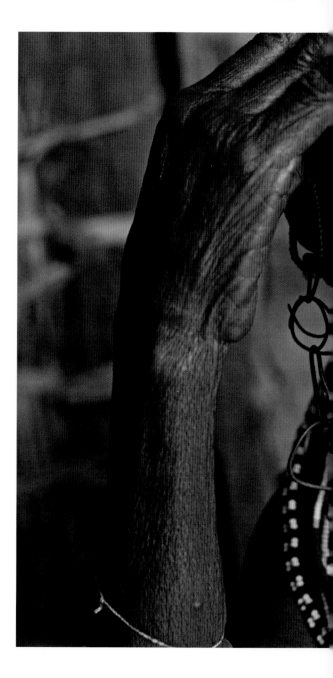

KENYA | LYNN JOHNSON
*Colorful beaded necklaces and the striking
gaze of an El Molo elder create a timeless
image. She lives in a small fishing village on
the southeastern shore of Lake Turkana.*

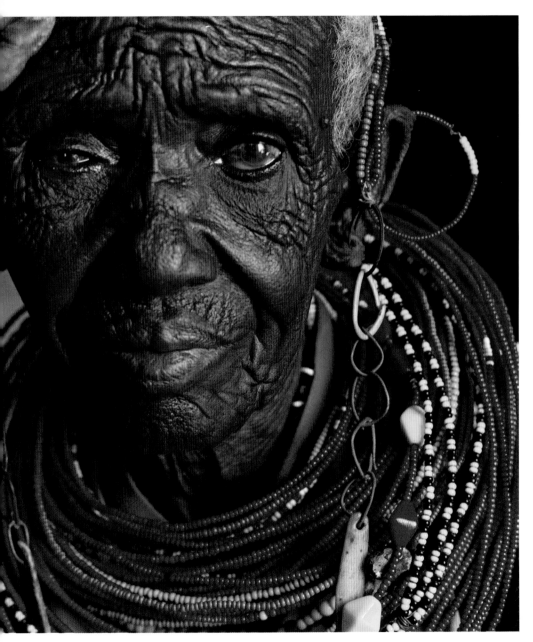

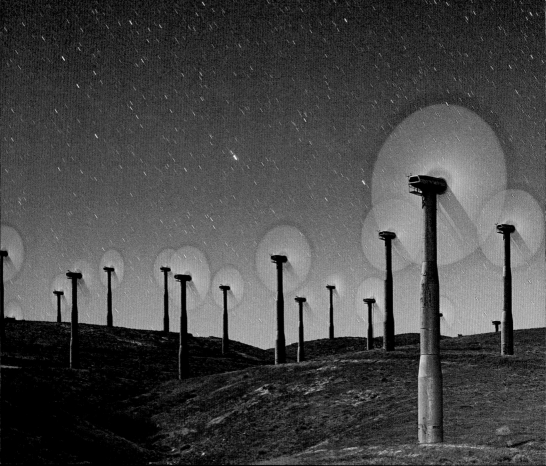

Generating enough electricity to serve a quarter million homes each year, more than 3,000 wind turbines bristle across the hills of the Tehachapi-Mojave Wind Resource Area.

PARA

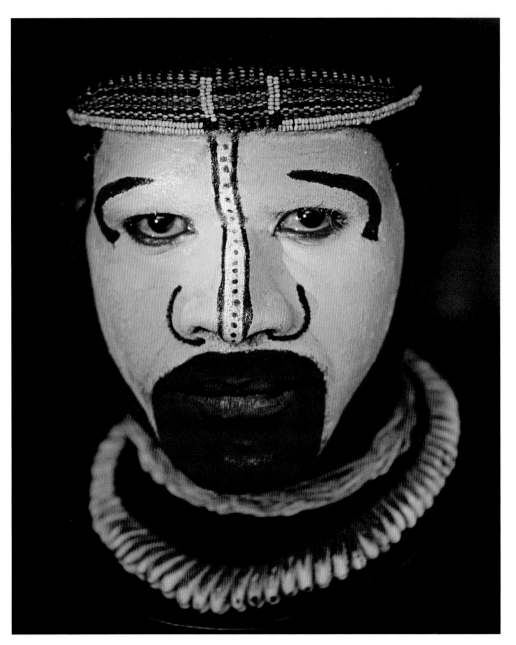

TO KNOW

how things differ, and to know how they are the same, we line them up in parallel. It's a lesson taught in school early—compare and contrast—and it's a mental exercise invited by visions of the Earth that we inhabit.

Flat rocks poke up out of a streambed, stepping-stones from one bank to the other. Through parallels, we travel from here to there.

Buttercups bloom along the roadside, one after another, each yellow head bobbing and seeking the sun. They stand straight, almost in a line, almost parallel, each bending a little differently to the same wind. Red-winged blackbirds congregate on the top wire of a farm fence, cheery chevrons distinguishing the males from dusky females, but silhouettes of solidarity, scores of birds perched in parallel. Through parallels, we feel confident that nature can still produce in abundance, and therefore, all feels right with the world.

We humans adopt the concept of parallels and go nature one better: We design our orchards and vineyards in orderly parallels, the better to plant, the better to prune, the better to weed, the better to harvest. Our gardens, too, push parallels to extremes. Carrot seeds poked into the soil in a very straight line sprout into feathery green stalks above and slender spears of orange below. Never would nature scatter seeds in such a pattern, but our backyard gardens prove how humans crave parallels.

PAPUA NEW GUINEA | JODI COBB | *The painted face of a Huli wigman, who wears a wig made from his own hair, presents a steady look in preparation for a ceremonial dance. Huli men in Papua New Guinea's highlands also use clay, flowers, bones, plant oils, and feathers for adornment.*

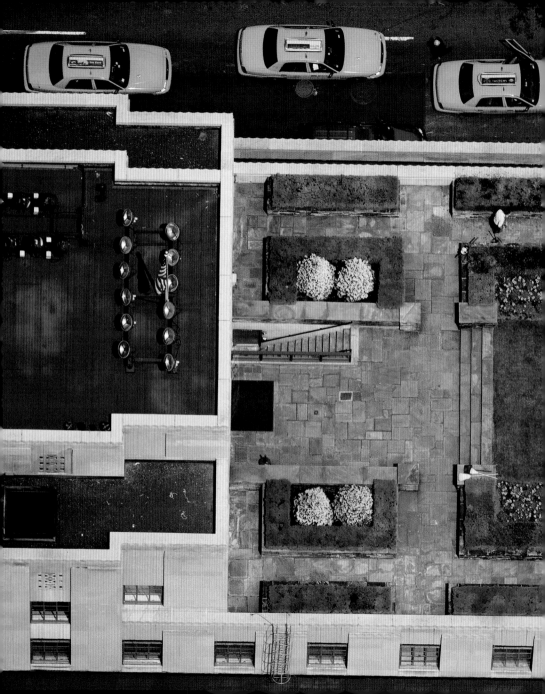

NEW YORK, UNITED STATES
VINCENT LAFORET
Secret prize on the urban game board,
a miniature garden brightens a Rocke-
feller Center rooftop seven stories above
midtown traffic in New York City. Four
gardeners labor eight hours a week to
keep its lawn and hedges trim.

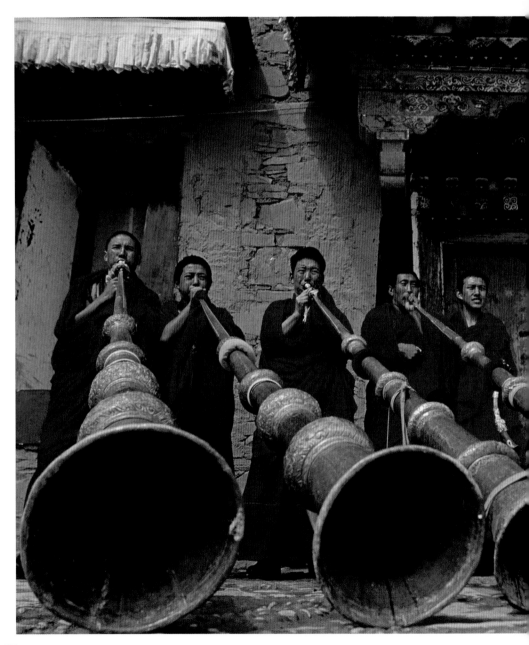

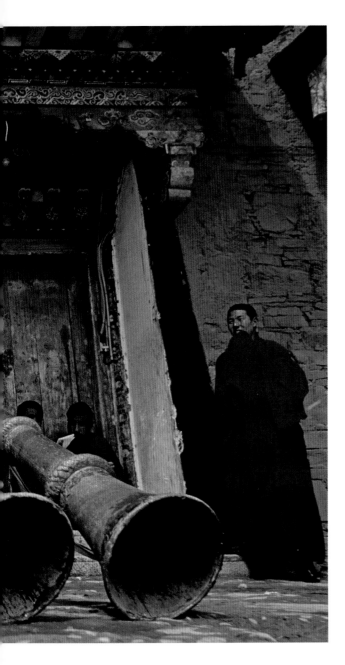

CHINA | MICHAEL S. YAMASHITA
Buddhist monks at Labrang Monastery
practice blowing horns, which they use to
call their fellow monks to prayer.
Neuroscientists hope that by studying
brain scans of meditating Buddhist monks
they can understand how they achieve a
state of oneness with the world.

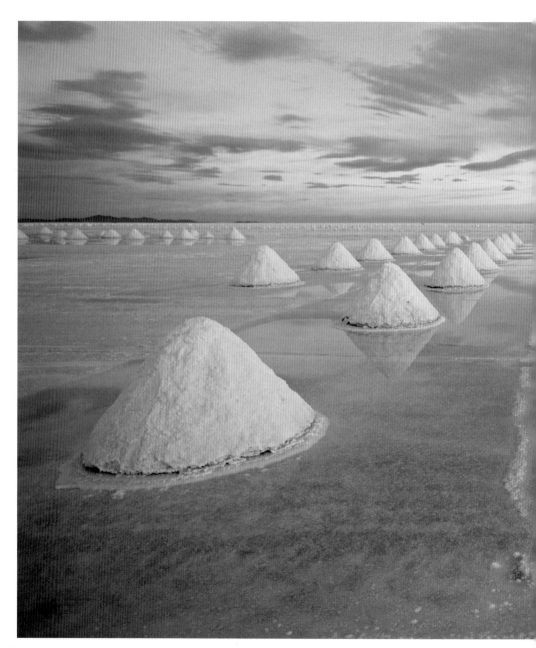

BOLIVIA | GEORGE STEINMETZ

Salt from the world's largest salt plain in Salar de Uyuni waits for transport to surrounding Andean villages. It's one of Earth's flattest places; relief varies by less than 16 inches (41 centimeters) across some 4,000 square miles (10,000 square kilometers).

The DEVONIAN PERIOD of history occurred from 416 million to 359.2 million years ago. It is also known as the age of fish because it was during this period that the first fish developed legs and moved onto land.

IRELAND | JONATHAN BLAIR | *Virtually out of the deep, this scientific model of a tetrapod shows how an animal with four limbs, instead of fins, could walk on land. The 150 fossilized tracks, discovered in 1992 on Ireland's Valentia Island, were laid down more than 365 million years ago.*

226

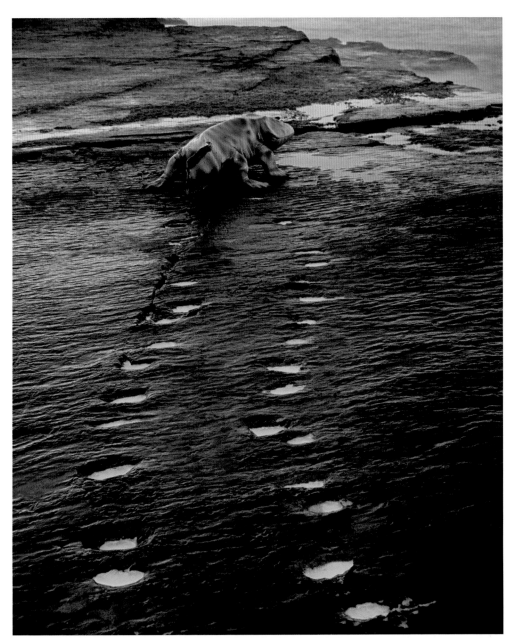

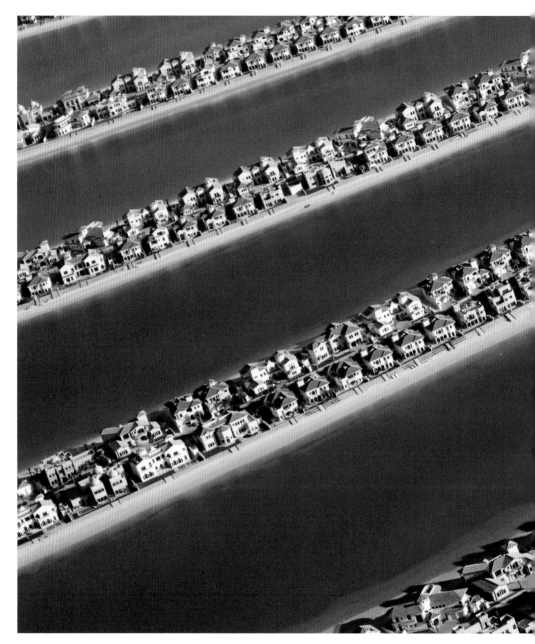

UNITED ARAB EMIRATES
ALEXANDER HEILNER
Peninsulas of prosperity, the "fronds" of Palm
Jumeirah—the world's largest artificial island—in
Dubai jut into the Persian Gulf.

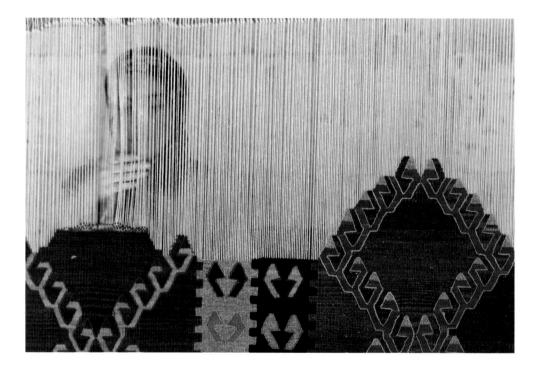

TURKEY | GEORGE STEINMETZ

Appearing veiled behind the patterns of a nascent Turkish carpet,
a weaver practices an art that traces its origins to more than
2,000 years ago in Central Asia. The craft was refined and honed
during the Ottoman Empire as a way to please rulers.

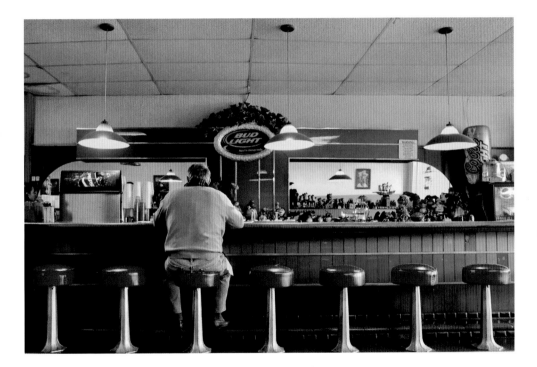

CALIFORNIA, UNITED STATES | SHAUN MCGRATH
Cherry-red bar stools and colorful walls add spirit to this
Mexican restaurant in Brawley, California, some 20 miles
(32 kilometers) from the border. Part of California's agricultural
Imperial Valley, cross-border fertilization enriches the area.

UNITED STATES | PAUL ZAHL

These bubble-eye goldfish and their fluid-filled eye sacs appear to be floating to the top of their aquarium. The fish often rest their eyes on aquarium surfaces, and the bubbles can grow so large that the fish have trouble seeing.

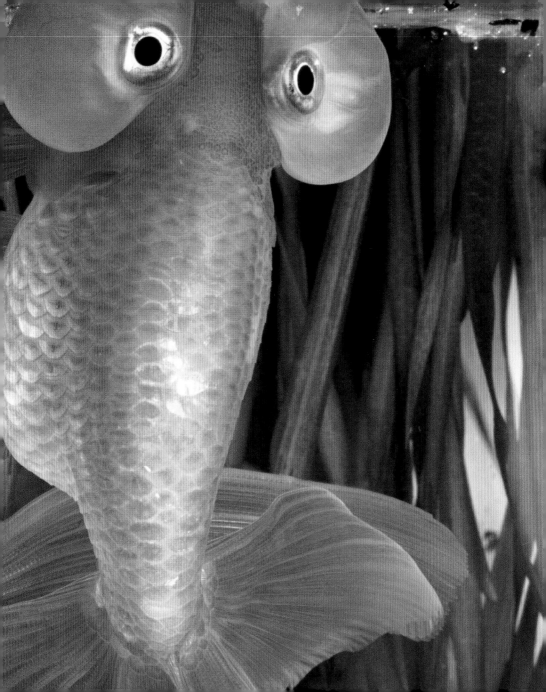

BRUNEI | ADAM HANIF
Colorful shawls and flowered dresses accentuate these Bruneian girls as they practice for a traditional Malay family gathering. Their hands, folded together, symbolize humility and peace.

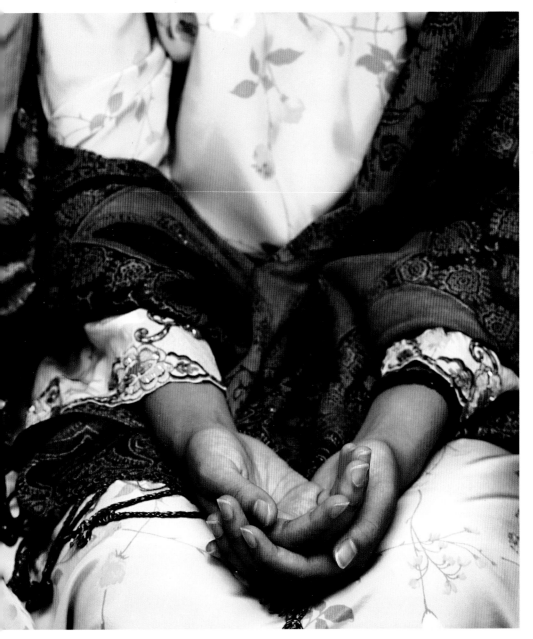

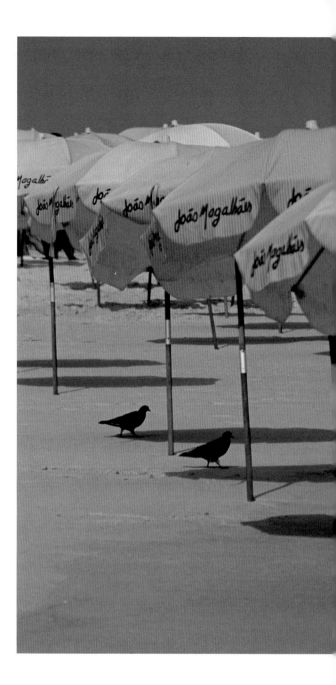

BRAZIL | JODI COBB
Beach umbrellas mimic pink flamingos on Ipanema Beach in Rio de Janeiro. Brazil is getting ready to host the 2014 World Cup and the 2016 Summer Olympics, when Rio's beaches are sure to be popular.

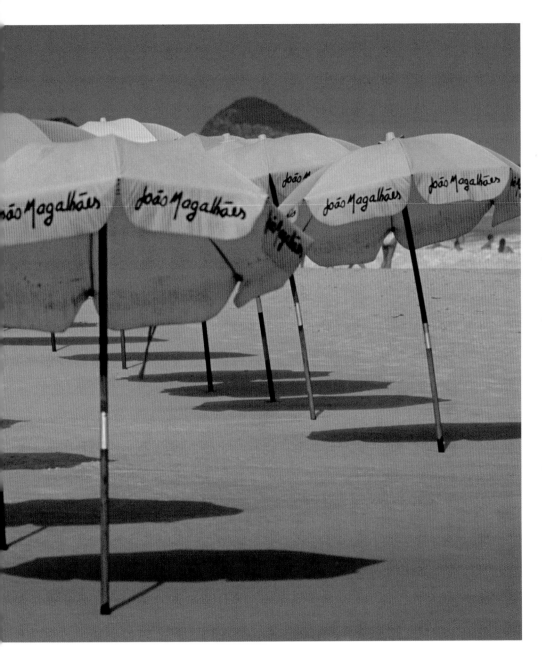

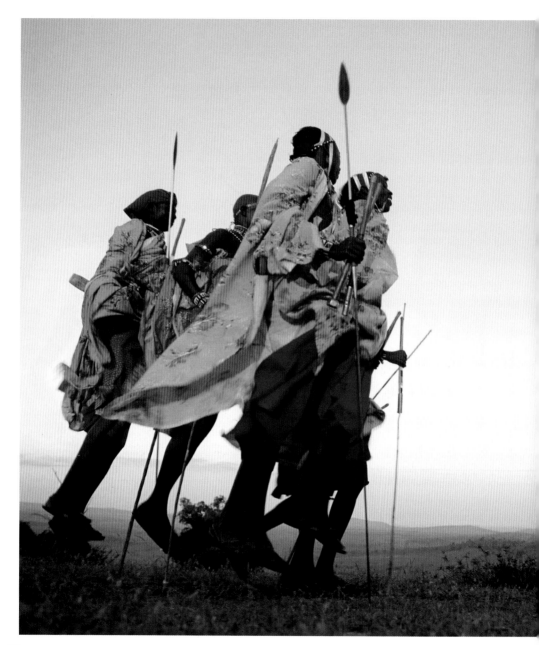

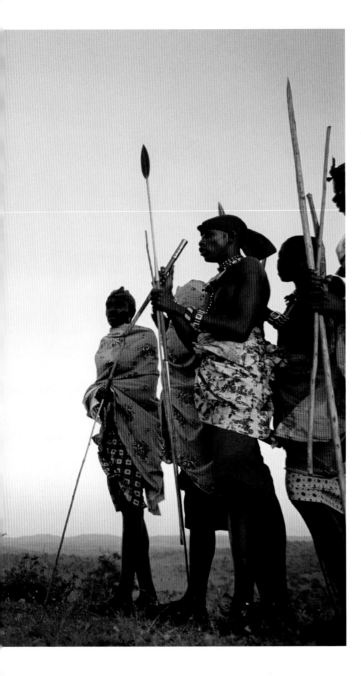

KENYA | DAVID MCLAIN

*Maasai men perform a traditional jump
dance. The Maasai, nomadic pastoral-
ists of East Africa, divide each year
into two: a year of plenty during the
rainy season, and a year of hunger.*

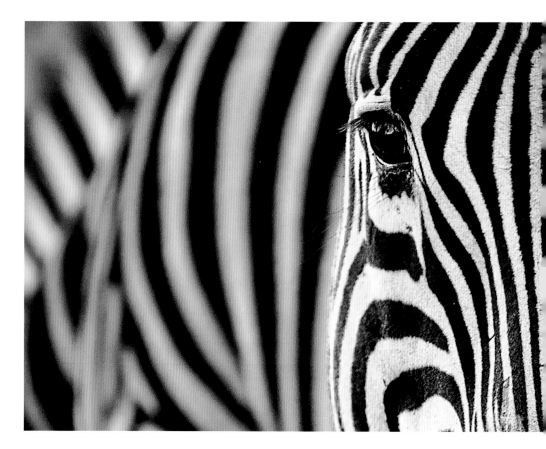

SOUTH AFRICA | CHRIS GRAY
The kind eyes of this zebra look out from behind its
stripes. Scientists think the elaborate pattern—no two
zebra coats are the same—may confuse predators or
repel pesky insects.

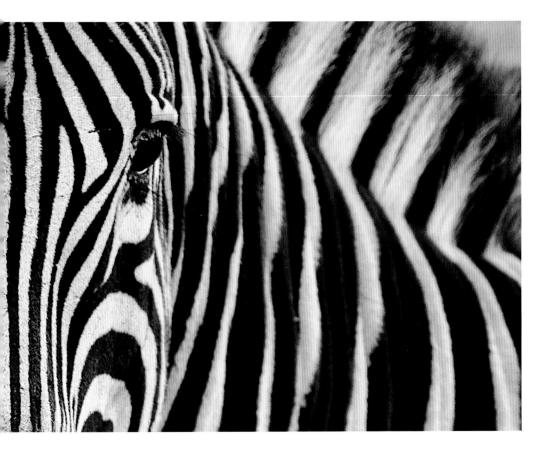

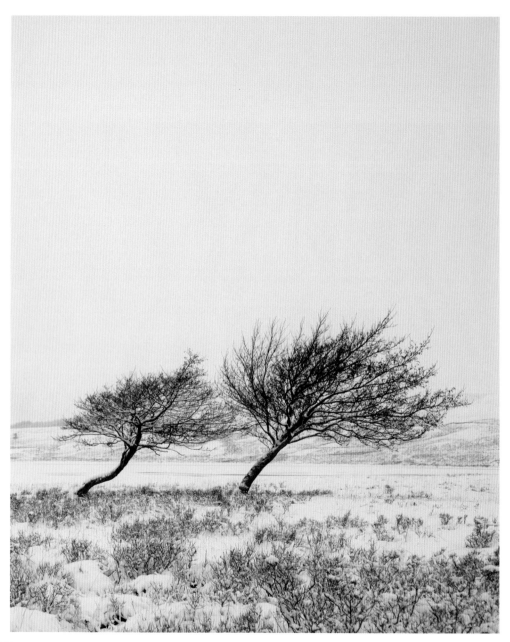

On Earth, wind gusts can blow more than 200 miles an hour (322 kph)—about as fast as a race car's top speed. In contrast, on Neptune the wind blows up to 1,243 miles an hour (2,000 kph)— about the top speed of an F/A-18 Hornet fighter jet.

SCOTLAND | BILLY CURRIE | *On the banks of Loch Tulla in the Scottish Highlands, wind-sculpted trees emerge momentarily during a snowstorm. Piles of powder and extreme cold made the winter of 2010 one of the region's harshest in decades.*

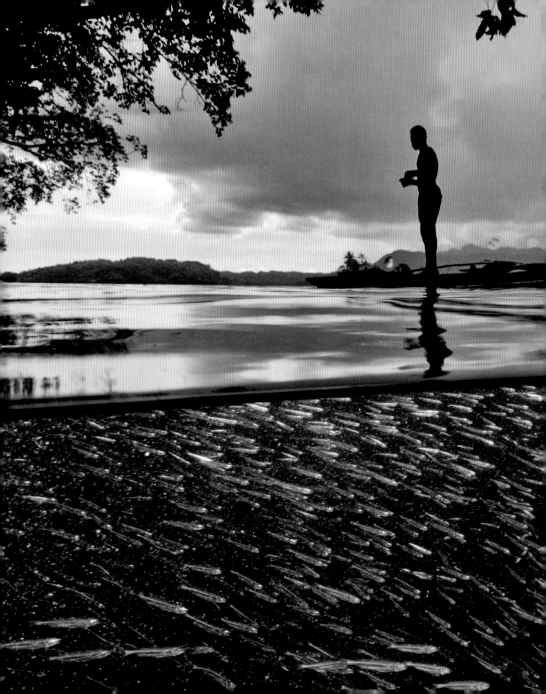

INDONESIA | DAVID DOUBILET
See dusk in the Dampier Strait through a
half-submerged lens and glimpse two distinct
worlds. Under a cloud-slung sky, fishermen
work on wooden boats. Beneath a mirror-
calm surface, waters flash with baitfish.

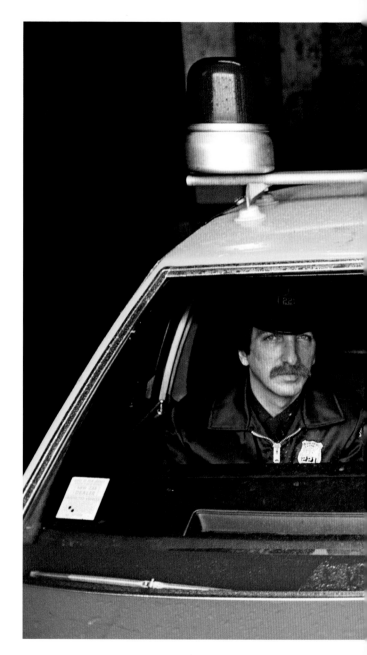

NEW JERSEY, UNITED STATES
MICHAEL S. YAMASHITA
These police officers share more than
the same uniform. New Jersey triplets
Andrew, Joseph, and Robert Koralja,
from left, had a combined 42 years of
service in 1981, when this photo was
first published.

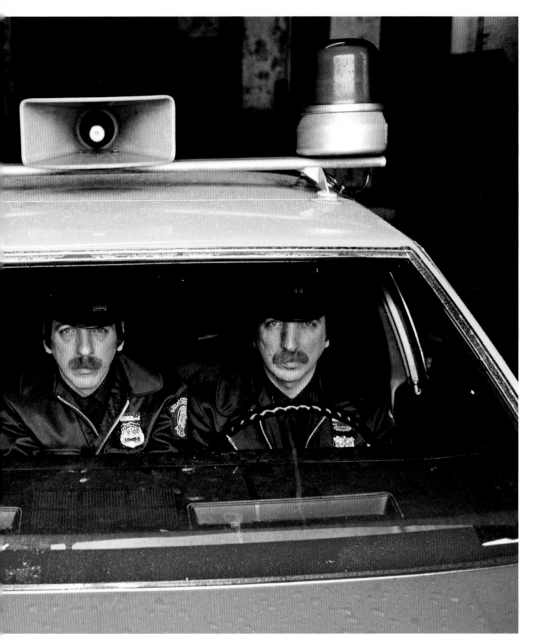

ANTARCTICA | PAUL NICKLEN
*Southern elephant bull males on South Georgia
Island bellow for the chance to mate with females.
These bulls can weigh 8,000 pounds (4,000 kilo-
grams), but only one in three will earn a chance
to mate with a group of females.*

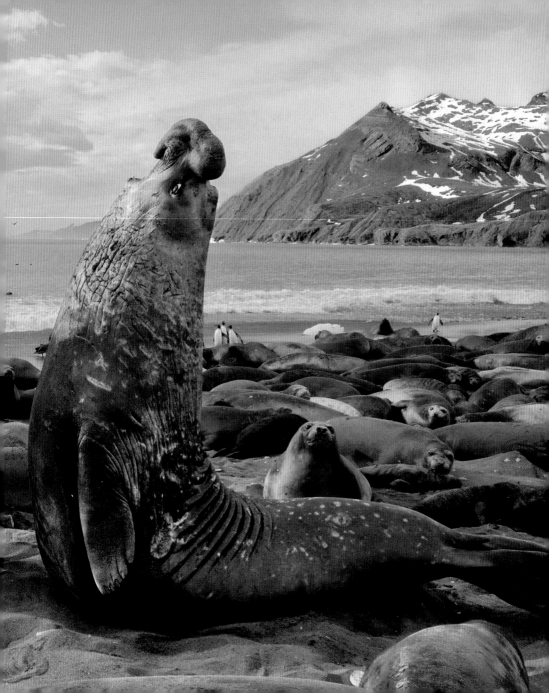

UNEXP

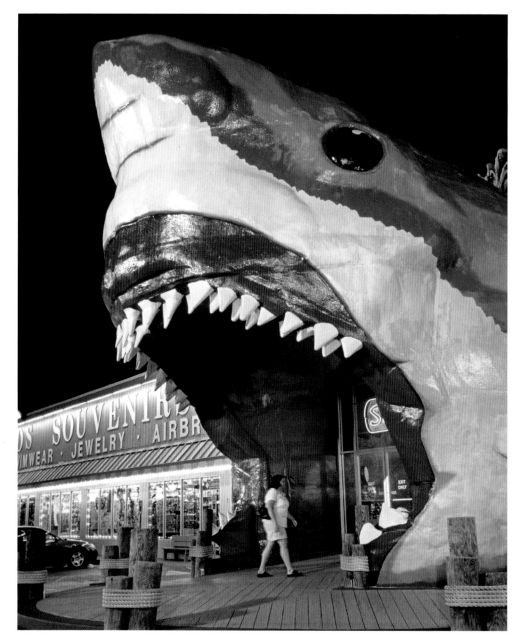

THE HUMAN

mind relaxes in the presence of patterns. Powers of observation dull, because we think we know what comes next. With a start, an interruption breaks that calm—and yet it sharpens our senses, because we begin to look again, more closely, more carefully, not only to regain the comfort of the regular but also to find some explanation for the appearance of the unexpected.

A golden retriever has a litter of ten, and nine of the puppies are born creamy white, but one has a black stripe right down his snout—an unexpected blaze, a genetic fluke, a mark that makes the puppy distinct, different, all the more lovable.

Photographers roam the world in search of the unexpected, because they know that when a photo breaks the rules, it grabs attention. A photograph of the unexpected makes the viewer look again. It helps the eye to truly see. One black swallowtail butterfly among a flurry of yellow ones. A dandelion holding tall its plump yellow bloom among the prize-winning tulips. One schoolchild breaking the rules and looking the other way. A tiny salamander, audaciously orange among the earthy leaf mold of the brown forest floor.

Sometimes there is no explanation, and what began as a jolt becomes a joke. We toss pattern to the wind, and in our laughter we speak love for this world full of so many possibilities.

MISSISSIPPI, UNITED STATES | TINO SORIANO | *This shark acts as a lure instead of a deterrent for souvenir shoppers at Sharkheads in Biloxi, Mississippi. Hurricane Katrina destroyed the store—and the shark—but owners reopened in 2012.*

Grasshoppers and cockroaches create an entomophobe's worst nightmare in this diorama at the Indiana State Fair in Indianapolis, part of a 4-H arts-and-crafts project that can include huck weaving, crocheting, and oil painting.

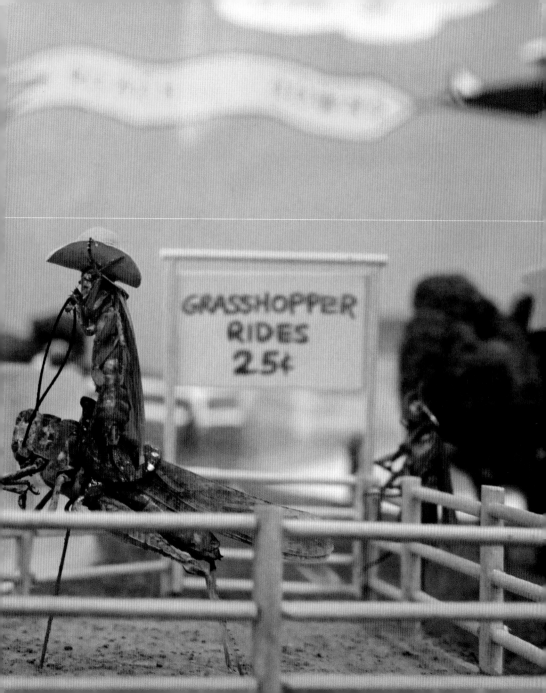

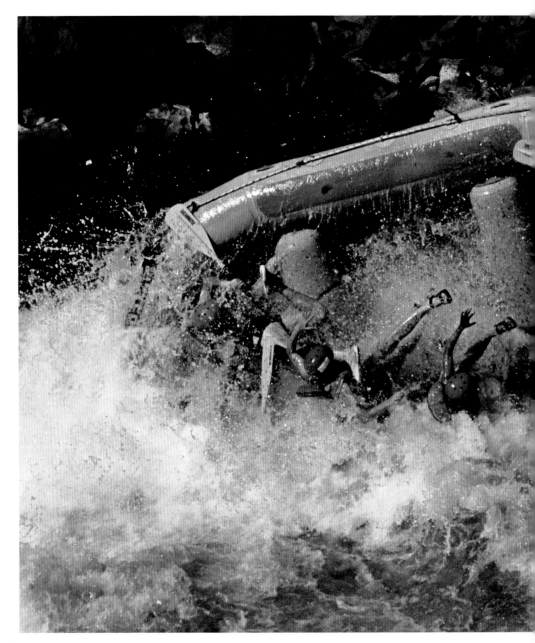

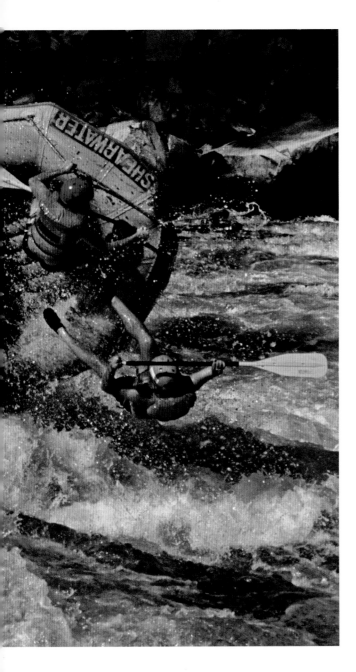

ZIMBABWE | CHRIS JOHNS

*Class V rapids on the Zambezi River
prove to be a worthy challenge for
these white-water enthusiasts.
These rapids, located near Africa's
famous Victoria Falls, may not have
the glory of that 355-foot (108-meter)
drop, but this one you can survive.*

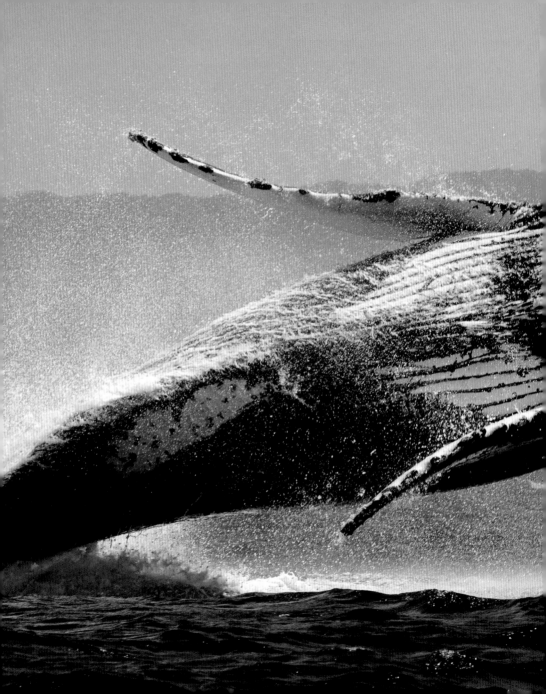

MEXICO | EDUARDO LUGO

A breaching humpback whale uses its tail fin, or fluke, to create a powerful splash. Scientists aren't sure if the breaching behavior serves a utilitarian function, such as cleaning off the whale's skin, or is just for fun.

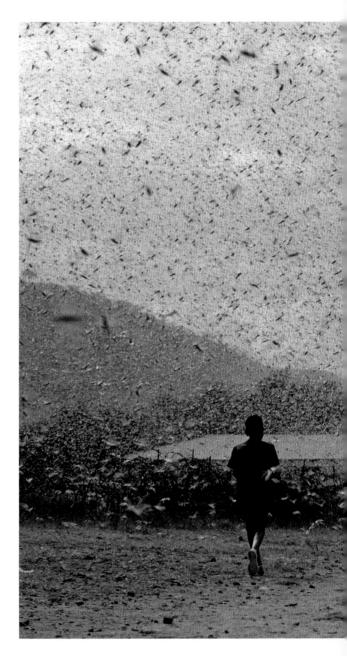

ETHIOPIA | GIANNI TORTOLI

*A blizzard of locusts overtakes the town
of Keren. Grasshoppers are normally
solitary insects, but excessive crowding
causes a switch in their behavior to what
scientists call a gregarious state and
results in a migrating swarm.*

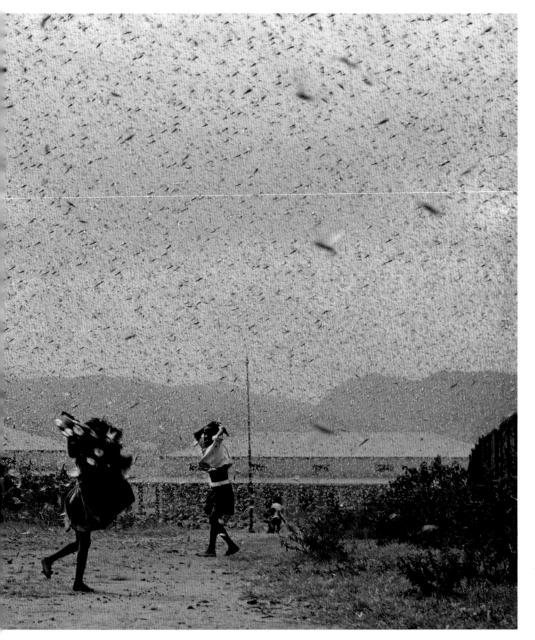

There are more than
a billion birds living
on the planet at any given time.
The most common
is the CHICKEN.

AFGHANISTAN | THOMAS J. ABERCROMBIE | *A woman in a sleeveless red chadri carries old-world goldfinches home from market in Afghanistan in 1967. The birds suggest the balancing act of a country still struggling for stability.*

262

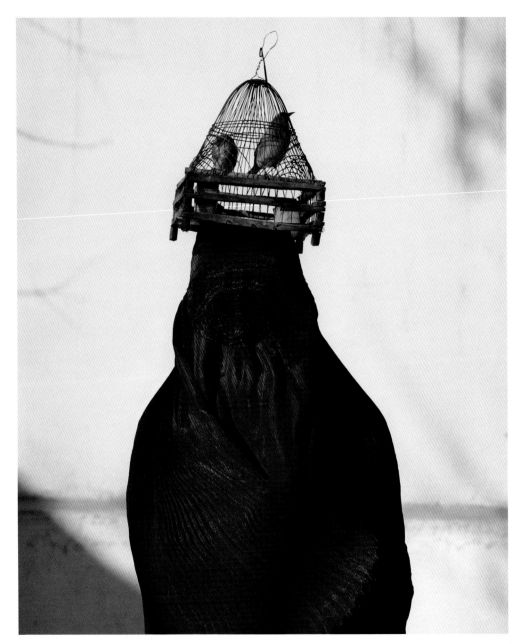

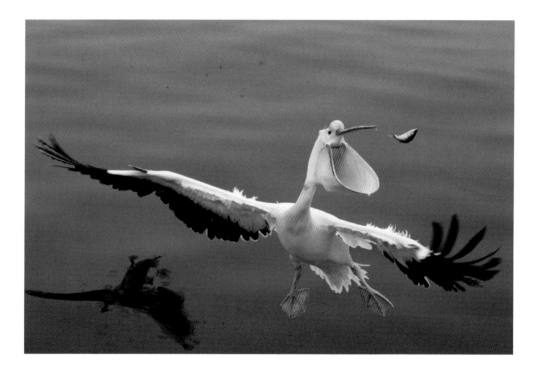

NAMIBIA | LAURENT MERCEY

*Its bright pouch agape and two-tone wings spanning
perhaps ten feet (three meters), a great white pelican
in Walvis Bay sets its sights on a fish breakfast. These
migratory birds are found in Africa, Asia, and Europe.*

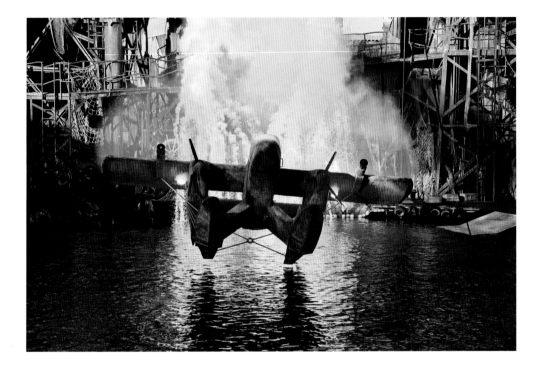

WISCONSIN, UNITED STATES
PRASANNA RAVINDRANATH
*Making a fast getaway, a stunt plane departs
from a fire on a stage set in West Allis, Wisconsin.
The film shoot adds fiery action to this town of
some 60,000 residents near Milwaukee.*

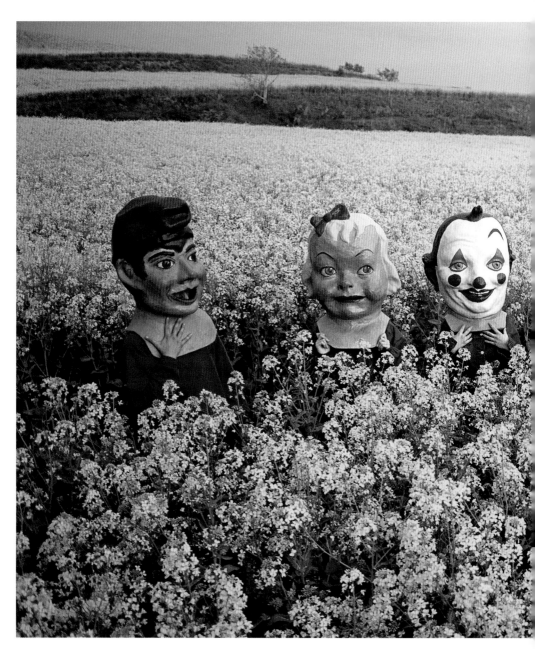

SPAIN | TINO SORIANO

Young people in oversize papier-mâché heads pause in a blooming field on the way to a summer festival in the town of Banyoles. Called capgrossos *in Catalan, the big heads are often worn on feast days.*

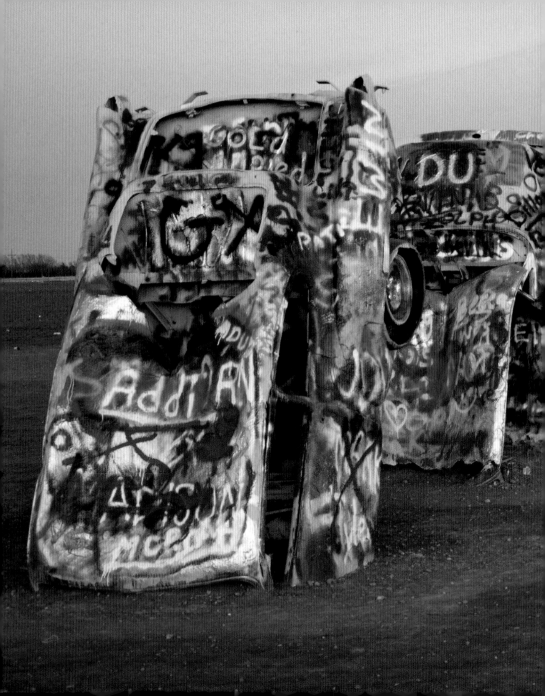

TEXAS, UNITED STATES
BRIAN GORDON GREEN

Ten half-buried and now vintage Cadillacs create a kind of modern-day Stonehenge for Stanley Marsh's work, "Cadillac Ranch." The 1974 art installation in Amarillo, Texas, has seen a lot of changes over the years: Cars have been painted different colors, and layers of graffiti have been added.

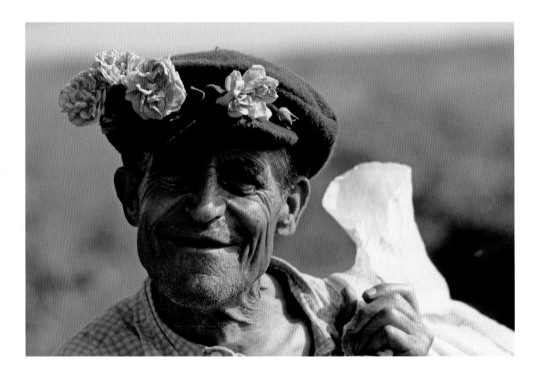

BULGARIA | JAMES L. STANFIELD

A Bulgarian rose picker, up since the crack of dawn,
decorated his hat with his trade. The roses are picked
early, before the sun can evaporate their oil.

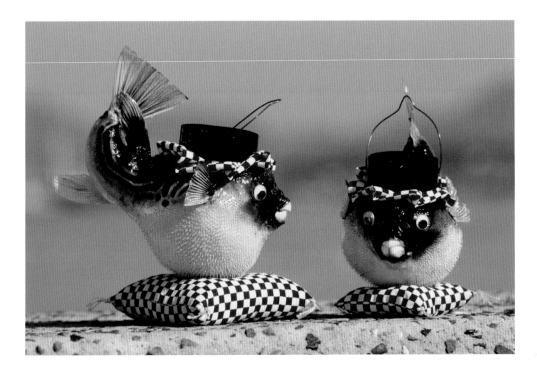

JAPAN | JOSEPH SCHERSCHEL

*These lantern souvenirs, available in Shimonoseki, are
made from the skin of the small puffer fish. The fish are
filled with sawdust to retain their shape, dried, fitted
with candles, and sold as good-luck charms.*

271

SOUTH AFRICA | SUSAN MCCONNELL

A cheetah appears to laze away the day on the floor of a safari lodge in Hoedspruit. Wild cheetahs have a much more uncertain future, as their numbers have fallen by 90 percent since the late 1800s.

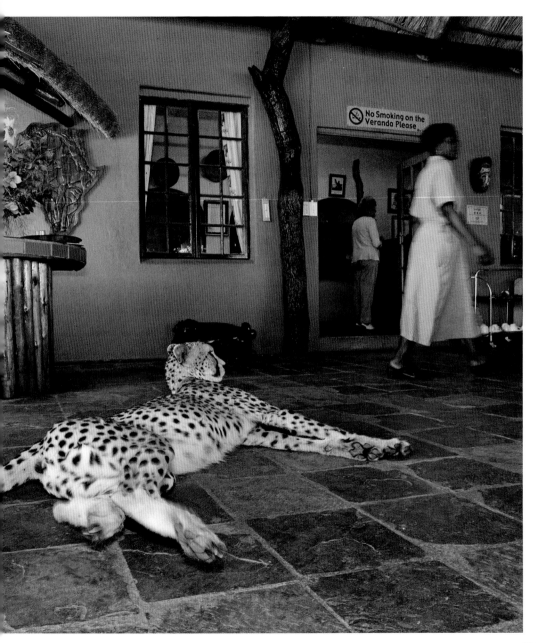

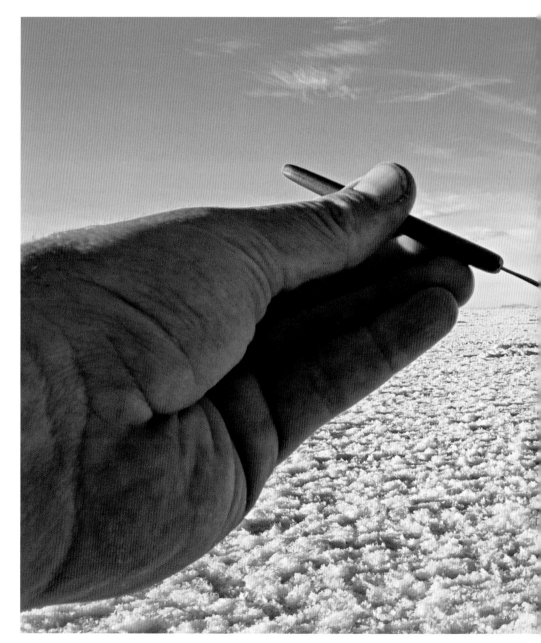

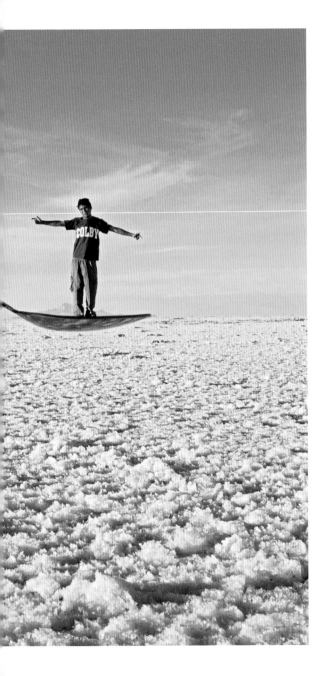

BOLIVIA | MIKE THEISS

*Just add a pinch of . . . ? This man appears
to stand on a spoon in Salar de Uyuni, the
world's largest salt pan. The pan, in Bolivia's
Altiplano, can be seen from space.*

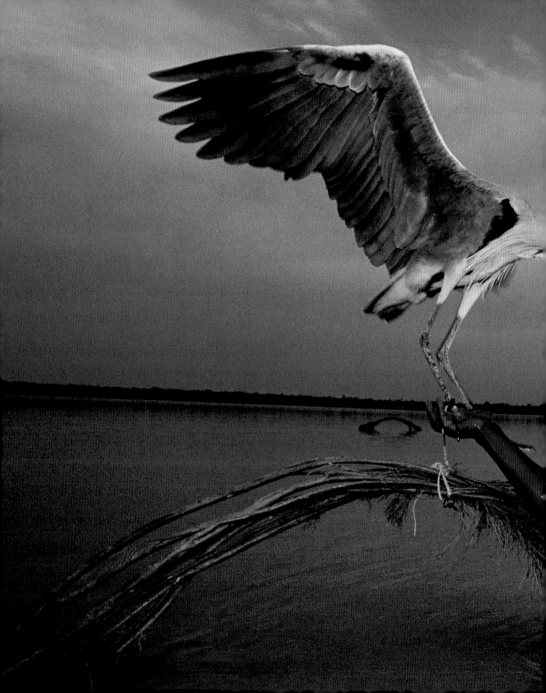

PAKISTAN | RANDY OLSON
*A bird hunter sports a heron decoy in the
Indus River. The ancient Indus civilization,
which reached its height some 3,000 years ago,
commanded an area the size of Texas that reached
from the ⬦ bian Sea to the Himalayan foothills.*

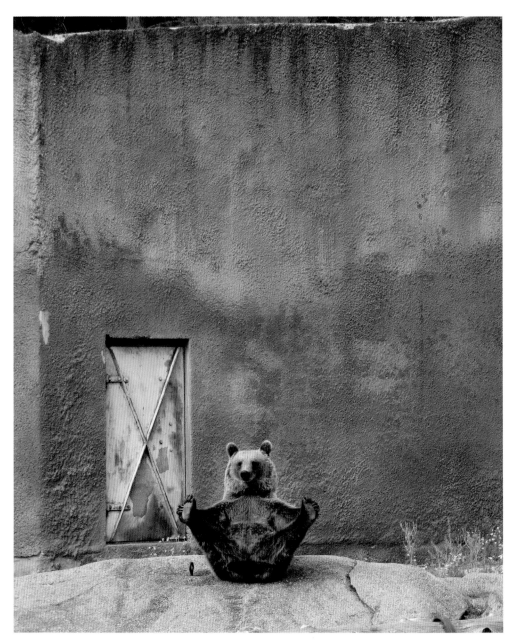

During its winter hibernation, the BROWN BEAR'S heart rate and metabolism slow down and it does not urinate or defecate. Most amazing of all, the female sleeps even during the birth of her cubs.

FINLAND | META PENCA | *Mimmi the brown bear shows her flair for flexibility during an afternoon stretch at the Ähtäri Zoo. Despite intense summer heat, the lively resident lifted paws for minutes at a time in poses learned from her mother.*

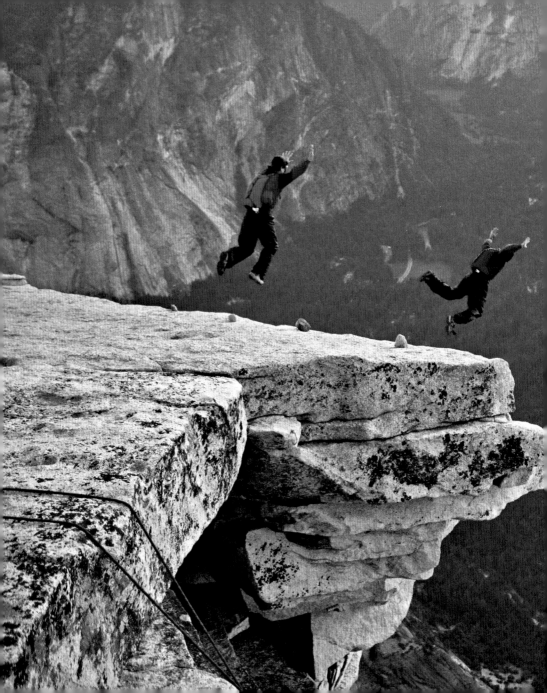

CALIFORNIA, UNITED STATES
JIMMY CHIN AND LYNSEY DYER
These BASE jumpers on Half Dome in Yosemite National Park take the easy way down by parachuting into the valley. Part of the risk in jumping from this spot comes from the fact that it is an illegal activity.

PERSP

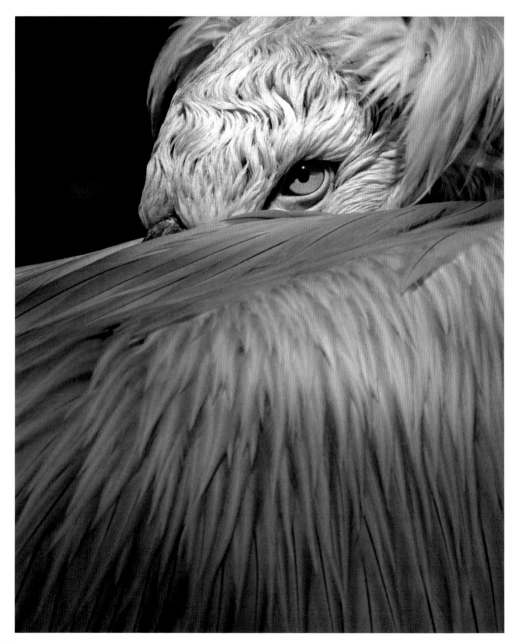

THE POET has said that the eyes are the windows of the soul—through them we look into the heart—but the eyes are also the spyglass of perception. We do not have 360-degree vision. Our human eyes partition the world into seen and unseen. Each person establishes his own perspective; each gathers in light and information from her own point of view. A chosen perspective can reveal a new truth.

More than anyone else, photographers know the importance of perspective—the angle of view, the slant of light, the tilt of the camera, the startling combination of subjects fused in an image within a moment's frame. Philosophers may propose some sort of eternal truth unchanging, but photographers know that with just a glance in another direction, the entire picture changes. Instead of getting caught up in the neon and heights of the city's skyscrapers, a photographer can train our eyes to look down at the worn sidewalks, or to look straight up through the bright lights to the stars. All a matter of perspective.

Some photographs help us gain perspective on the ordinary: a blooming flower seen from root end up, when we are so used to looking down upon the garden. Other photographs share a perspective of the rare: the colorful, gleaming beak of a toucan, a perpendicular echo of the bright flowers near the rain forest floor. Never would we see the two in relationship were it not for the perspective caught by the photographer's camera.

ROMANIA | HELMUT MOIK | *A migrating Dalmatian pelican fixes its photographer with an icy stare as it awakens from sleep during a stopover on a small island in the Danube River. Fewer than 20,000 of these birds exist worldwide, but some colonies are on the increase.*

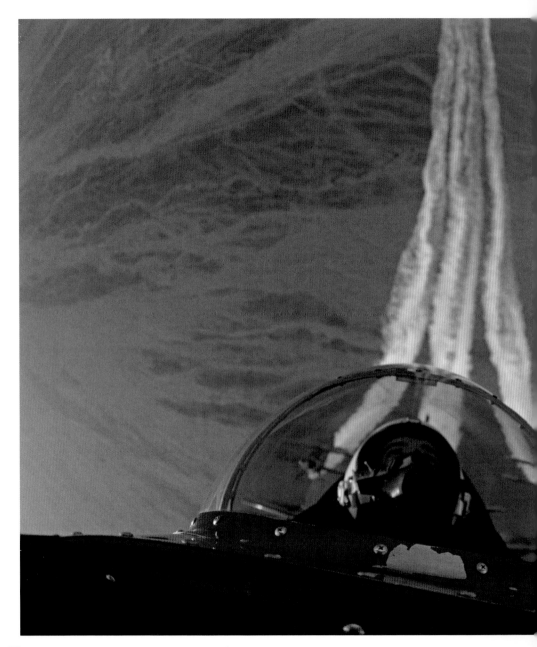

JORDAN | JODI COBB
A fish-eye lens captures a Royal Jordanian Falcons pilot as his plane leaves a contrail behind. The water in the exhaust condenses as ice crystals in the cold, wet air.

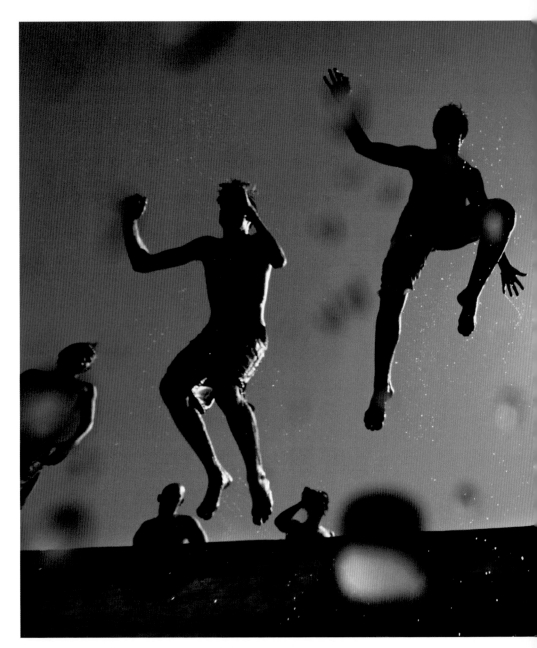

AUSTRALIA | ALEX COPPEL
Kids embody the excitement of summer in
Melbourne, Australia, by jumping off a pier.
This scene may become more common as
Australia keenly feels the effects of climate
change, with average temperatures on the
rise and rainfall patterns shifting.

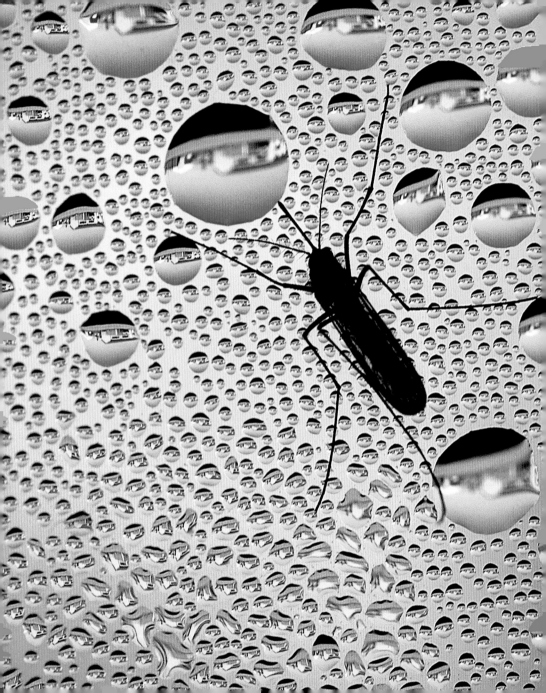

Not only is ANTARCTICA the coldest place on Earth—the coldest temperature ever recorded (-129°F/-89°C) was from there—but it is also the driest, an area of the continent called the Dry Valleys not having received any rain for nearly two million years.

ANTARCTICA | GORDON WILTSIE | *It's all shadow and sunlight for climber Conrad Anker on the sheer granite face of Rakekniven, the Razor, in Queen Maud Land. All but 2,000 feet (600 meters) of this 7,759-foot (2,365-meter) peak remains under the ice.*

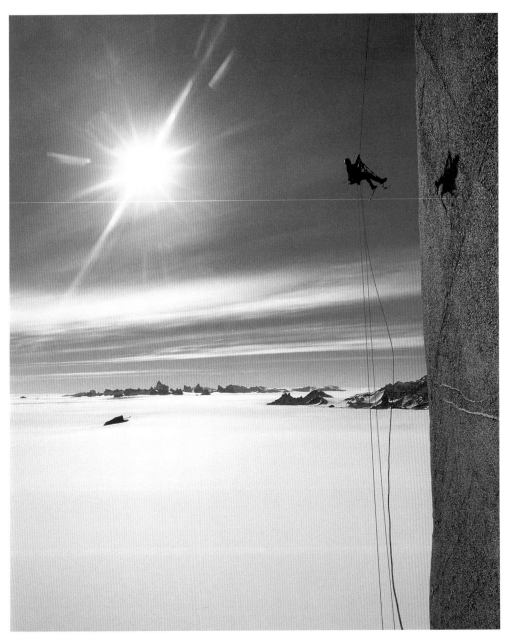

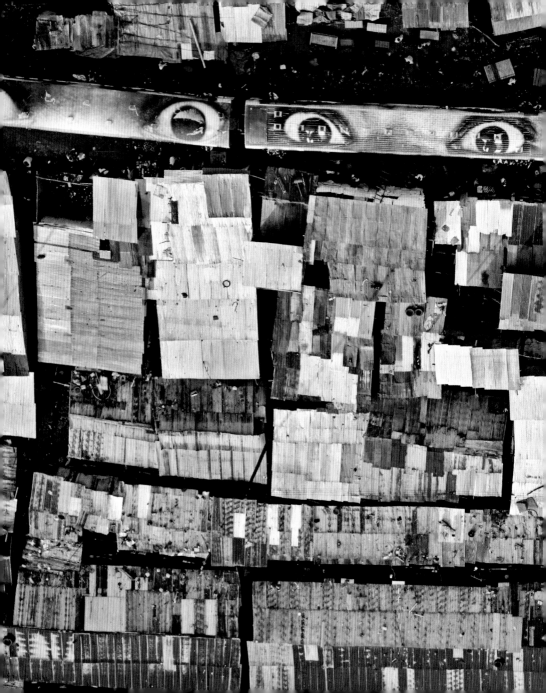

KENYA | JR

Aimed skyward from photos atop a train, the eyes of women pierce a rooftop landscape in Nairobi's Kibera slum. The display, part of a global art project, paid tribute to women from Africa, Brazil, India, and Cambodia.

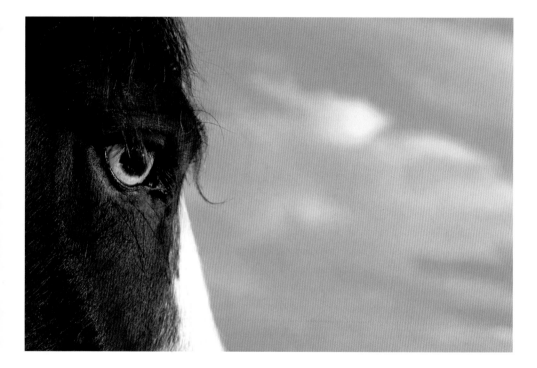

CALIFORNIA, UNITED STATES | ROXI MUELLER
In the blink of this horse's eye, the blue sky becomes a counterpoint to its stare. Early horses arose in North America some five million years ago, only to die out and be introduced, in domesticated form, by Spanish conquistador Hernán Cortés in 1519.

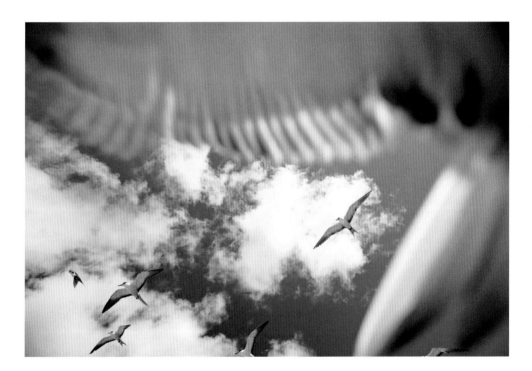

MARQUESAS ISLANDS | TIM LAMAN

Sooty terns, Sterna fuscata, *take flight in the Marquesas Islands in French Polynesia. These islands, located thousands of miles from any continental landmass, allowed for plenty of diversification and specialization resulting in a rich biodiversity hot spot.*

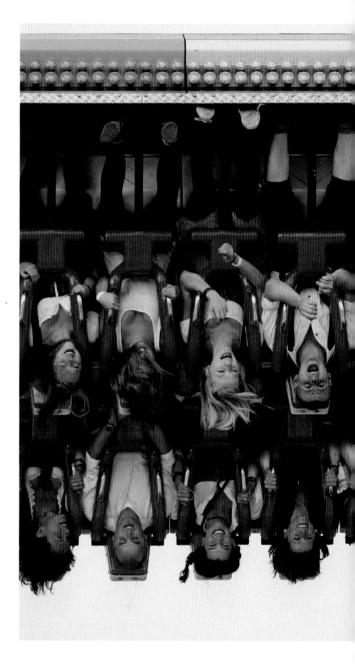

GERMANY | MIGUEL VILLAGRAN
*Upside-down thrill seekers ride the Top
Spin at Munich's 176th Oktoberfest.
Despite terrorist threats, the 16-day beer
festival—the largest fair in the world—
drew 5.7 million people last year.*

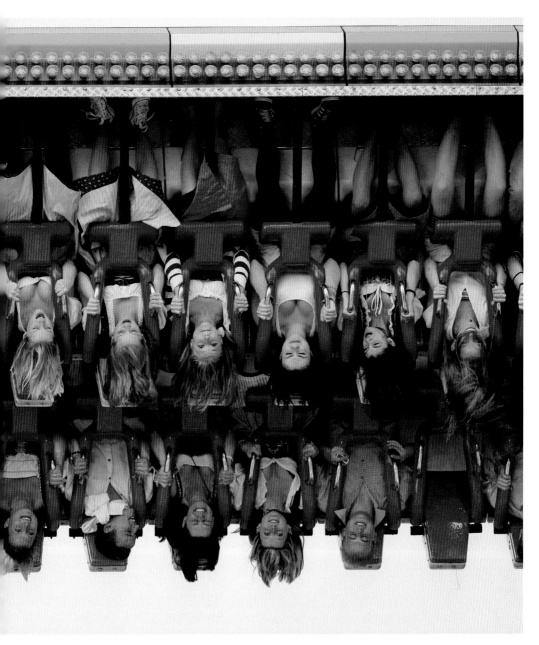

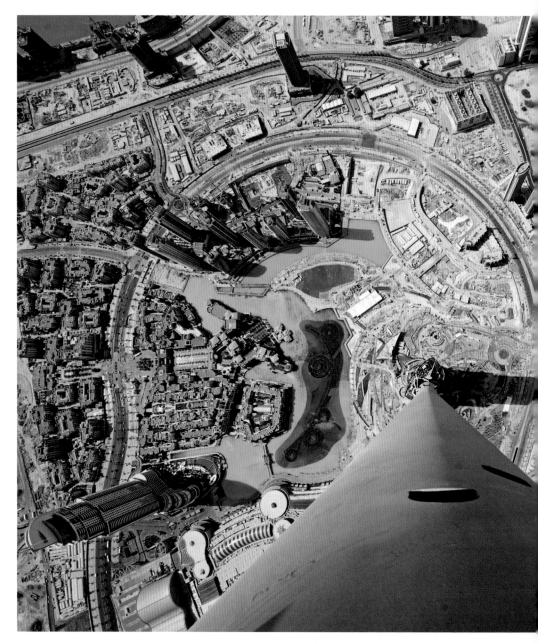

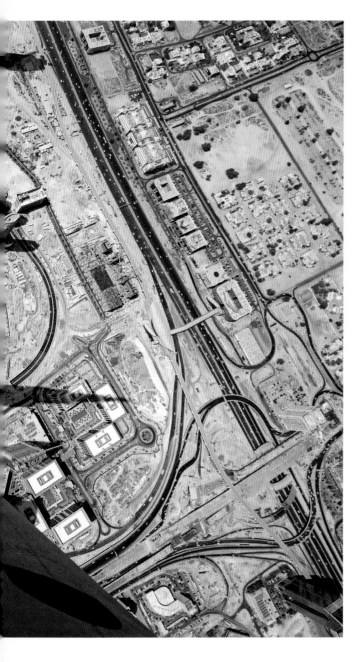

UNITED ARAB EMIRATES
SAMAR JODHA
From the top of the world's tallest building—the 164-story, 2,717-foot (828-meter) Burj Khalifa—an economic history of Dubai is visible. Dense development reflects the recent boom; open spaces are remnants of an earlier era.

ANTARCTICA | PAUL NICKLEN

A leopard seal shows its teeth to photographer
Paul Nicklen. The four-foot-long (1.2-meter)
predator has teeth designed for killing—and
eating—everything from fish to fledgling
penguins, squid, other seals, and krill.

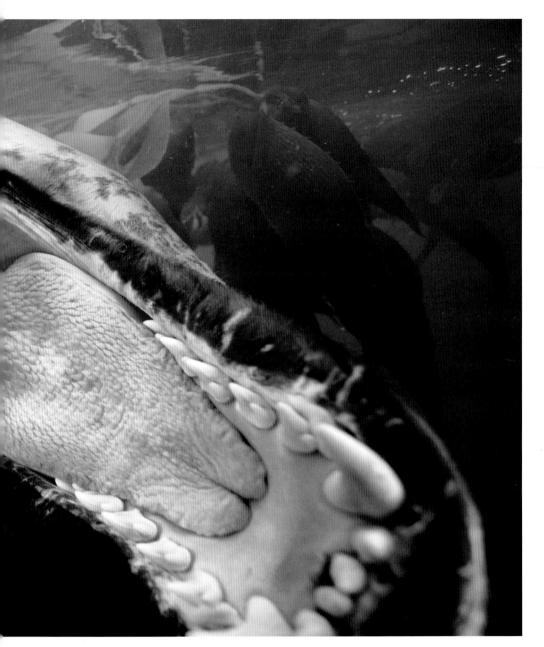

The world's largest known natural bridge is RAINBOW BRIDGE, in Rainbow Bridge National Monument, Utah. This rock bridge is 290 feet tall (88 m) and 275 feet wide (84 m), and at its top the arch measures 42 feet thick (13 m) and 33 feet wide (10 m).

CHINA | JUSTIN GUARIGLIA | *The lights under this bridge in Shanghai create a tapestry of neon. The city, primed for resurgence, reportedly spent $45 billion getting ready for Expo 2010 and its 73 million visitors.*

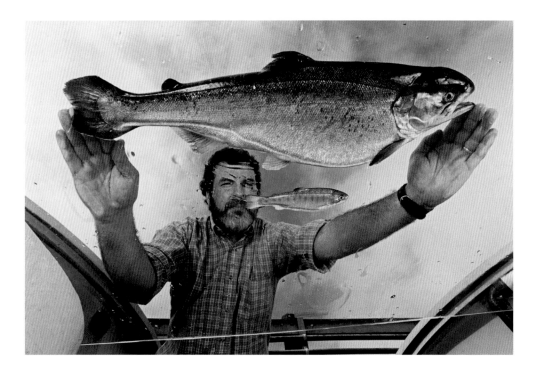

CANADA | JIM RICHARDSON

*With his own fish tale, this biologist in British
Columbia demonstrates how genetic engineering
creates supersize salmon.*

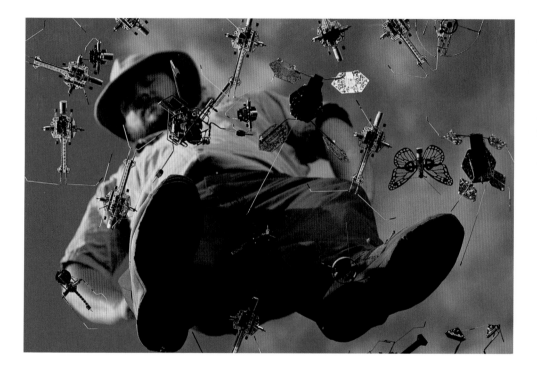

NEW MEXICO, UNITED STATES
GEORGE STEINMETZ
A robot developer looks down on his creations.
Used for both military and industrial purposes,
today's robots know no bounds.

CHILE | JOEL SARTORE
This shriveled miner's corpse in a cemetery in
Puelma, Chile, appears to survey its surrounding
cemetery. Life is harsh in Chile's Atacama Desert,
and mining and tourism drive the economy here.

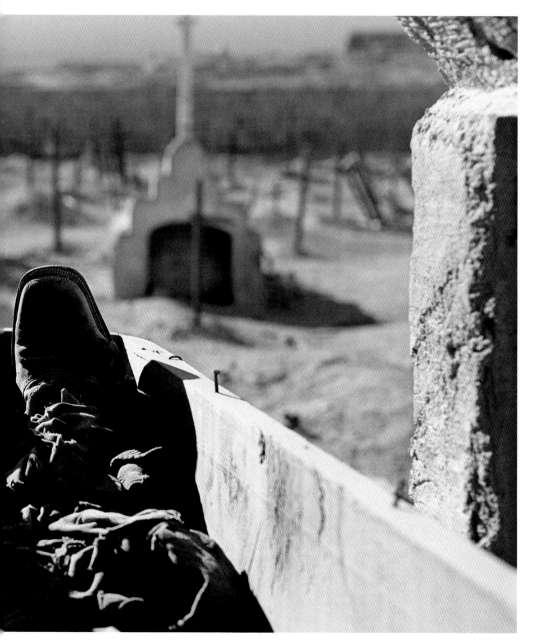

SPEC

NATURE

keeps her best secret hidden in white light. Crack it open—hold a crystalline prism just right in the sunlight—and what light comes in white comes out the other side split into many true colors, a wonder to behold. You see the spectrum in other circumstances: in a slick of oil on a driveway puddle, or the spray of a garden hose, or, of course, in the sparkle of tiny raindrops spread between you and the sun at just the right angle and just the right moment. Catch that vision, and you peer into nature's marvelous kaleidoscope, the spectrum of all colors: violet, blue, green, yellow, orange, red.

Every color sings a different note, and the natural world rings with song, sometimes with colorful harmonies and sometimes with a cacophony of colors so brilliant it rattles the brain.

Red, the rich, deep color of roses that pulses through mind and body. Orange, the blaze of dawn, the color of fire, flickering, hot, momentary, fascinating. Yellow, the darting flight of a warbler, brilliantly new, shy, tempting. Green, the calm of tree leaves in summer, growth and health, a resting place for the eyes. Equally serene is the blue of a cloudless sky. Purple comes down to earth again in the lowly violet flower.

These associations may be local—someone else knows a different yellow bird, a different purple flower—but the colors are universal. Rainbows glow all over the planet, but only when there are eyes to see them.

ROMANIA | TOMASZ TOMASZEWSKI | *A bride, partially concealed behind a lace curtain, surveys her surroundings in the Carpathian Mountains of Romania. The Csángós, loosely translated as "wanderers," work to retain cultural traditions that trace back to Attila the Hun.*

OHIO, UNITED STATES | MATT EICH
Stripes and flakes share space at the Wilds, a refuge for rare and endangered species. Here, a three-year-old Grevy's zebra named Elvis stomps in the winter pen, which adjoins heated indoor quarters.

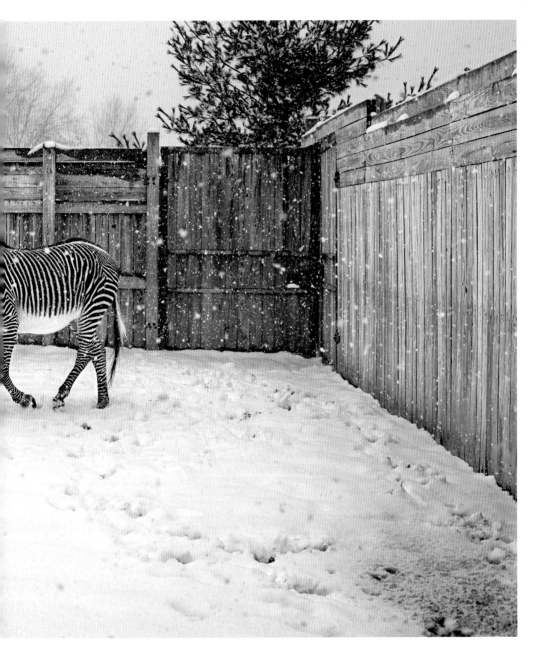

WASHINGTON, D.C., UNITED STATES
PAUL SUTHERLAND

A coiled eyelash pit viper, Bothriechis schlegelii, *looks harmless enough, but it's venomous. This Central and South American species earned its name from the modified scales around its eyes that mimic eyelashes.*

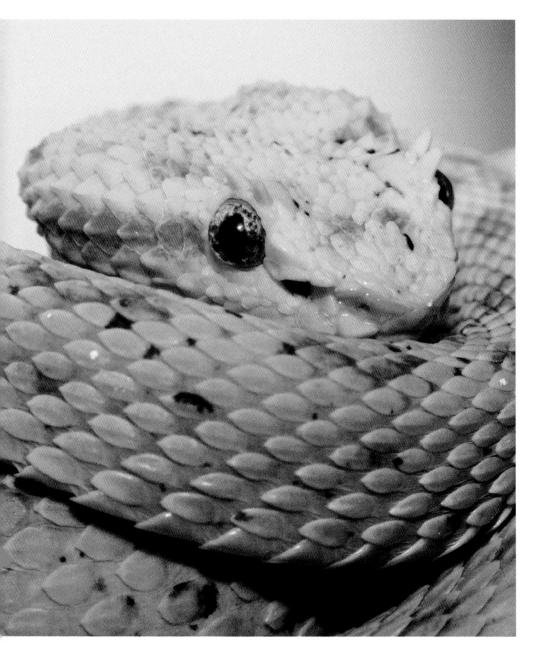

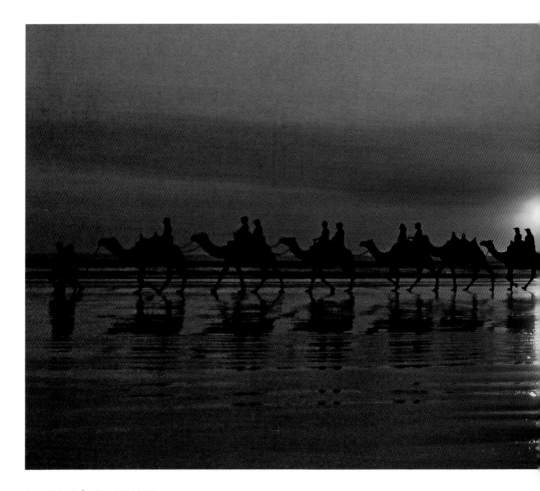

AUSTRALIA | PAUL WILLETS
A line of camels and their riders walks into the sunset on Cable Beach in Broome, Western Australia. Miles of white sands and crystal-clear waters offer a relaxed location that makes this one of Australia's most popular beaches.

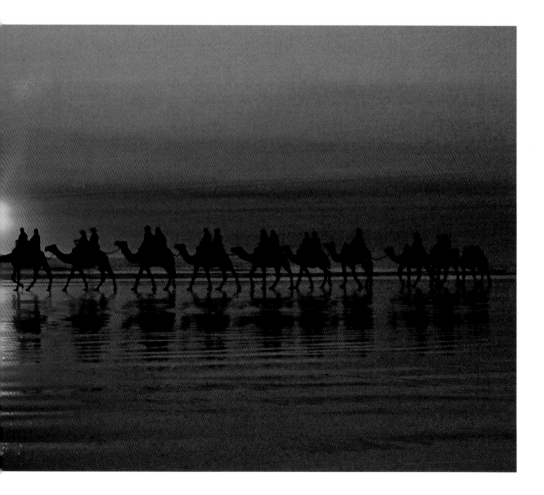

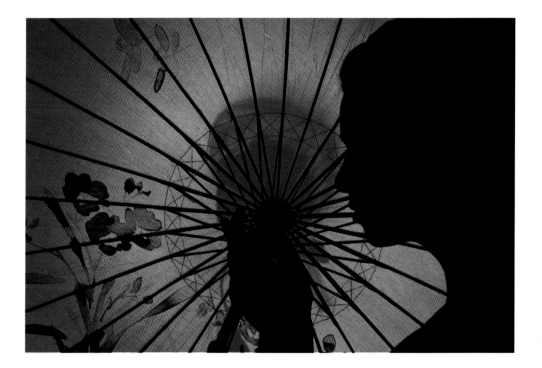

AUSTRALIA | HELEN DITTRICH

An orange paper parasol silhouettes a woman's curves.
In ancient Egypt, China, India, and Mesopotamia,
umbrellas protected important people from the sun.

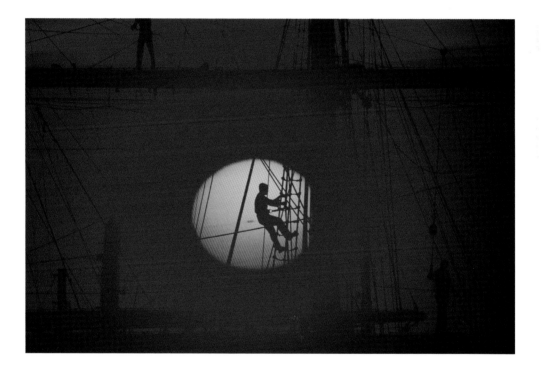

ARGENTINA | BRUCE DALE

The setting sun shows off the agility of a ship hand climbing rigging in Buenos Aires. At this favorite stopover, cruise ships travel up the Río de la Plata and straight into downtown.

More men than women are affected by COLOR BLINDNESS; about one in ten men has some form of it. The most common type of the condition causes people to have trouble distinguishing between red and green.

NEW YORK, UNITED STATES | SUSAN SEUBERT | *A patron of the Sherwood Cafe doesn't seem to mind the slogan of an omniscient poster. One of Brooklyn's landmark eateries, this café offers a popular spot for brunch.*

326

THE MAN WHO KNOWS

CHINA | MICHAEL S. YAMASHITA
Verdant trees reflect in the morning waters of
Five Flower Lake, colored by mineral deposits
and aquatic plant life. Five Flower is one of
118 lakes in Jiuzhaigou Nature Reserve, which
came under Chinese protection in 1978.

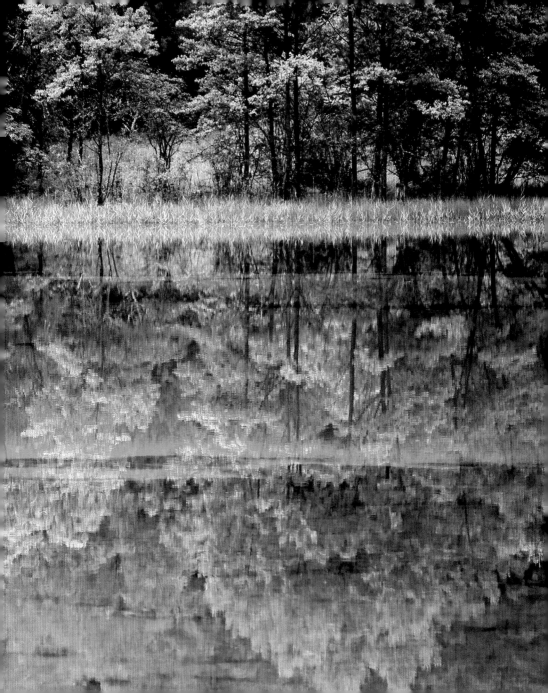

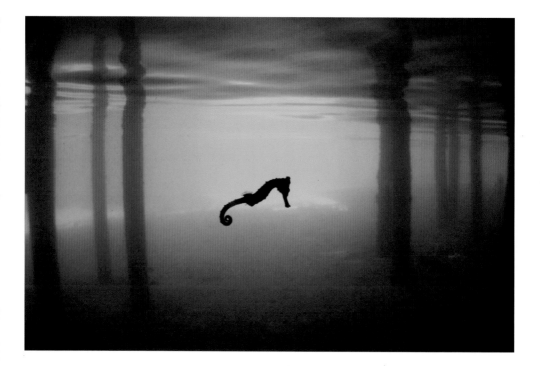

HONDURAS | MARC MISTERSARO
Snorkeling under a nightclub in Roatán, Honduras, the photographer caught this ethereal image of a seahorse. Great snorkeling and scuba diving while surrounded by rich coral reefs attract visitors here to the largest of Honduras's Bay Islands.

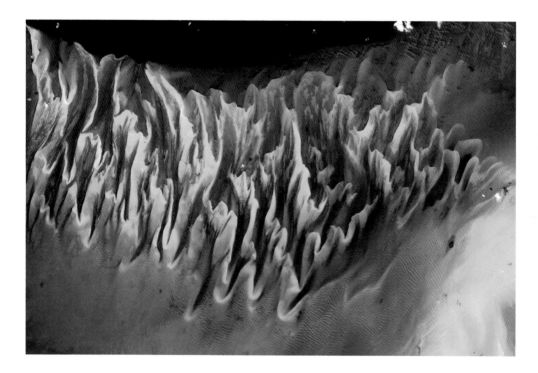

BAHAMAS | SERGE ANDRÉFOUËT
AND FRANK MÜLLER-KARGER
West of the Bahamas, the waters are so clear in
a trough known as the Tongue of the Ocean that a
satellite captured the sand and sea grass some 50 feet
(15 meters) below the surface. The image comes from
a scan from a sensor on a Landsat 7 satellite.

GEORGIA, UNITED STATES
RICHARD T. BRYANT
Though tipped with nightmare claws,
the limbs of American alligators—this
one photographed at a local park—are
more often used to excavate wallowing
holes than to slash at prey.

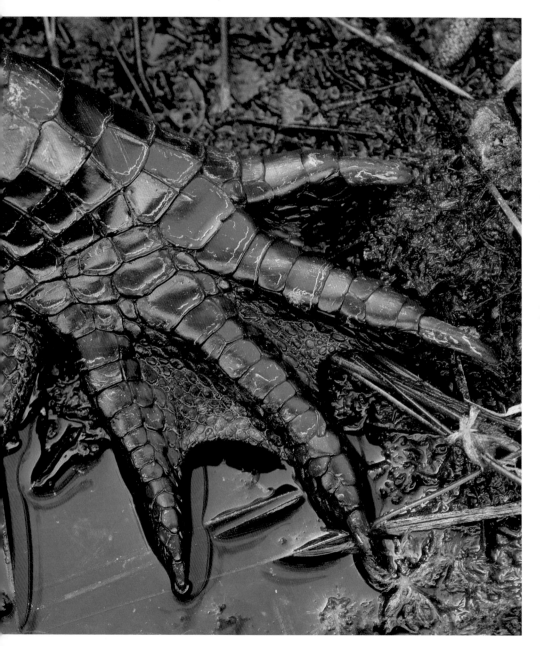

SOUTH GEORGIA ISLAND
PAUL SOUDERS

*An elephant seal relaxes in a shallow pool
along the shores of Stromness Bay, 1,100 miles
(1,770 kilometers) east of Tierra del Fuego in
the South Atlantic Ocean.*

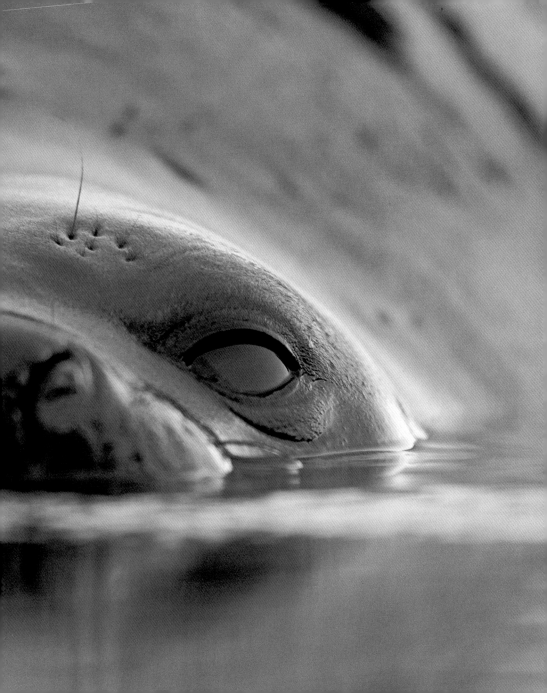

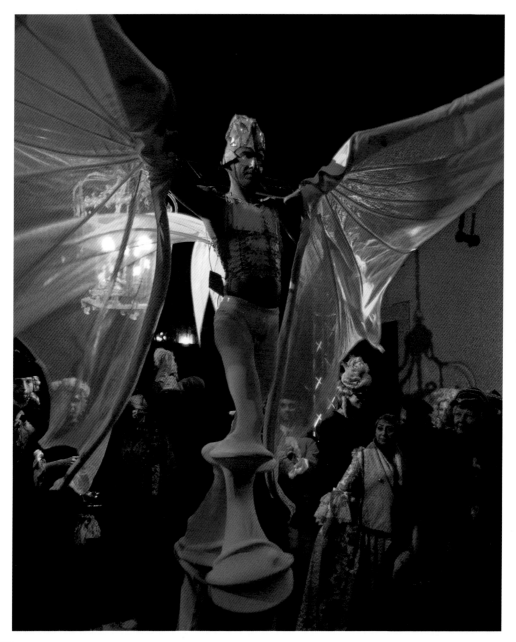

Comprising 117 small bodies
of land crisscrossed by 150 canals
and connected by more than
400 bridges, Venice is the only
city in Europe to have its public transport
entirely on the water.

GREENLAND | BRYAN
AND CHERRY ALEXANDER
*Eight hundred miles (1,300 kilometers) south of the
North Pole, stalactite-like stratus clouds—churned by
90-mile-an-hour (145-kilometer-an-hour) winds—
and the light of a bruised dawn paint an apocalyptic
portrait over Inglefield Bay.*

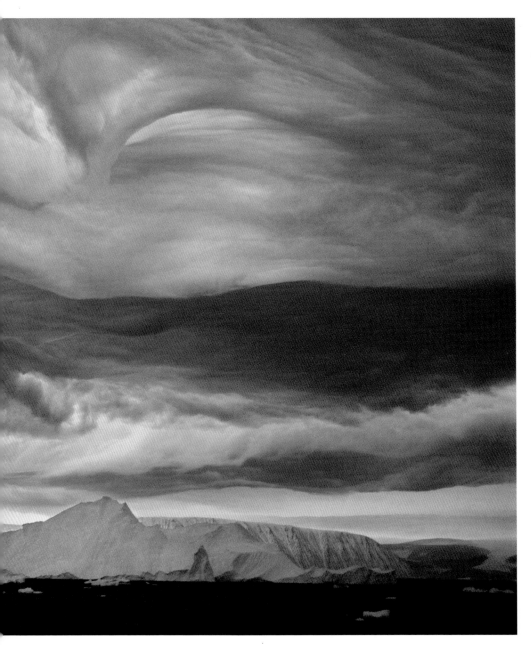

BRAZIL | AGNES KISS

It's only fitting that a hyacinth macaw, the largest parrot in the world at more than 3 feet long (0.9 meter), lives in one of the world's largest wetlands, the 74,000-square-mile (192,000-square-kilometer) Pantanal. The population of macaws, which have been sold actively to the pet trade, is estimated at around 5,000.

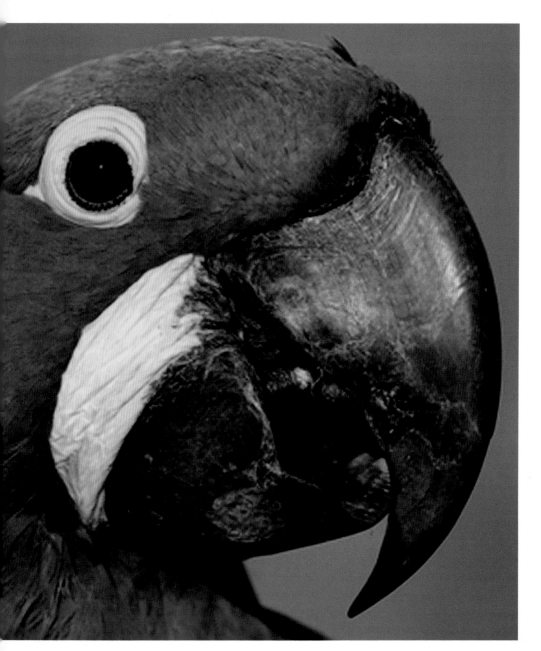

MADAGASCAR | STEPHEN ALVAREZ

Decken's sifakas appear right at home in their karst home in western Madagascar. These lemurs live among the unusual pinnacles of the Tsingy de Bemaraha, which started to form 1.8 million years ago as groundwater dissolved and shaped the porous limestone.

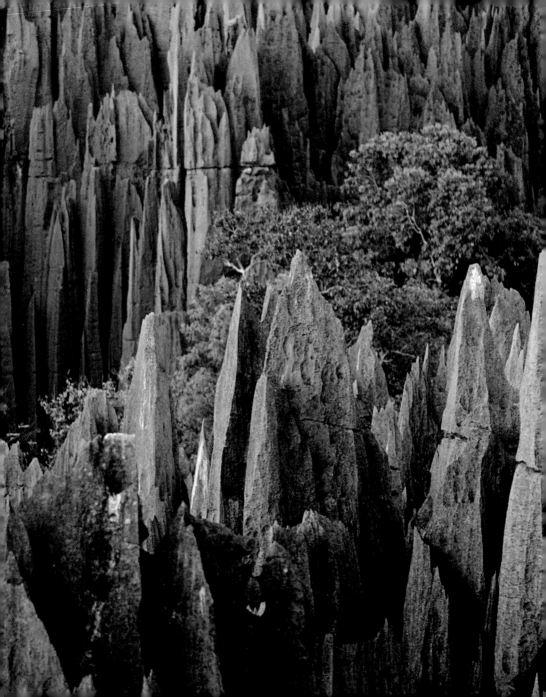

SPAIN | JOSEP LAGO
*A late afternoon stroll in Barcelona becomes
a study in black and white during a rare snow
shower in March 2010. Temperatures in the city,
on the Mediterranean coast, usually fall between
50°F (10°C) and 60°F (15°C) this time of year.*

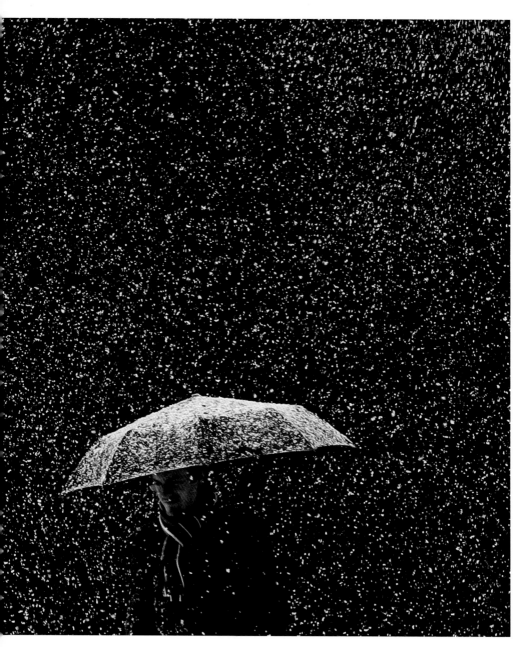

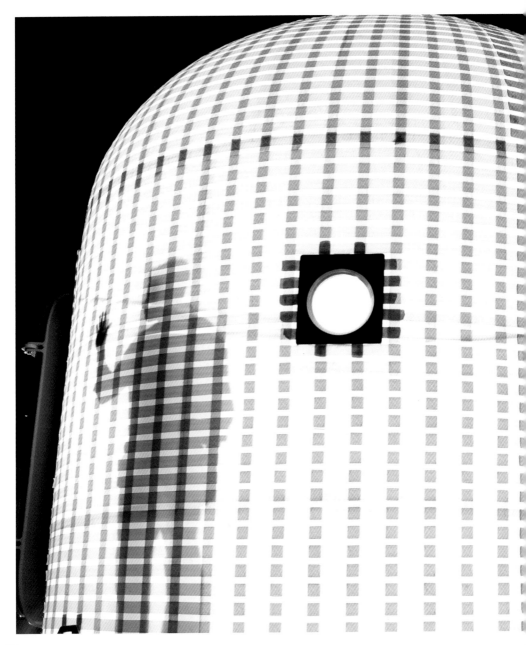

Scientists at Langley Air Force Base explore using inflation-deployed structures as a potential lunar base. Such inflatable (and expandable) habitats might provide the perfect habitat for lunar living.

INTERL

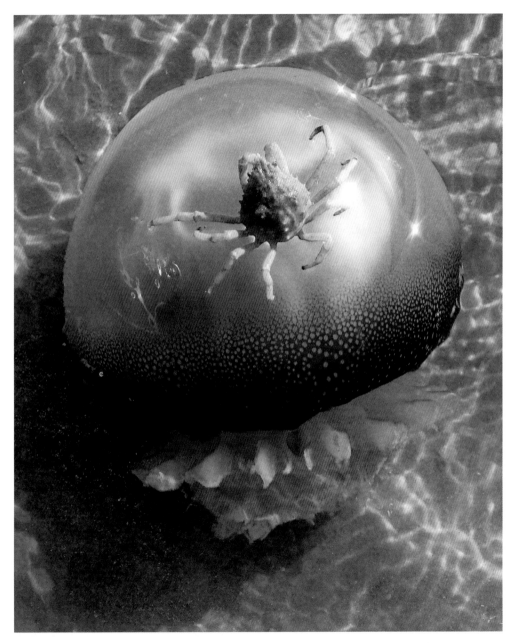

THERE IS something lovable about an interloper—the odd one out, assured in its separate being yet perfectly comfortable among the many others.

Imagine: It's twilight, and a small herd of white-tailed deer, drawn by the possibility of clover, tiptoes out of the forest darkness to the edge of a field. Somehow you work your way in between a doe and two yearlings without causing concern; somehow you fit in, an interloper, enjoying the pleasure of not belonging.

Or imagine: Deep in the Costa Rican rain forest, you shimmy up a jobo tree and sit, motionless, until the squirrel monkeys start once again to chatter and swing, jump and preen, bounding across the forest floor and into the tree branches close at hand. They accept you; you fit in, an interloper, taking in all the sounds and smells and sights of creatures different from you.

Perhaps it is by imagining the viewpoint of an interloper that we find special pleasure in photographs of interlopers, too—surprises as much to the senses as to our understanding. An orange-and-white clown fish sculls in place among the waving purple-gray fingers of a sea anemone, as if by hovering close enough it might turn its neon colors into the dull earth tones of its surroundings. As much as its colors deny it, this fish belongs.

The stark stripes of one lone zebra call out amid the mud brown of a herd of hundreds of wildebeests, hoofing it through the savanna. Benign interloper, you don't fool me.

NORTH CAROLINA, UNITED STATES | HANNAH JOHNSON | *A hitchhiking crab grabs a ride on a jellyfish in the crystal-clear waters along the Atlantic Intracoastal Waterway in North Carolina. The canal, which runs between Norfolk, Virginia, and Miami, Florida, provides an alternative to traveling the open ocean, and it offers boaters—and crabs—safe passage.*

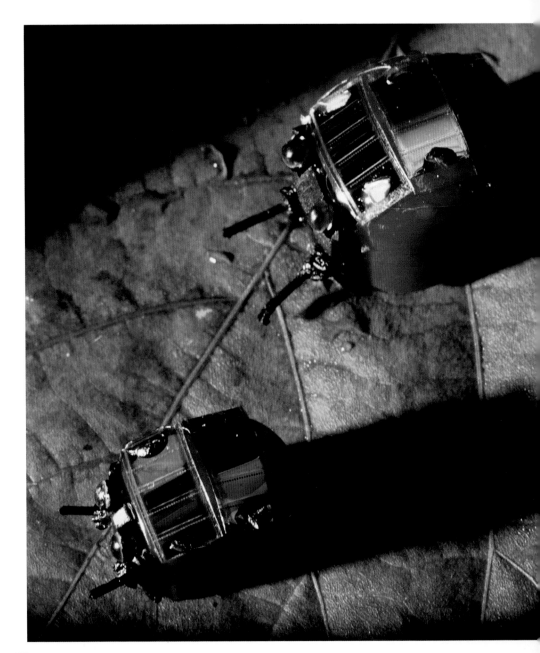

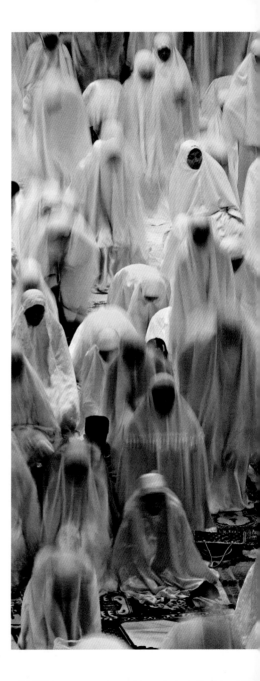

INDONESIA | SIGIT PAMUNGKAS

*On the first day of Ramadan, in a mosque filled with
white-robed women, one child stands up and stands out.
During the month-long holiday, Muslims seeking spiritual
purification fast from dawn till dusk.*

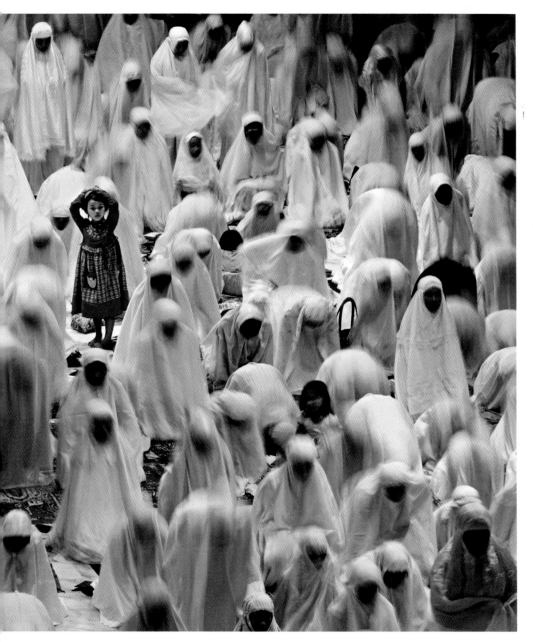

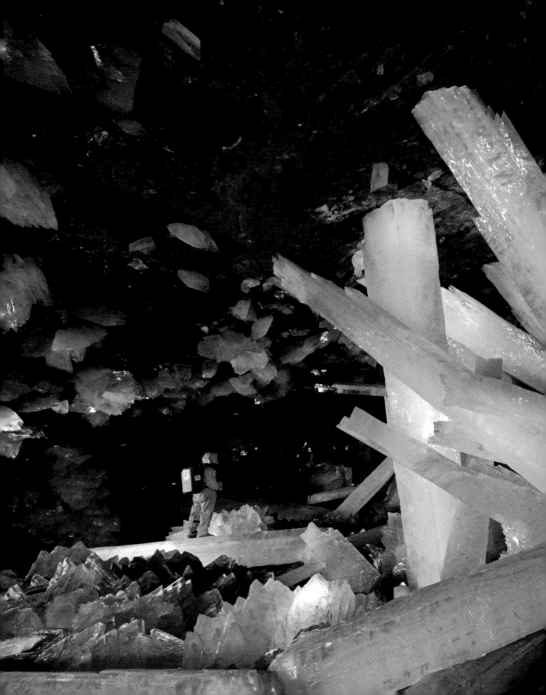

MICHIGAN, UNITED STATES
JASON RYDQUIST
It's hard to imagine this 1940s Chevrolet pickup moving down the road. Showcasing the ephemeral truth of automobiles, the earth has overtaken it.

ALABASTER is a form
of gypsum, a soft, translucent stone.
The sand in New Mexico's White Sands
National Monument is almost
pure gypsum, making it
the largest gypsum dune field
in the world.

CHINA | CHIARA GOIA | *All is alabaster at a sculpture factory in Dangcheng, where marble and chalk dust suffuse the air and workers churn out relatively inexpensive copies of iconic Western works for foreign and domestic clients.*

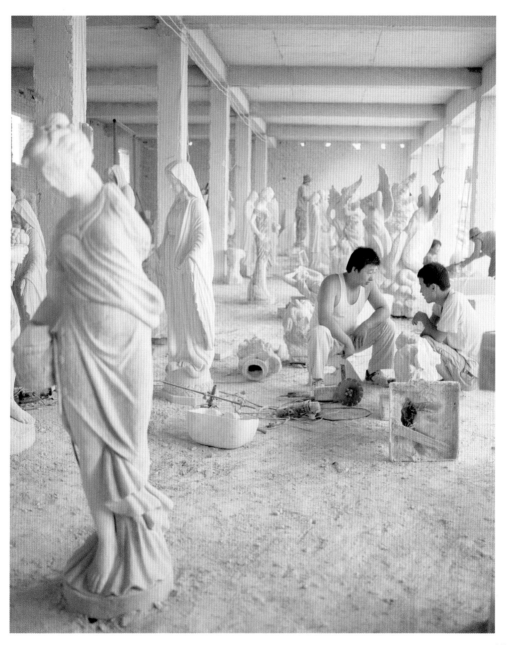

MONTANA, UNITED STATES
MARK THIESSEN

*A fire supervisor surveys the scene in Seeley
Lake, Montana, from the relative safety of a truck.
Wildfire flames jumped the road and engulfed
trees, creating this apocalyptic landscape.*

OBJECTS IN MIRROR ARE
CLOSER THAN THEY APPEAR

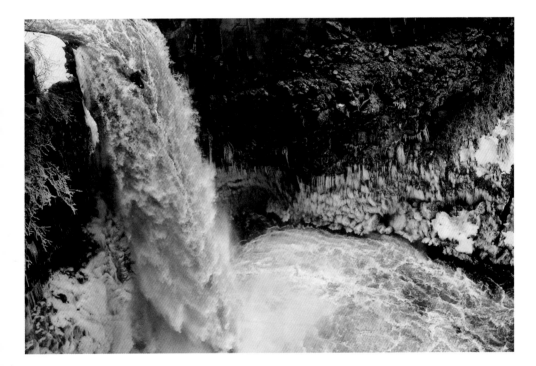

WASHINGTON, UNITED STATES
JED WEINGARTEN
A kayaker plunges 70 feet (21 meters) into winter water at Washington State's Outlet Falls. His January 2009 descent was one of only five tallied on the Klickitat River tributary, here swollen by floods and sallow from runoff.

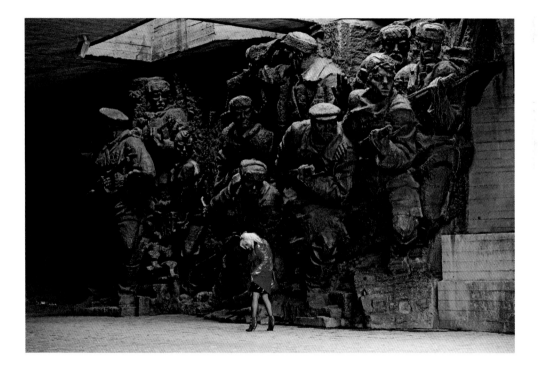

UKRAINE | SERGEI SUPINSKY

Dwarfed by the memory of her nation's past, a woman at Kiev's National Museum of History of the Great Patriotic War of 1941–45 adjusts her outfit in front of a monument to Soviet soldiers.

CANADA | JACKSON AND MELISSA BRANDTS

This ground squirrel couldn't resist the limelight. Melissa and Jackson Brandts were looking for a memento of their trip to Banff National Park, but instead they got an immediate Internet sensation when this squirrel stopped to check out their camera.

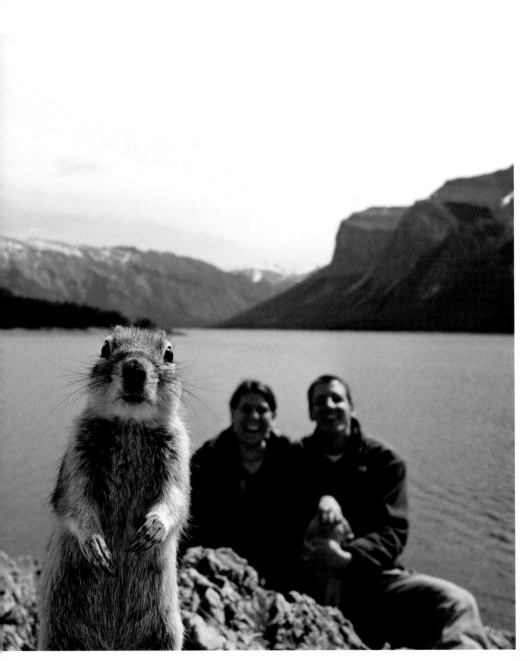

ENGLAND | BOB KRIST

*Lost in a wending laurel maze at Cornwall's
Glendurgan Garden—a series of verdant
subtropical gardens planted privately in the
1820s and bequeathed to the National Trust in
1962—two visitors huddle in a hut.*

LATVIA | MARTIN ROEMERS
A long exposure blurs sea and sky into a minimalist backdrop for a crumbling Soviet-era military building near Liepāja. More than a decade after Moscow withdrew its forces from Latvia, such ruins litter the Baltic coast.

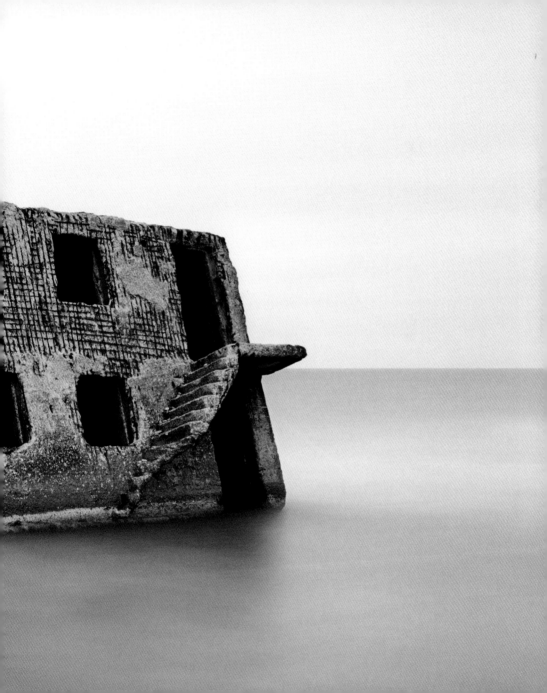

GERMANY | BRUCE DALE

A glowing half of a pair of scissors joins a cooling pile
in Solingen, Germany. Situated near a steady supply of
water, iron ore, and timber for charcoal, the city has
become known for its quality metalwork.

PENNSYLVANIA, UNITED STATES
STEPHEN ST. JOHN

*A miniature white pumpkin in Gettysburg,
Pennsylvania, provides a worthy counterpoint
to its orange cousins. While pumpkins contain vitamins
A and C and potassium, they often are used for
autumnal decorations instead of for eating.*

A thermal suit proves to be high style for Carsten Peter as he explores a lava lake in Nyiragongo Volcano in the Democratic Republic of Congo. "It can protect you from the radiant heat, but if you get hit with a lava splatter, the force will likely kill you," he says.

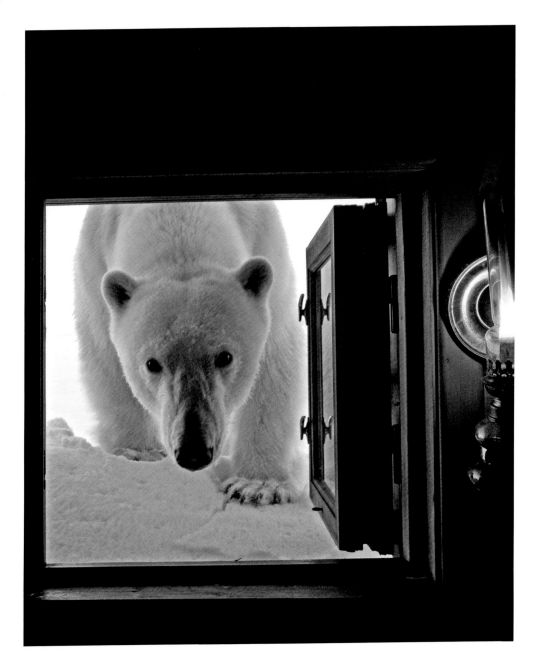

POLAR BEARS sport a thick coat of insulated fur to help them survive in one of the planet's coldest environments. They even have fur on the bottom of their paws to protect against cold surfaces and provide a good grip on ice.

NORWAY | PAUL NICKLEN | *A female polar bear pays a visit to a cabin in Svalbard, Norway. Her curiosity offers a touching portrait of a species that is a formidable hunter both on the ice and in frigid Arctic waters.*

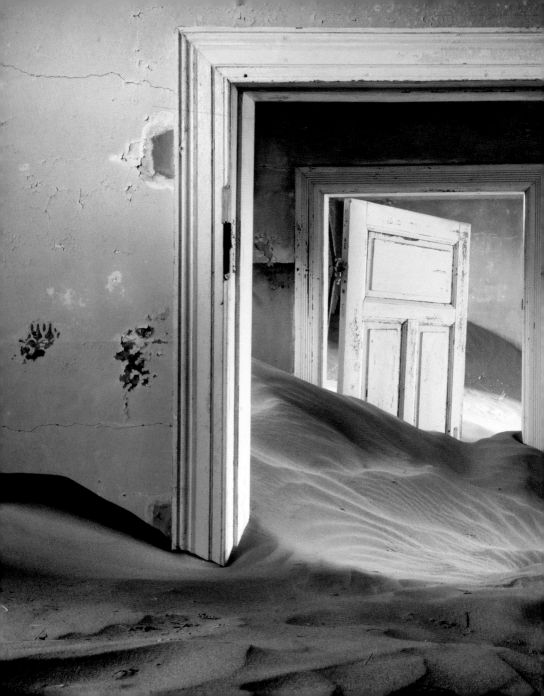

NAMIBIA | MARSEL VAN OOSTEN
In a scene stolen from a dream, a house succumbs to sand in Kolmanskop, once a thriving settlement for diamond miners. Winds have helped desert dunes reclaim the site, abandoned for more than 50 years.

BREA

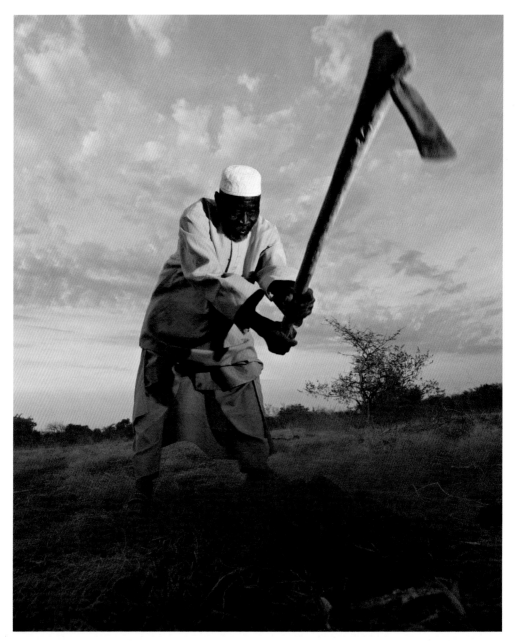

IN A WORLD

that extols the wholeness of being, breaking represents a threat. A broken egg will never hatch. A fractured acorn will not sprout. A crushed flower bud will not mature into fruit. Yet breaks will always occur in the shuffle and movement of life on Earth. Photographers see them not as interruptions but as part of Earth's action, fissures into which we gaze to look upon time and space more deeply, stumbles from which we recover and carry on.

Some breaks take an eternity. The Grand Canyon is a massive breaking of Earth's crust. Seen from on high, its carved-out crevices recall the jagged edges of a drought-driven mudflat. A river flows through, still deepening the cracks and smoothing sharp edges, making all things round.

Other breaks happen in an instant. In tropical turquoise waters, the heedless flap of a dolphin's tail or the mighty torrent of hurricane-tossed waves snaps off a broad arm of elkhorn coral. It totters and falls to the ocean floor. Resting fish scatter. Where it broke off, a jagged stub remains.

But from the fallen branch, a new coral world may grow, and this chance is the promised cycle of Earth's breaking. Even in violence, even in death—even when a cheetah mounts a gazelle, sharp teeth sinking into jugular, last shiver of strong limbs, last heartbeat—the lost one feeds the many. Cheetah, hyena, vulture, soil: all enriched by blood, meat, and marrow, one life broken that others may live.

BURKINA FASO | JIM RICHARDSON | *Digging in dry soil, this farmer in Gourga, Burkina Faso, uses refined techniques to grow his crops. His landlocked country, between the Sahara to the north and the wet forests to the south, has experienced years of drought.*

ALASKA, UNITED STATES | MICHAEL MELFORD
A stream-carved canyon in Alaska's Valley of Ten Thousand Smokes highlights the area's volcanic history. The 1912 eruption of Novarupta Volcano, one of ten active volcanoes surrounding this valley, formed these canyon rocks.

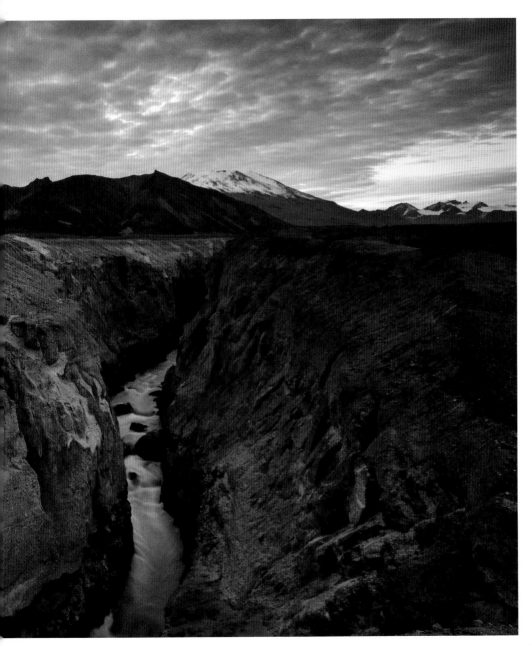

CALIFORNIA, UNITED STATES | STEVE SKINNER
An F-18 fighter jet seems to appear out of a milky curtain as it breaks the sound barrier during a San Diego air show. A vapor cloud surrounds the fighter as it reaches supersonic speeds.

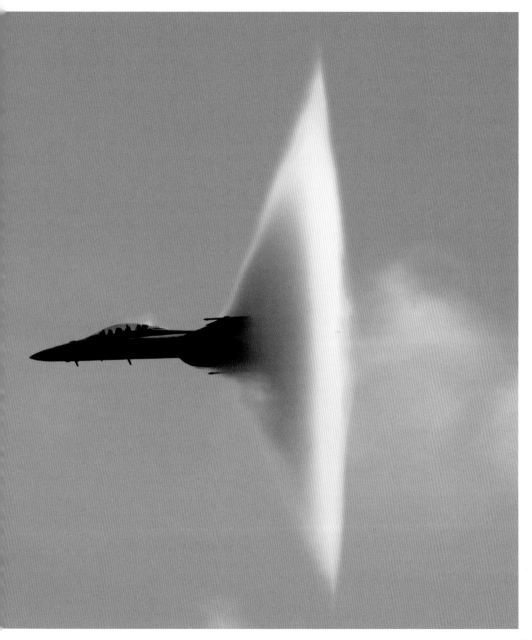

KENTUCKY, UNITED STATES
MELISSA FARLOW
Thoroughbreds break out of the starting gate at
Keeneland, a racetrack in Lexington, Kentucky.
Bluegrass country is also high-stakes horse
country, where a mating with a prized stallion
can cost six figures.

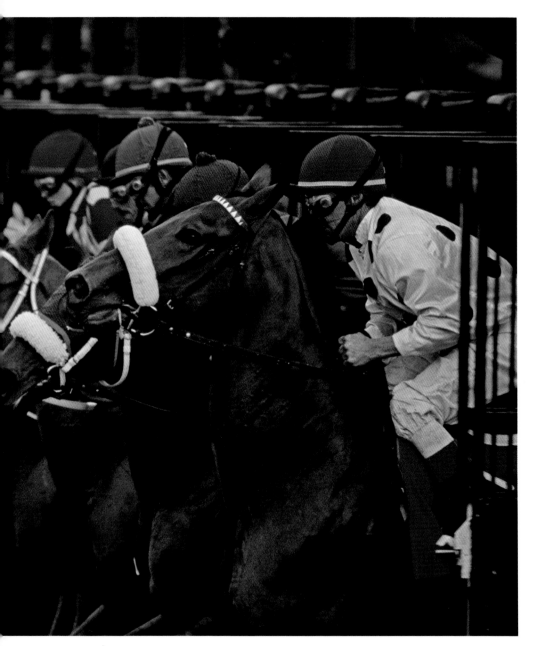

HAWAII, UNITED STATES
PATRICK MCFEELEY
*Maui's North Shore offers this surfer a challenging
wave. The second largest (and second youngest)
island in the Hawaiian chain offers warm waters
and spots for surfers of all abilities.*

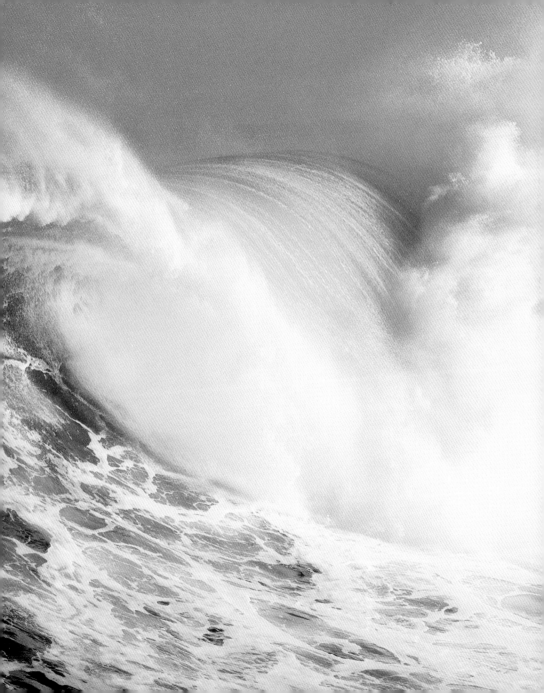

Birds use song to attract a mate or make known their territory. One bird, the Brown Thrasher, has 2,000 or more distinct songs in its repertoire.

CANADA | SCOTT LINSTEAD | *Despite its vivid blue appearance, the Indigo Bunting,* Passerina cyanea, *lacks blue pigment. This songbird's beautiful color is a result of the microscopic structure of its feathers and the way that structure refracts light.*

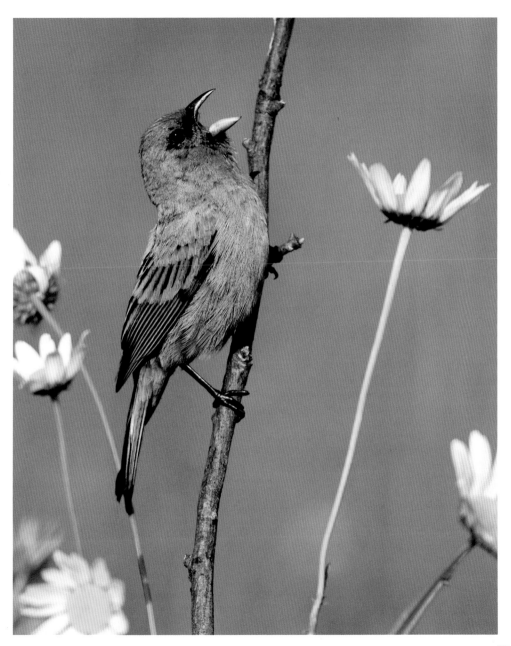

ISRAEL | ANNIE GRIFFITHS

Studying can be stressful, and these young Hasidic Jews grab the chance for a smoke break in Jerusalem. The modern Hasidic faith, considered a more mystical form of Judaism, began in the 18th century with Polish rabbi Ba'al Shem Tov.

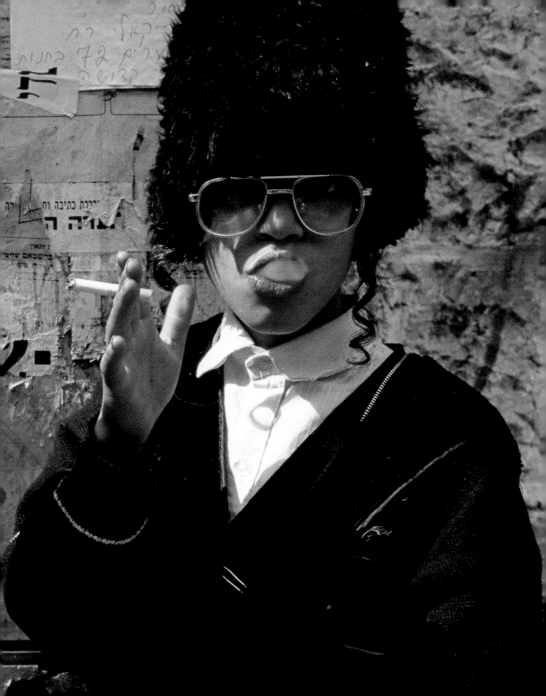

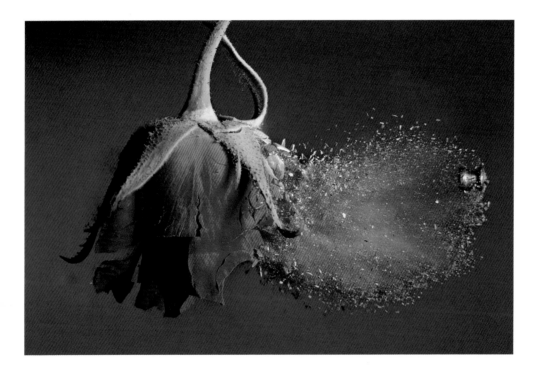

CALIFORNIA, UNITED STATES | ALAN SAILER
Like a high-speed Cupid's arrow, an air-rifle pellet
pierces the heart of a rose at some 800 feet per second
(244 meters per second). The flower, plucked from a
garden and flash frozen in liquid nitrogen, shatters in
a spray of petal fragments.

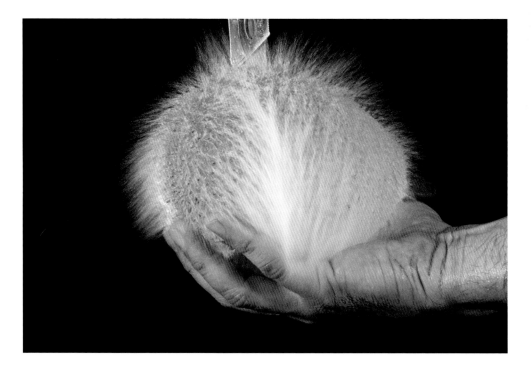

UNITED STATES | TYLER THOMAS

A ruptured water balloon keeps the broad outlines of its shape, at least for a brief time. As it explodes into a misty spray of droplets, surface tension and the gravity of the water help retain the sphere.

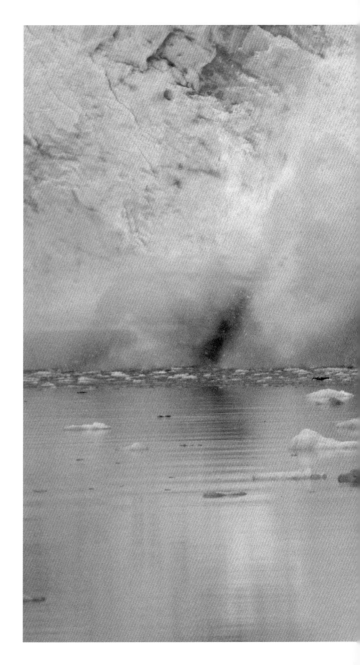

ALASKA, UNITED STATES
ERNEST MANEWAL
The calving Meares Glacier provides
quite a summer splash for kayakers
in Prince William Sound. As the
glacier advances, sections break off
into Unakwik Inlet after overtaking
an old-growth forest.

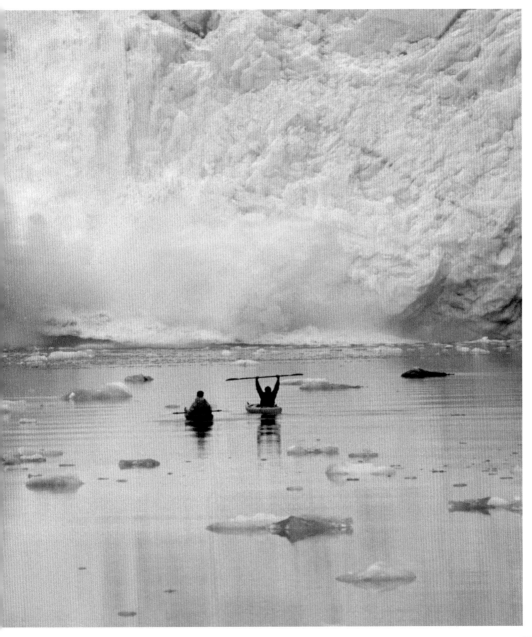

In a race to emerge at the Sriracha
Tiger Zoo, one 8-inch (20-centimeter)
Siamese crocodile wins by a head.
Few such crocs exist in the wild, yet
20,000 are born each year during the
zoo's May-to-August hatching festival.

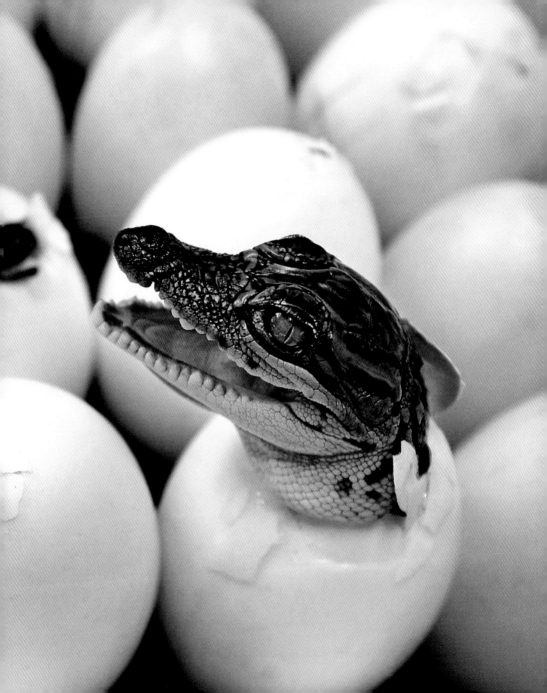

NAMIBIA | FRANS LANTING

Hikers appear as specks climbing on the face of a giant dune in the Sossusvlei region of Namibia's Namib-Naukluft Park. Winds have shaped and reshaped the sands, colored red by iron oxide, for thousands of years.

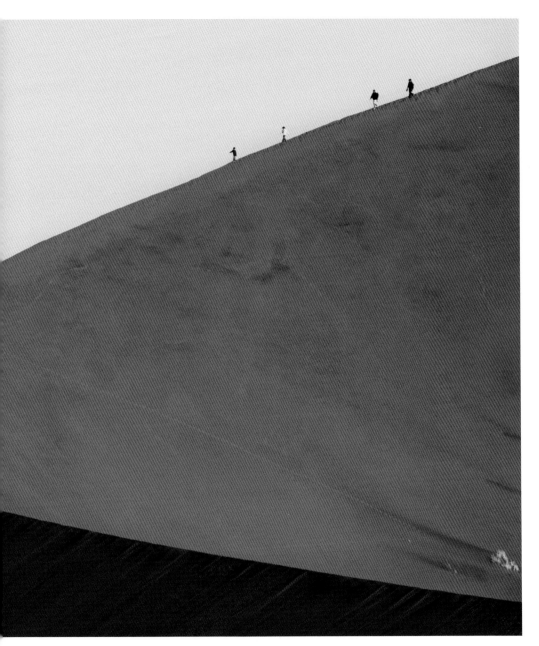

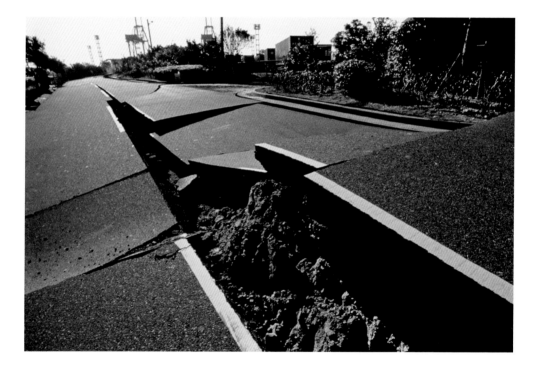

JAPAN | KAREN KASMAUSKI
A visual reminder of plate tectonics, a fissure seemed
to follow a road's white line when it cracked open
the pavement in Kobe, Japan, in 1995. After that
earthquake, Japan set up a nationwide alert system
to give its citizens precious time to prepare.

CANADA | PAUL NICKLEN

Pressure cracks in brilliant blue, multiyear Arctic sea ice create a tie-dyed tapestry. This ice contains less brine and more air pockets than first-year ice, and if a hummock a few years old is found, it can provide water fresh enough to drink.

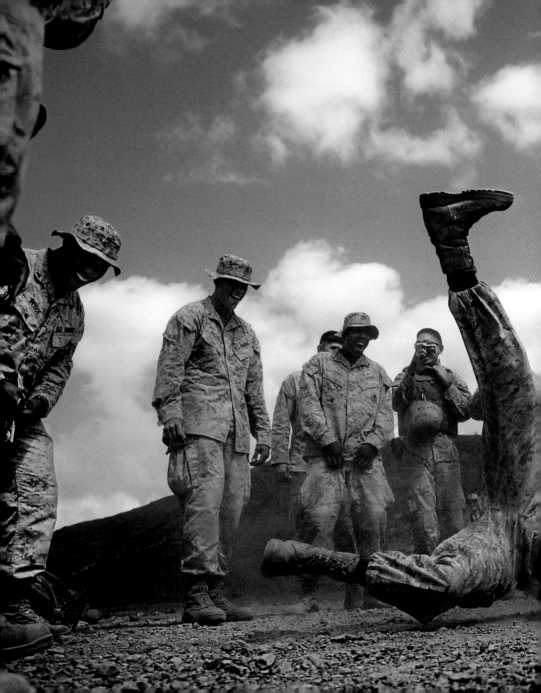

DJIBOUTI | JEREMY LOCK
A break in training exercises lets Marine
Cpl. Brett Herman try out his break-dancing
moves during a freestyle contest at Camp
Lemonier. The former French barracks is
the sole U.S. base on the Horn of Africa.

BATS are the only mammals that can truly fly. Their wings are made up of thin layers of skin that stretch between very long finger bones.

PANAMA | CHRISTIAN ZIEGLER | *A swooping greater bulldog bat on Barro Colorado Island in Panama uses its gaffing claws to grab a fish. Echolocation gives this predator an added edge: It can detect when a fish's fin breaks the water's surface.*

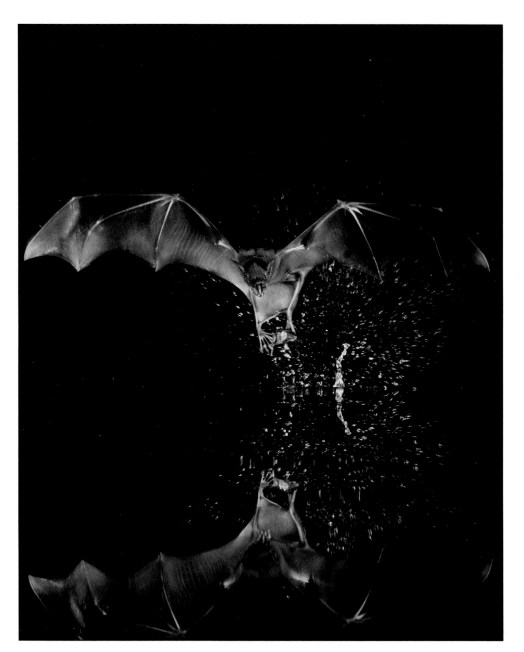

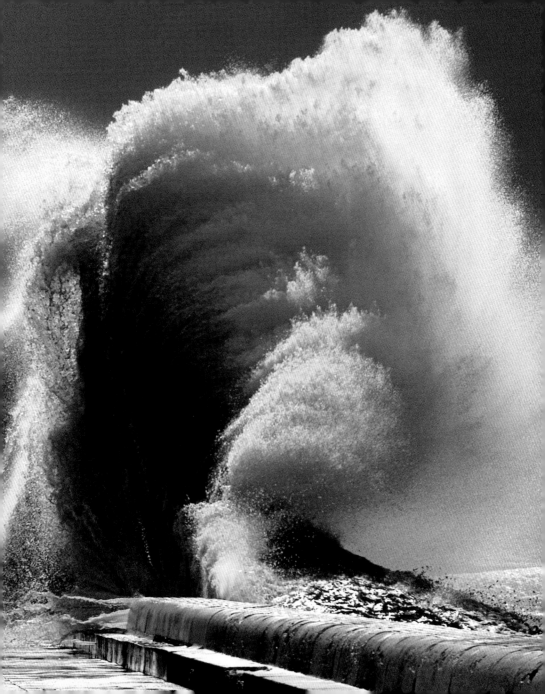

END

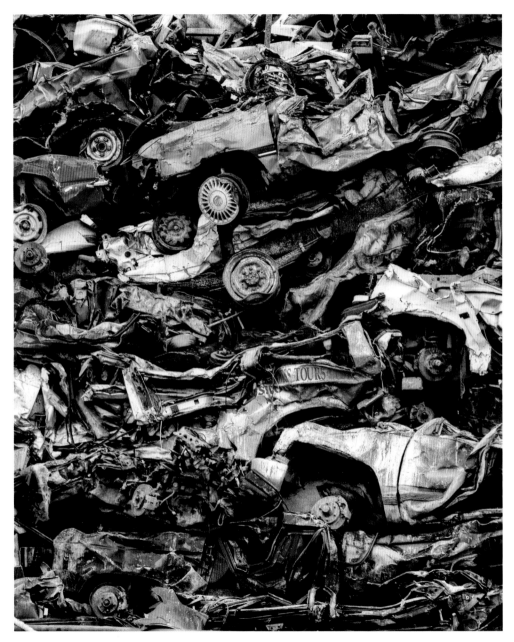

EVERY LIVING thing on Earth enjoys a beginning, and thus

will face an end. The time may come in a matter of days, or years, or centuries. In gazing upon and reckoning with the endings of others, we in a way rehearse our own.

The animals that we know and care for most intimately rarely outlive us. Our dogs and cats, even our cattle and horses, live lives easily framed within the fourscore years of our own. A beloved mutt begins as an adopted puppy, all exuberance and energy and new life. She matures into a dog with personality, faithful and patient, eager to please. Then she mellows into the slow moves of a dog of many years, and we watch as her senses dull, her joints creak, her body sleeps. We participate in the cycle of life with that dog we love, and we cry as the circle closes.

Flowers present a different sort of ending: less tragic, less final, less like our own, and yet tinged with sad reminders of the finitude of beauty.

Rosebuds bulge with hope and promise. They swirl open, petals slowly unfurling. The sweet center of the flower stays hidden, the peak of blooming still ahead. Days pass, and the rose fully opens. Petals lean back and lose their scent and their luster. They fade to brown and fall to the ground. What once was the promise of floral splendor is now spent, invested in the fruit of the fall.

CANADA | PETE RYAN | *It's the end of the line for these crushed cars in a Victoria, British Columbia, scrap yard. Their metal, though, is destined to be recycled into other consumer products, and British Columbia encourages "early retirement" for older vehicles.*

ST. MAARTEN | FABI FLIERVOET
Landing at Princess Juliana International Airport,
a looming 747 thrills people on Mahó Beach.
The white-sand stretch on the Caribbean island's
Dutch side (the rest is French) is a famous
plane-watching perch.

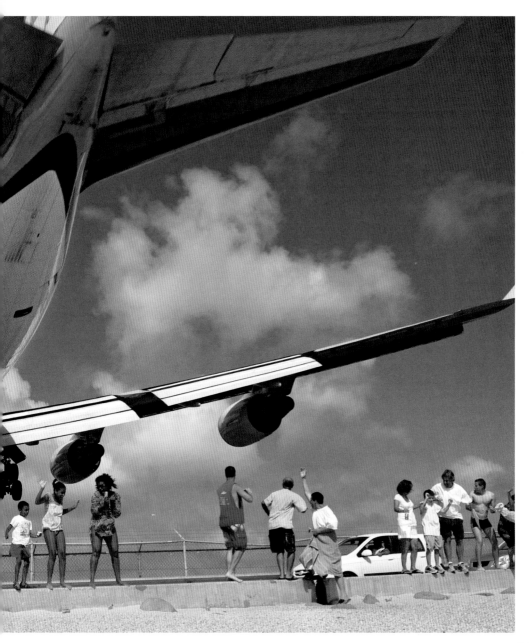

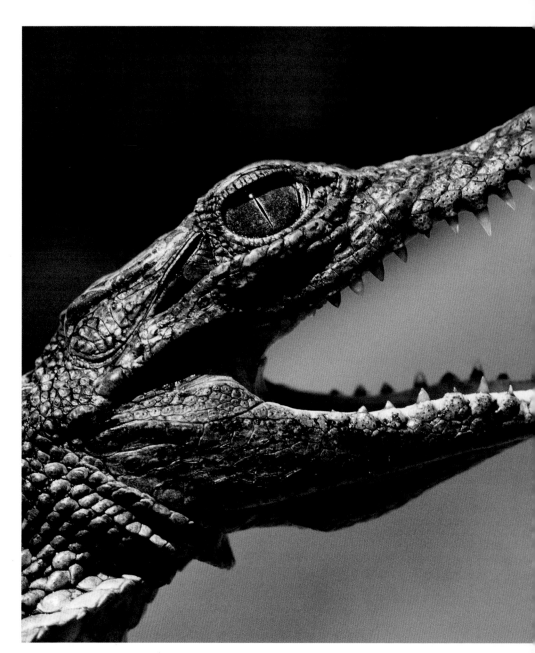

SOUTH AFRICA | JONATHAN BLAIR

A year-old Nile crocodile attempts to snap up a frog in the St. Lucia Estuary. Part of the iSimangaliso Wetland Park, which UNESCO named a World Heritage site in 1999, the protected area is Africa's largest estuarine system.

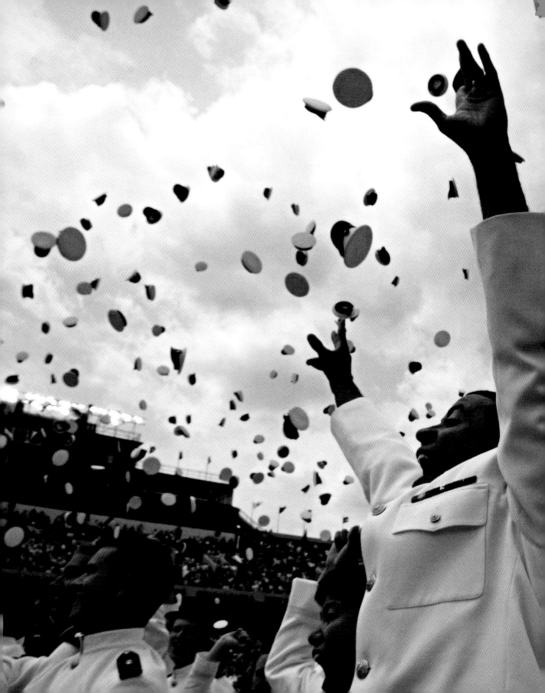

In MEXICO,

legend says that if you lose a tooth,

el ratón (the mouse) will leave

a treasure under your pillow.

FLORIDA, UNITED STATES | JOEL SARTORE | *An endangered Choctawhatchee beach mouse,* Peromyscus polionotus allophrys, *has good reason to appear shy. The nocturnal herbivore faces the ongoing threat of development of the sand dune ecosystem it inhabits.*

NORTH DAKOTA, UNITED STATES
EUGENE RICHARDS

A worn copy of the Harvester's Prayer, nailed to a
weathered cross and placed on a cracked shelf in
Belfield, North Dakota, creates an enigmatic scene.
It also provides a fitting testament to the grit and
faith of North Dakotan farmers.

CANADA | PETE RYAN

The weathered red wood of a grain elevator speaks to better times. Many of the small family farms of Saskatchewan Province were shuttered by the early 21st century due to replacement by larger operations.

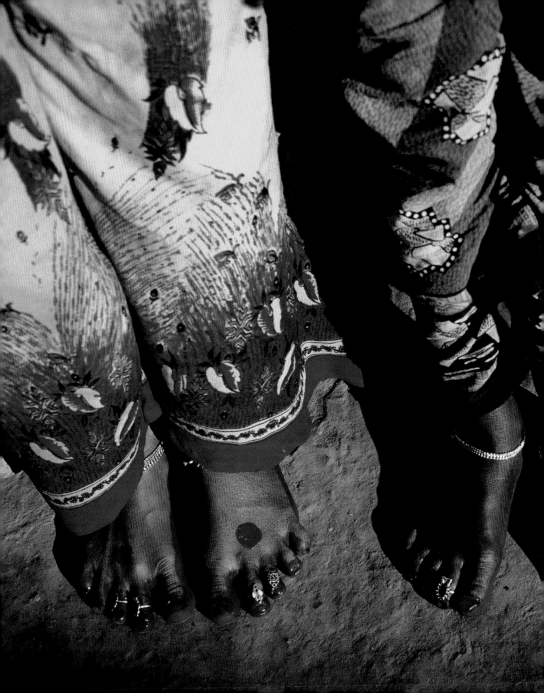

INDIA | SARAH LEEN

Beneath bright saris, shining silver jewelry and red painted toes decorate the feet of women in the northern Indian town of Ahraura. One of the edicts of King Asoka, a Buddhist ruler who encouraged moral behavior more than 2,000 years ago, was found in the town.

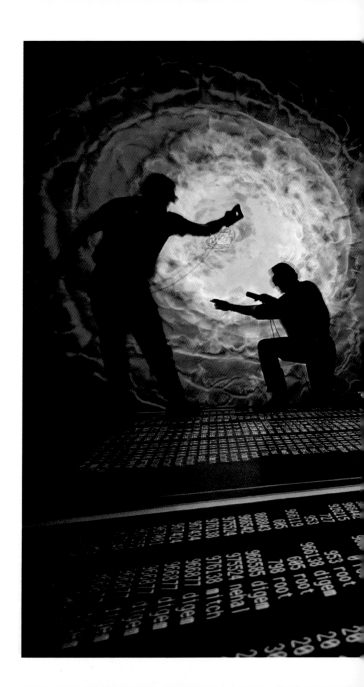

NEW MEXICO, UNITED STATES
LYNN JOHNSON
Scientists at Los Alamos National Laboratory study nuclear explosions by using 3-D simulations. They follow a long tradition of nuclear research that led to the creation of the atomic and hydrogen bombs.

ISRAEL | AVIRAM AVIGAL
A diver uses lights to illuminate a crusty wreck in 160-foot-deep (49-meter) water off the coast of Eilat, Israel, the country's southernmost city. Once out of the water, the diver will find a popular resort city on the Red Sea.

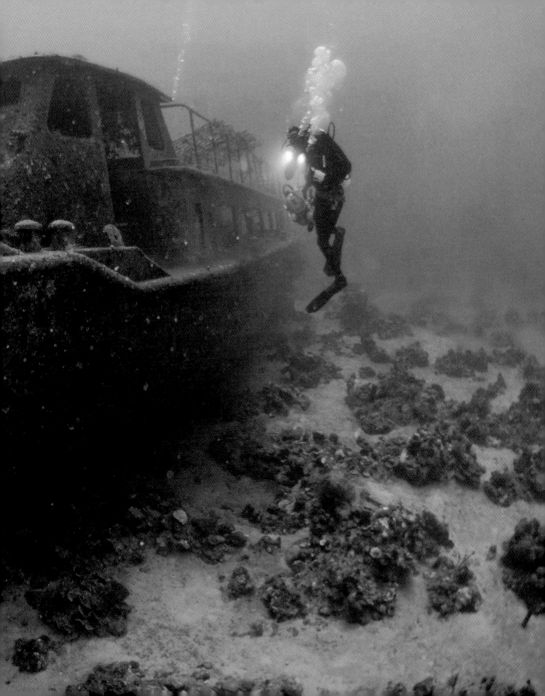

CALIFORNIA, UNITED STATES
RAUL TOUZON

An abandoned gas station, reflected in the glass door of an establishment, offers another fitting place to hang a closed sign. The small community of Death Valley Junction, California, also appears to live up to the message.

The adult HUMAN BRAIN weighs approximately three pounds (1.4 kg). It is more than three times bigger than the brains of other mammals that are about the same size as humans.

MEXICO | KENNETH GARRETT | *A fiery orange-and-red backdrop, white lights, and three black skulls create a still life of somber celebration at Day of the Dead festivities in Oaxaca, Mexico. The holiday has pre-Hispanic origins and today is celebrated on All Saints' and All Souls' Days in November.*

LOUISIANA, UNITED STATES
JAMES L. STANFIELD
Celebrating the life of their friend, clarinetist Emile
Barnes, musicians play jazz during Barnes's funeral
procession in New Orleans. Barnes, who died in 1970,
can be heard on the Smithsonian Folkways label.

CALIFORNIA, UNITED STATES
STEPHEN ST. JOHN

This sign lets you know when you've reached the end of historic Route 66 in Santa Monica, California. The 2,448 miles (3,940 kilometers), which start in Chicago, Illinois, and make up what novelist John Steinbeck called the Mother Road, have captured dreams since 1926.

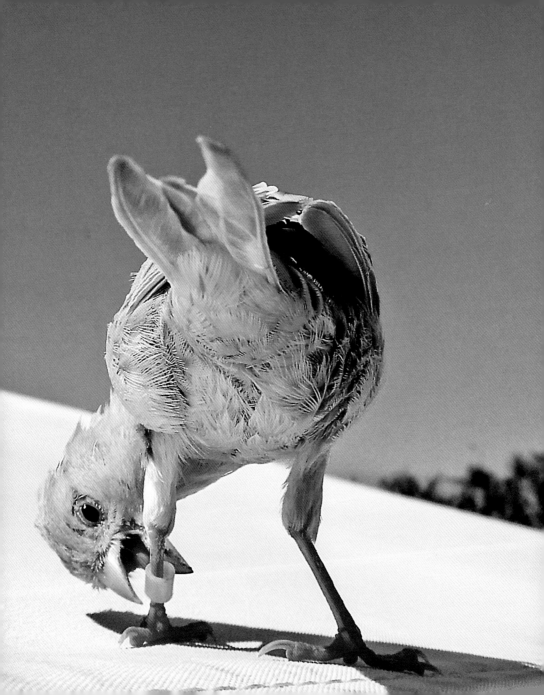

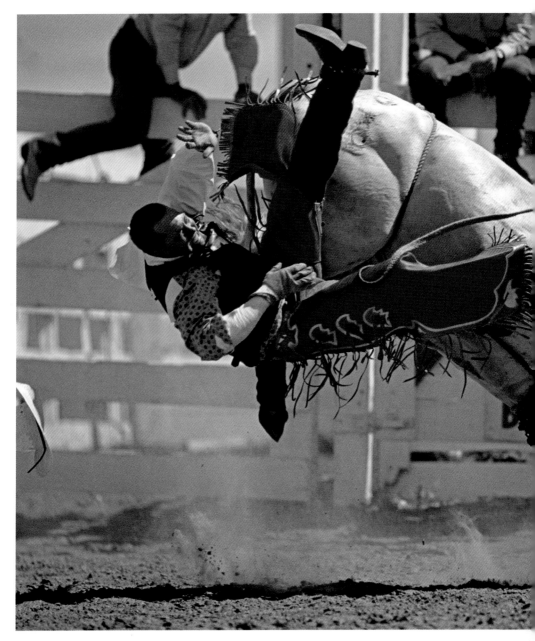

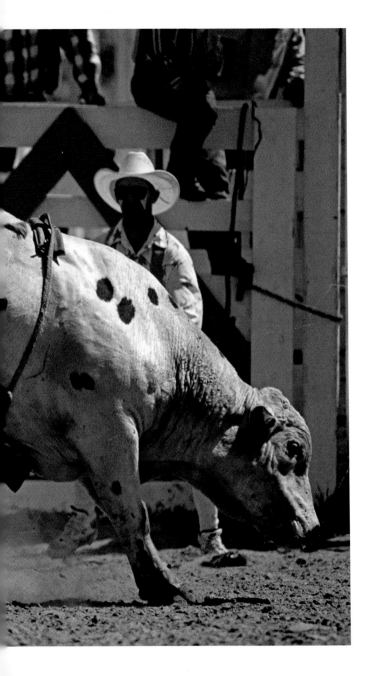

NEBRASKA, UNITED STATES
JOEL SARTORE
Catching the wrong end of a bull,
a rodeo rider at the Big Rodeo in
Burwell, Nebraska, can no longer
hang on. On a bucking horse or
bull, a qualifying ride lasts at
least eight seconds.

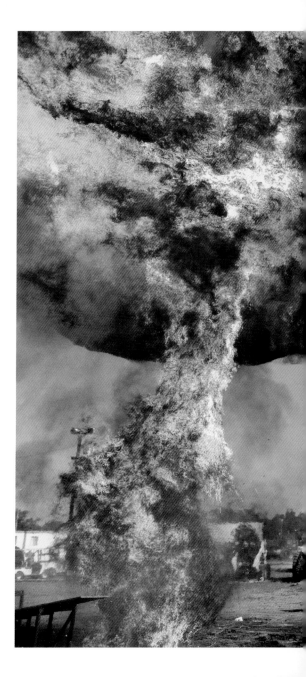

IOWA, UNITED STATES | JOEL SARTORE
Nothing like fiery crashes and twisted metal to make a demolition derby come alive. This stunt driver jumped his car at 60 miles an hour (97 kilometers an hour) from a flaming ramp 50 feet (15 meters) into a stack of junked cars.

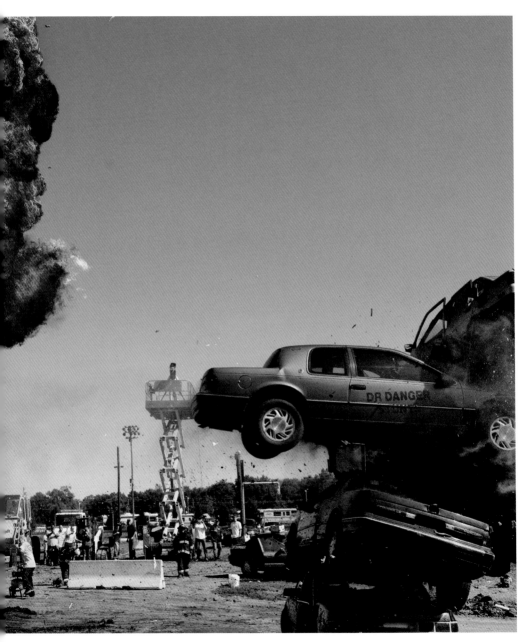

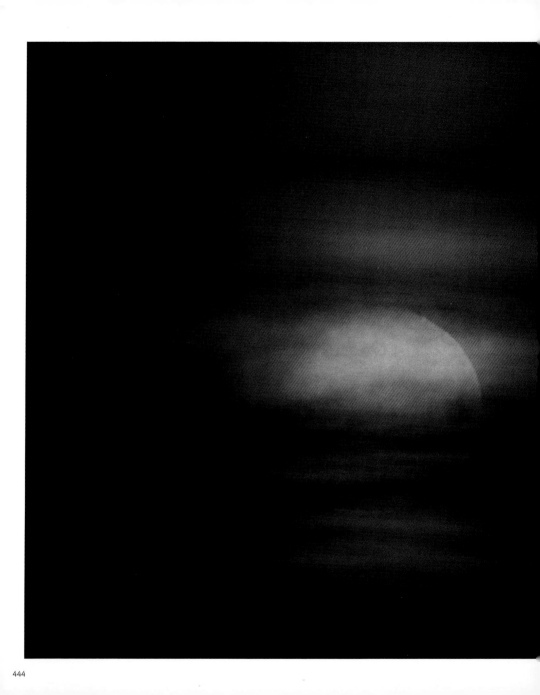

CANADA | PETE RYAN

Dusk lends an ethereal tone to the setting sun in Victoria, British Columbia. Whereas our planet has one magnificent moon, there are 165 others in our solar system.

x

PORTFOLIO FOURTEEN

FL

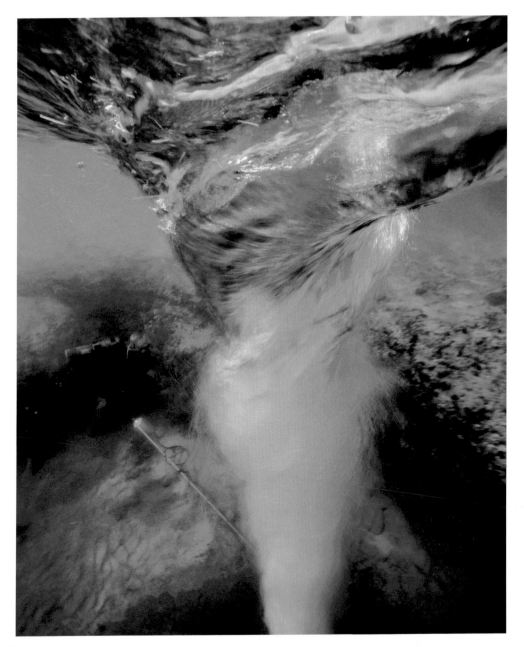

DESPITE

all the breaks and all the endings, despite interruptions and contradictions, despite threats and warnings and worries, the universe of things flows on. Photography captures a moment. Hungry eyes, senses, memories, synthetic imagination—we use all faculties to observe, and we connect those captured moments into a stream of meaning that flows through the mind, now dark, now glittering, every now and then presenting an aha! moment.

That flow begins in tiny trickles, whispers of water seeping up out of soil and shimmering over rock, joining together into streams, streams that course down mountain slopes and carve out valleys, streams that join together into great rivers, strong and life affirming, blood of this world of thought, shape, and feeling. Flow connects the everlasting universe of things with the never-ending quest to see and understand.

Flow beats through every pulse that propels a rarely seen jellyfish through Antarctic waters: rainbow iridescence, numinous tentacles, body made of translucent film that could not even be called flesh. Flow enflames an arctic wolf's eyes, sunset red as she stands above the cold, dry tundra. Flow shapes the curves of a copper-hued corn snake; it is the very impulse that shimmies through an earthworm, the lowly creature that turns death into life.

It is flow that keeps us human beings alive and wondering, and it is flow that helps us believe in such things as eternity.

BAHAMAS | WES C. SKILES | *A diver carefully sets up instruments to measure the flow rate of a vortex in Chimney Blue Hole off Grand Bahama Island. When the tide comes in, the whirlpool acts as a giant drain, taking millions of gallons of water with it.*

BRAZIL | ZIG KOCH

Butterflies spatter the shoreline of the Juruena River in the 4.7-million-acre (1.9-million-hectare) Juruena National Park. Several different species flock to the riverbanks to sip mineral salts from the sand.

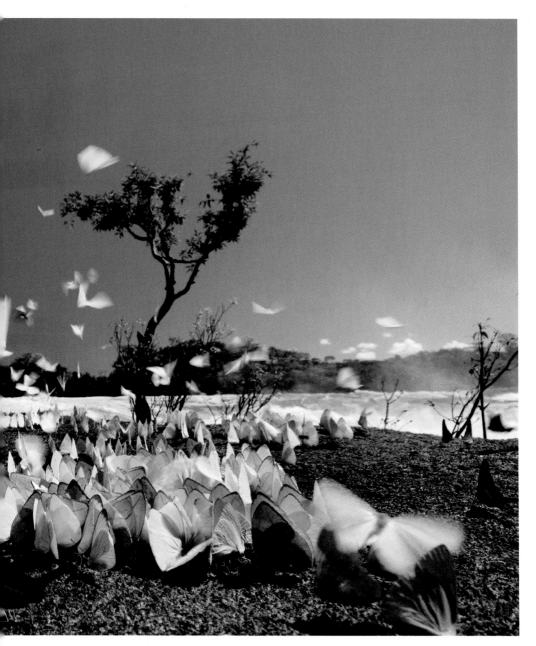

INDIA | AMIT DAVE
Parched people mob a vast well in the village of Natwargadh, Gujarat. In this drought-prone western state, yearly monsoon rains can total less than 8 inches (20 centimeters), and summer temperatures have topped 115˚F (46˚C).

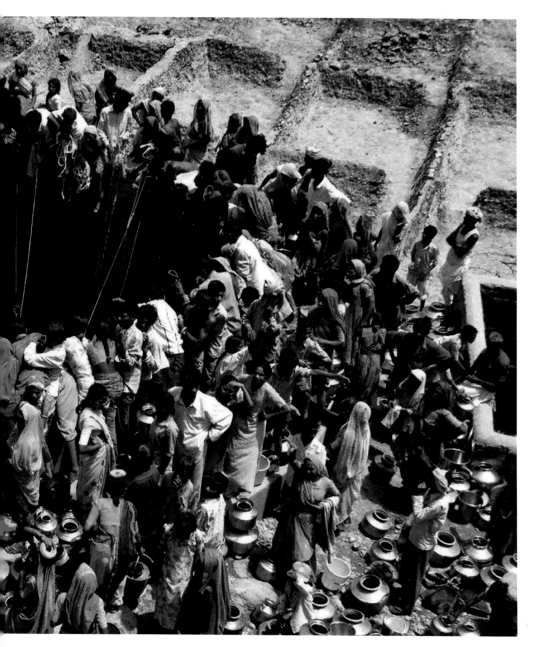

CALIFORNIA, UNITED STATES
GERD LUDWIG
*In 2007, high levels of bromate—a carcinogen
formed when bromide and chlorine react with
sunlight—were found in Los Angeles's Ivanhoe
Reservoir. Today three million black plastic balls
help deflect UV rays.*

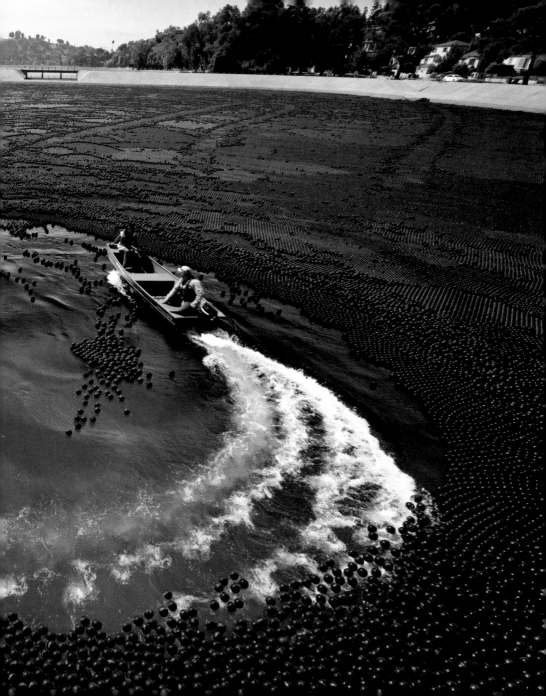

MYANMAR | ALEX TREADWAY

The wind does some of the work for this Burmese girl winnowing wheat. She can separate the hand-harvested wheat from the chaff by letting the wind blow away the lighter chaff.

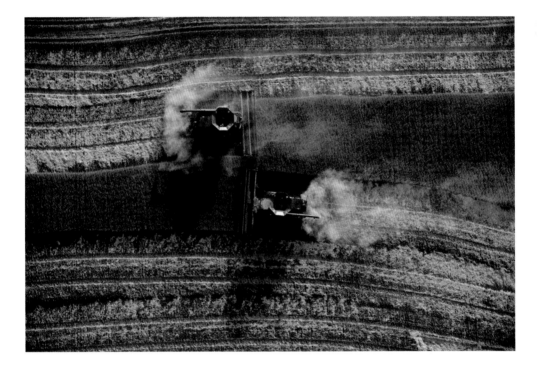

KANSAS, UNITED STATES | JIM RICHARDSON

High-tech combines harvesting a wheat field create a patchwork when viewed from the air. As an example of big business in America's heartland, these machines can reap 200 acres (81 hectares) a day.

The NAMIB DESERT
is the only spot on Earth where
the remarkable welwitschia
plant grows. Although the average age
of these plants is 500 to 600 years, some of
the larger ones are thought
to be 2,000 years old.

NAMIBIA | MICHAEL AND PATRICIA FOGDEN | *A venomous sidewinder,* Bitis peringueyi, *shows off how it got its name while slithering on a Namibian dune. The snake sometimes camouflages itself in the sand, with only its eyes popping out.*

458

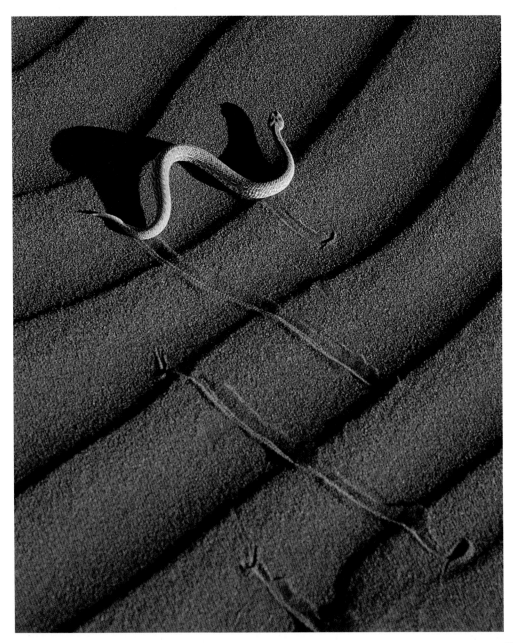

ICELAND | MICHAEL MELFORD
*Crashing white surf, a model in a flowing red dress,
and rich black sand combine to create an image of
motion and color on an Iceland beach. Such stunning
beauty is nothing new for this country, forged from
fiery volcanoes and icy glaciers.*

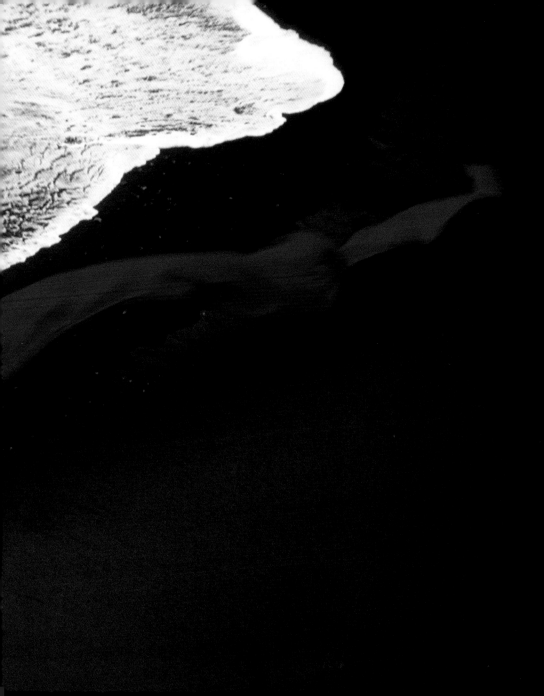

DEMOCRATIC REPUBLIC OF THE CONGO | CARSTEN PETER
An explorer walks on the cooled lava from an eruption of Nyiragongo Volcano, an active peak in striking distance of the city of Goma. The red color comes from the reflected glow of the nearby lava lake.

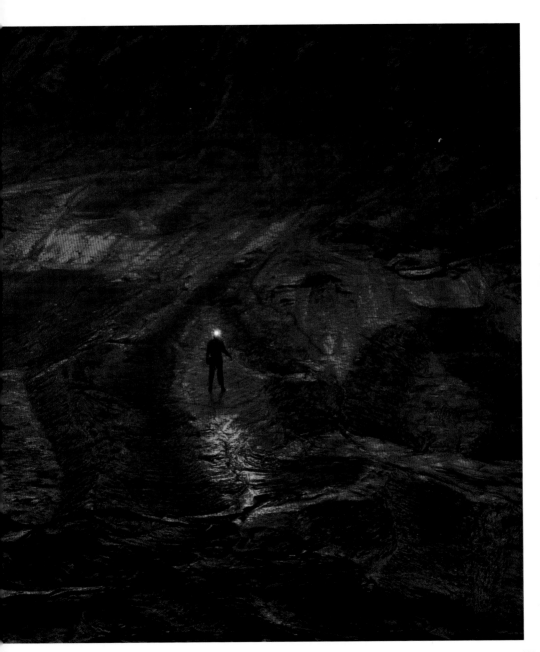

ISRAEL | JAMES L. STANFIELD
A coiling serpent of watery fun greets
vacationers in Ein Gev, Israel. The water-
slide welcomes visitors to this kibbutz on
the Sea of Galilee's eastern shore.

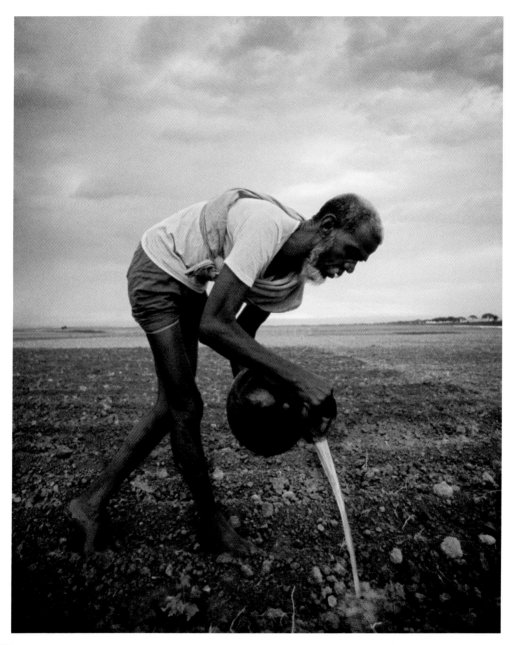

Ninety-seven percent of

EARTH'S WATER

is in the oceans. This means that

if all the world's water could fit in

a 1-gallon (3.8 L) jug, only about

1 teaspoon (5 mL) of it

would be fresh water.

BANGLADESH | DICK DURRANCE II | *A farmer in Bangladesh carefully tends his crops during a 1972 drought.*
Knowing firsthand the importance of a precious resource, he waters each plant individually.

467

ALASKA, UNITED STATES
ALISON WRIGHT
A bartender at the Fairbanks Ice Museum mixes cocktails at a bar made of ice. For those who can't get enough of the cold, this museum offers visitors "Alaska's winter in the summer."

SOLOMON ISLANDS | CHRIS NEWBERT
A close-up of corallimorpharians, also known as
mushroom anemones, in the western Pacific looks like
alien life when lit by strobe lights. Related to hard corals,
this mainly tropical order lacks hard, calcareous skeletons.

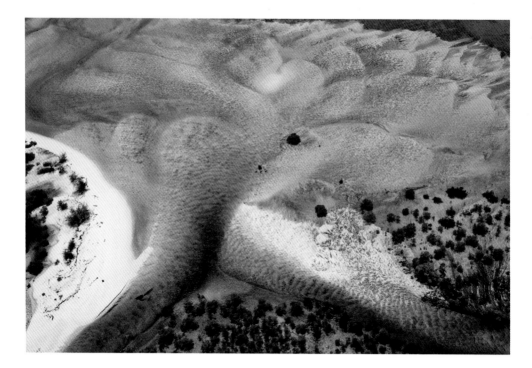

MOZAMBIQUE | MICHAEL POLIZA

A river in Mozambique flows into the Indian Ocean and creates a scalloped pattern. This southeastern African nation has abundant natural resources, including rivers for hydroelectric power.

NAMIBIA | BRYNN BAYMAN
It doesn't take much to get rolling down a Namibian dune. These students on a geographical field trip find the slope irresistible but end up with sand in every nook and cranny.

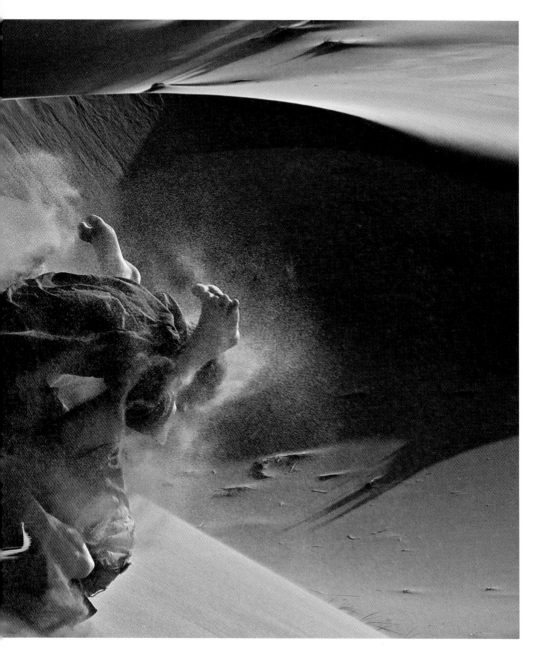

CANADA | PAUL NICKLEN
Colored neon green by a nontoxic dye, the current surrounding this sea urchin colony near British Columbia's Vancouver Island flows through it instead of over it. The fast, nutrient-full waters of the Queen Charlotte Strait nurture an abundance of sea life.

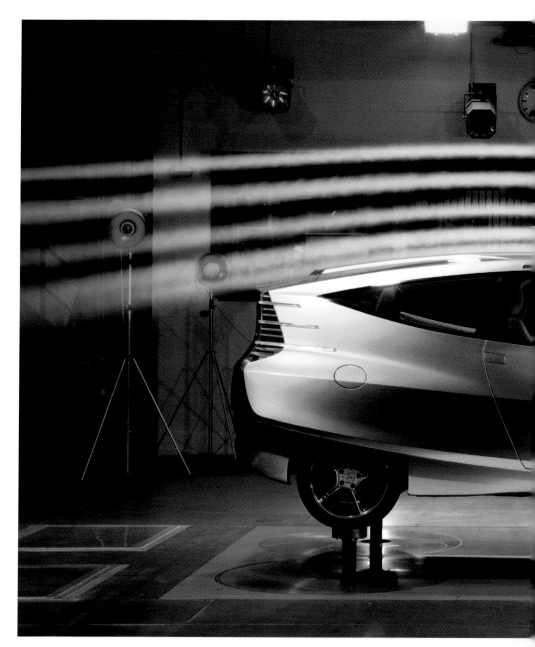

GERMANY | ROBERT CLARK

A Stuttgart wind-tunnel test clearly shows the aerodynamics of this concept car by Mercedes-Benz. Inspired by the low-drag design of the boxfish, this car can achieve gas mileage of 70 miles per gallon (30 kilometers per liter).

RADI

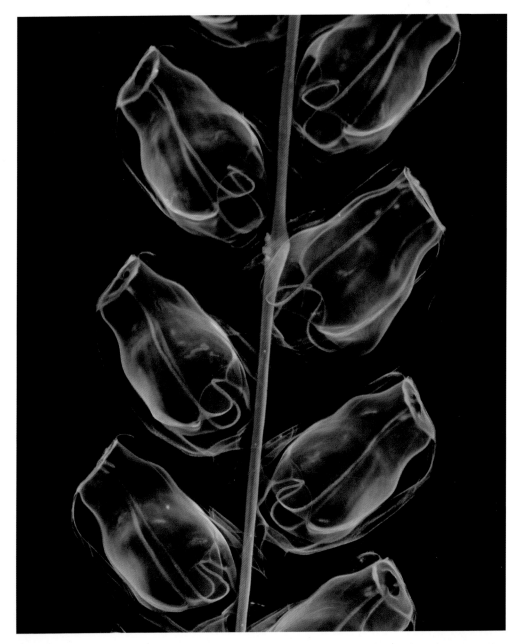

480

IN THAT

moment of understanding that happens more deeply than words, we find radiance.

A fragrant white peony, just one of its multiflora petals fringed with red, exudes a scent that lifts the heart. It smells like dawn.

The whir of hummingbird wings sounds on a summer afternoon; the iridescent creature pauses, emerald green balancing on air. It dips its beak, sips nectar from the luxuriant trumpet flower, then rears back delicately and darts up, out, and over to the next flower-rich hedgerow.

A swampside anhinga—awkward of shape, drab in color, ugly in face—glories in the radiance of the day, stretching angled wings out wide to catch the warmth of subtropical sunshine, avian yoga at midday.

Moments of radiance surround us, yet our dulled senses do not always perceive them. We need the help of watchful eyes, trained to precision of expectation.

At just the moment of ripeness, a gleaming yellow apple falls into the grassy field. In evening shadows, a doe takes each step with care, her fawn beside her. She nuzzles the sweet fruit and nudges it toward her young. A moment of love and light in the forest.

The winter sun gleams through bare tree trunks lining the blue ridge of a mountain. Radiance, then darkness. Dawn will come.

And if we are lucky, someone will be there, watching and waiting, on the alert for the new day's first light, making the next great photograph, capturing anew these visions of Earth.

ARCTIC OCEAN | KEVIN RASKOFF | *Looking like a rack of blown-glass vases, inch-long (2.5-centimeter) swimming bells of a siphonophore—a jellyfish relative called* Marrus orthocanna—*hang from a tubular stem that delivers nutrients to the bells.*

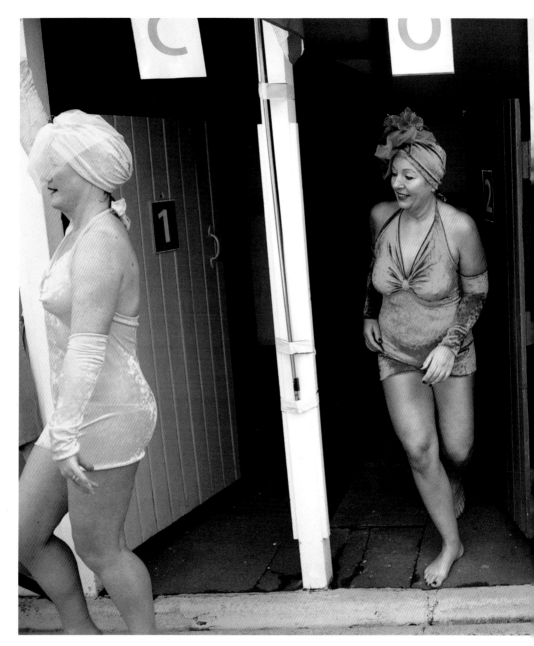

ENGLAND | KIERAN DOHERTY

At London's Tooting Bec Lido pool, four fancifully attired, color-coded women kick off the Cold Water Swimming Championships. More than 300 bathers, ages 12 to 85, competed and promoted the thrill of the chill.

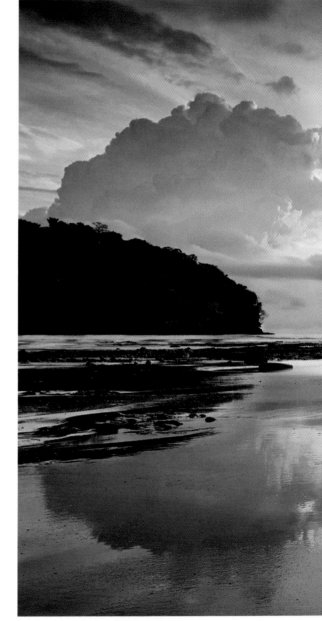

COSTA RICA | PATRICK DI FRUSCIA

Building clouds and a setting sun reflect on a sandy beach on Costa Rica's Nicoya Peninsula. The Pacific offers tranquil beauty and good surfing, just two of many reasons why this stable Central American country has become a favorite destination.

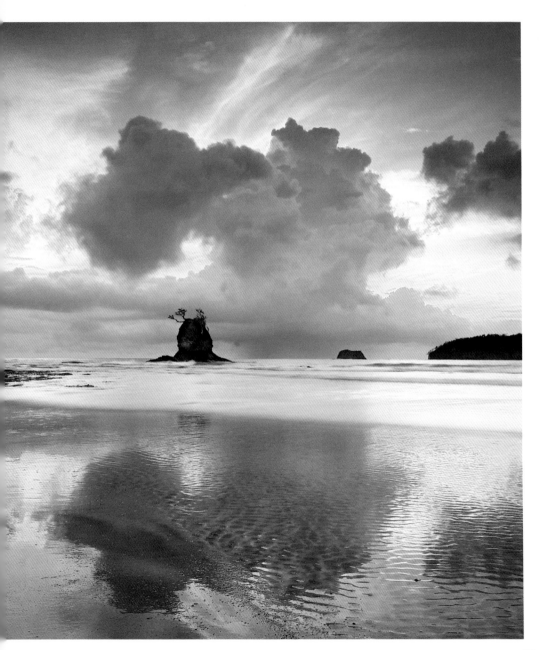

INDONESIA | TIM LAMAN

*Clown anemonefish nestle amid the tentacles
of a sea anemone off the Tukangbesi Islands in
Indonesia. The clear waters surrounding coral
reefs have encouraged the evolution of color
and pattern among the inhabitants.*

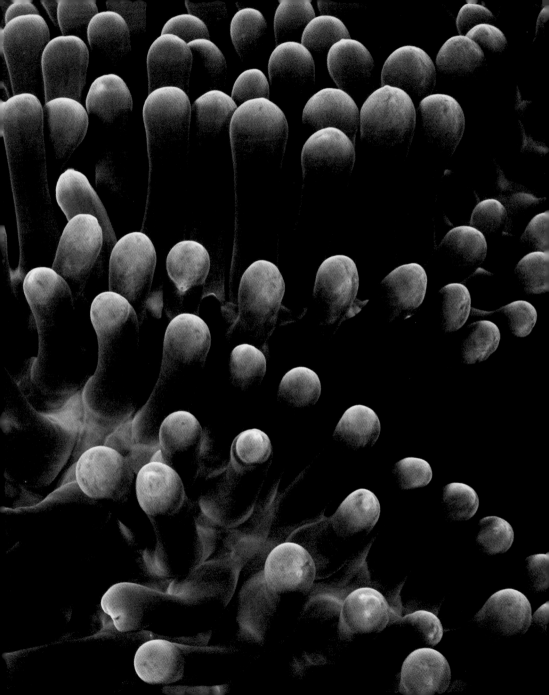

The leg muscles of a LOCUST
are about 1,000 times
more powerful than an equal
weight of human muscle.

NEVADA, UNITED STATES | RICHARD NOWITZ | *The sequined legs of a Cirque du Soleil performer create a radiant portrait. More than 100 million spectators have seen the world-famous troupe, known for their daring and graceful acrobatics.*

GEORGIA, UNITED STATES | CHRIS BLIGH

The glowing yellow eyes of a black cat in Dacula, Georgia, suggest an interest in nefarious deeds. Cats, owing to the tapetum in the backs of their eyes, can see about six times better at night than humans can.

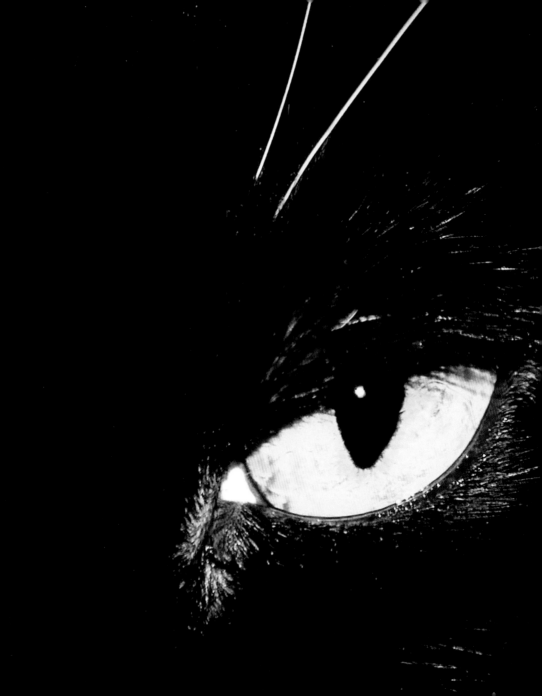

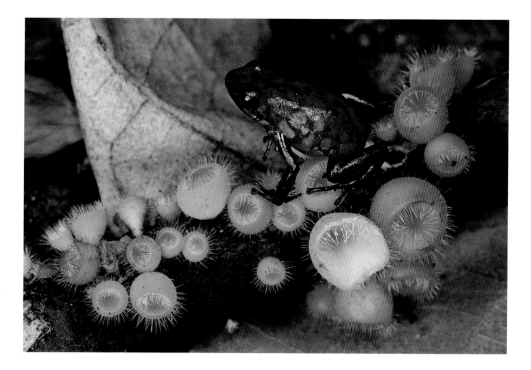

ECUADOR | MARK MOFFETT

A lovely but toxic harlequin poison dart frog,
Dendrobates histrionicus, *sits on cup fungus in*
an Ecuadorean rain forest. Its colorful pattern acts
as a warning to potential predators to stay away.

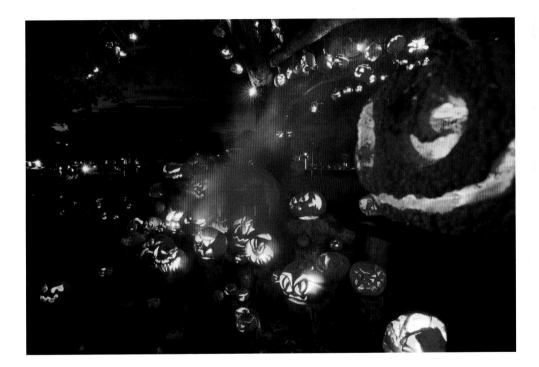

MASSACHUSETTS, UNITED STATES
RICHARD NOWITZ

*Grinning jack-o'-lanterns spill across a tree and a porch as
a festive welcome to Halloween. The custom of pumpkin
carving originated in the British Isles, but people used
large turnips or other vegetables instead of pumpkins.*

JAPAN | ROGER SNIDER
Covered in chrome and gleaming neon, big rigs from across Japan shine at a truck show in Aichi Prefecture. Known as dekotora, *most are working trucks— though on long hauls, they're typically not driven with all their lights on.*

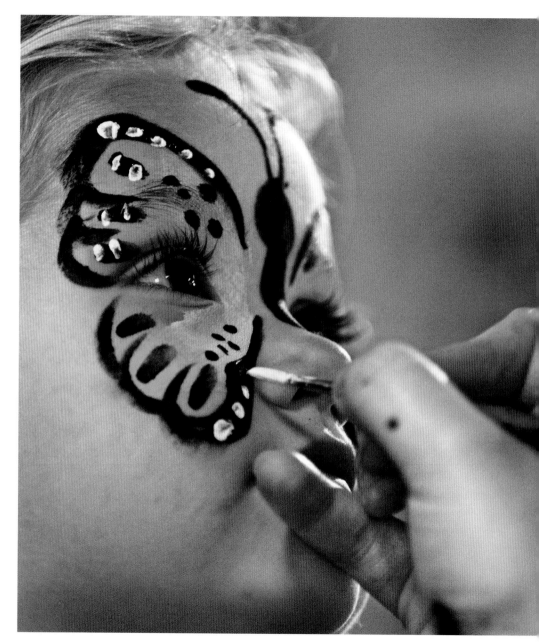

CALIFORNIA, UNITED STATES
RICH REID

A young girl in Pacific Grove, California, transforms into a green butterfly under the brush of a face-painting artist at the Pacific Grove Museum of Natural History, which is dedicated to exploring the wildlife, plants, cultures, and geography of California's central coast.

CHINA | JAMES P. NELSON
*Chandeliers and pillars of stone, their edges and
shadows doubled in the glass-smooth surface of an
underground pool, have awed visitors to the Reed
Flute Cave for more than a thousand years.*

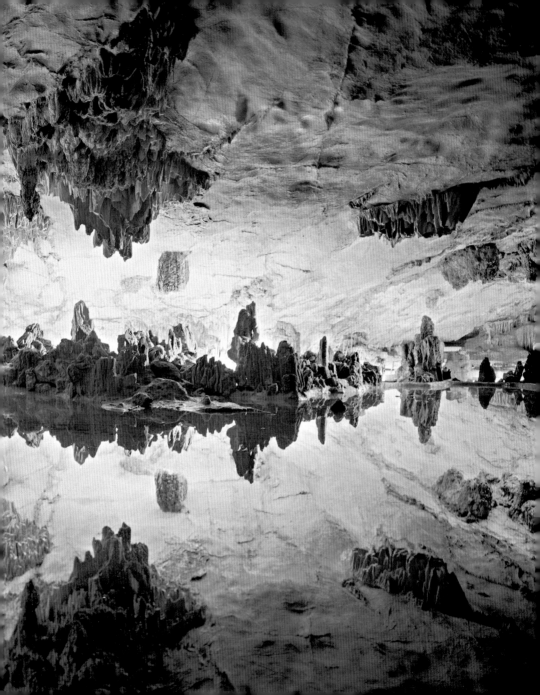

KANSAS, UNITED STATES | JOEL SARTORE
The Ferris wheel at the Kansas State Fair in Hutchinson mimics a giant Lite-Brite toy. Long lines can form at popular midway rides, but in this long exposure all the stress melts away.

KANSAS, UNITED STATES | JOEL SARTORE
Spinning midway rides light up the night at the Kansas
State Fair in Hutchinson. The end-of-summer ritual
creates a tapestry of spinning motion, squeals of glee,
homespun contests, and the smell of fried foods.

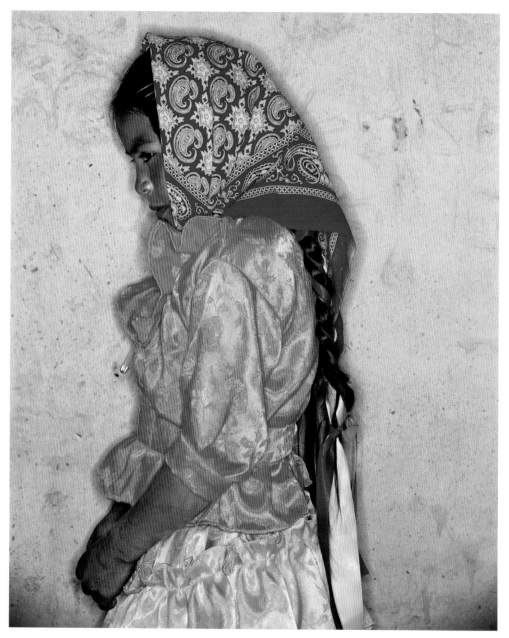

PUEBLA, MEXICO,

boasts the world's smallest inactive volcano. Called **Cuexcomate**, it is only 43 feet tall (13 m).

A beam of sunlight shines through the dome of St. Peter's Basilica in Vatican City. The church, completed in 1615 under Pope Paul V, has become an important pilgrimage site.

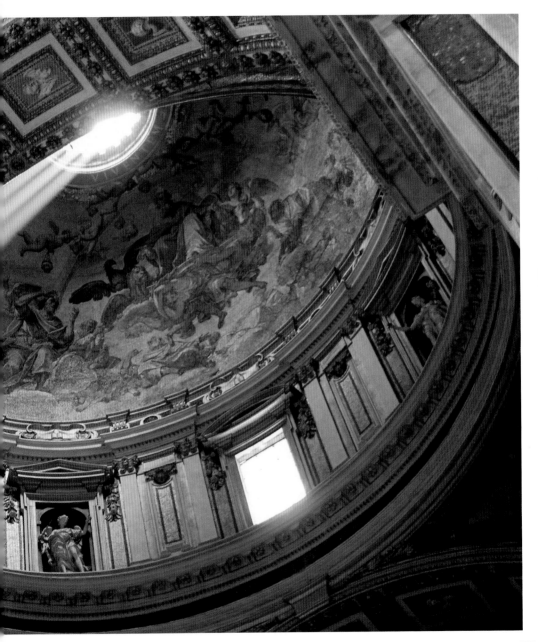

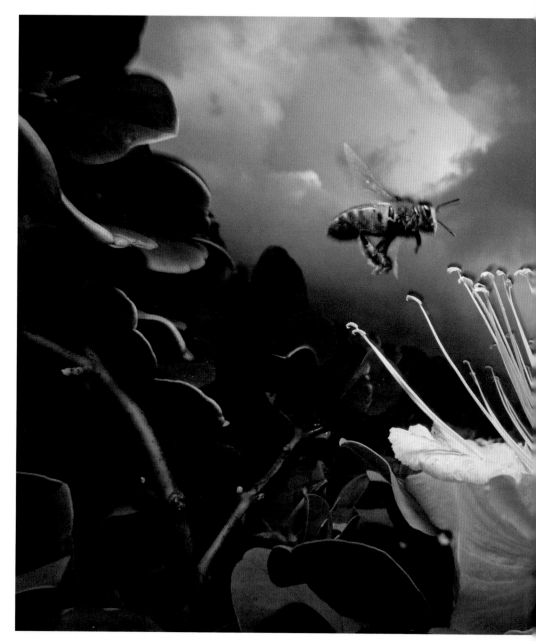

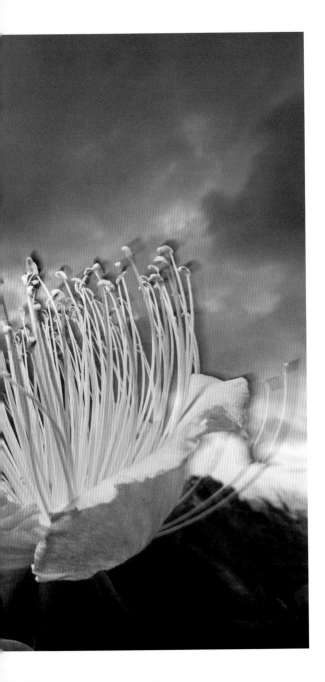

HAWAII, UNITED STATES
MARK MOFFETT

A honeybee comes in for a landing on a
caper flower in Kauai, Hawaii. Attracted by
the flower's perfume and arriving at dusk,
this bee is taking part in worldwide insect
pollination that is valued at $200 billion.

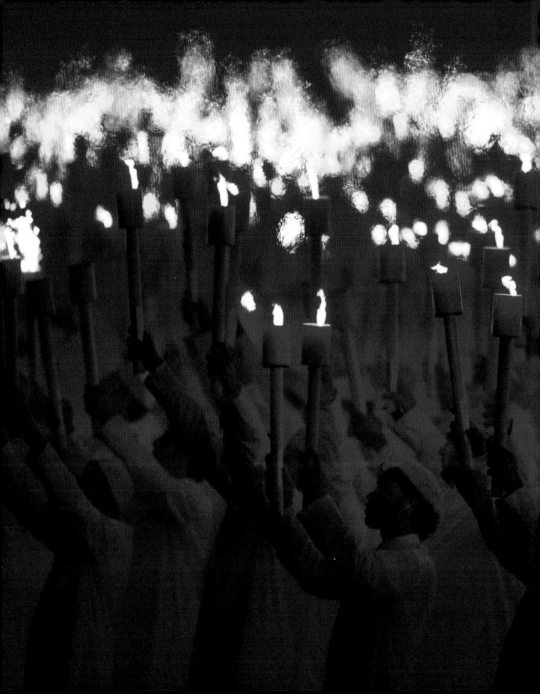

ILLUSTRATIONS

All of the images in this book were drawn from past issues of *National Geographic* magazine or are part of National Geographic's Image Collection. On the page with each photograph in the book we have included the photographer's name.

The list below is additional information on the source of this material, when it is not the National Geographic Image Collection.

If you are interested in licensing a National Geographic image for professional use, please go to NationalGeographicSTOCK.com.

2-3, REUTERS; 4-5, epa/CORBIS; 14-15, National Geographic My Shot; 26, National Geographic My Shot; 32-33, National Geographic My Shot; 40, Minden Pictures/National Geographic Stock; 41, National Geographic My Shot; 44-45, National Geographic Stock; 46-47, National Geographic Stock; 50, NASA, ESA, and F. Paresce (INAF-IASF, Bologna, Italy), R. O'Connell (University of Virginia, Charlottesville), and the Wide Field Camera 3 Science Oversight Committee; 52-53, AFP/Getty Images; 62-63, National Geographic Stock; 69, National Geographic My Shot; 70-71, ZUMA Press; 72, Minden Pictures/National Geographic Stock; 74-75, Redux Pictures; 80-81, AP Photo; 82, National Geographic My Shot; 94-95, National Geographic My Shot; 96-97, National Geographic My Shot; 100, National Geographic My Shot; 101, National Geographic My Shot; 106-107, National Geographic My Shot; 108-109, REUTERS; 112-113, Getty Images; 114, National Geographic My Shot; 116-117, National Geographic My Shot; 122-123, REUTERS; 124-125, Minden Pictures/National Geographic Stock; 126-127, REUTERS; 128-129, National Geographic Stock; 131, National Geographic Stock; 133, National Geographic My Shot; 136-137, National Geographic Stock; 139, National Geographic Stock; 140-141, National Geographic Stock; 152, National Geographic Stock; 154-155, CORBIS; 158-159, Minden Pictures/National Geographic Stock; 164, CORBIS; 165, National Geographic My Shot; 166-167, epa/CORBIS; 168-169, VII/CORBIS; 170-171, Minden Pictures/National Geographic Stock; 176-177, National Geographic My Shot; 178, National Geographic My Shot; 180-181, National Geographic My Shot; 184, National Geographic Stock; 186-187, Wonderful Machine; 188-189, Magnum; 190-191, National Geographic

CELEBRATING
‹125›
YEARS

VISIONS OF EARTH

Susan Tyler Hitchcock

PUBLISHED BY THE NATIONAL GEOGRAPHIC SOCIETY

John M. Fahey, Jr., *Chairman of the Board and Chief Executive Officer*
Timothy T. Kelly, *President*
Declan Moore, *Executive Vice President; President, Publishing*
Melina Gerosa Bellows, *Executive Vice President; Chief Creative Officer, Books, Kids, and Family*

PREPARED BY THE BOOK DIVISION

Barbara Brownell Grogan, *Vice President and Editor in Chief*
Jonathan Halling, *Design Director, Books and Children's Publishing*
Marianne R. Koszorus, *Design Director, Books*
Carl Mehler, *Director of Maps*
R. Gary Colbert, *Production Director*
Jennifer A. Thornton, *Managing Editor*

STAFF FOR THIS BOOK

Meredith Wilcox, *Project Manager*
Susan Blair, *Illustrations Editor*
Melissa Farris, *Art Director*
Jane Sunderland, *Text Editor*
Michelle R. Harris, *Picture Legends Writer*
Judith Klein, *Production Editor*
Michael Horenstein, *Production Manager*
Cameron Zotter, *Design Assistant*

MANUFACTURING AND QUALITY MANAGEMENT

Christopher A. Liedel, *Chief Financial Officer*
Phillip L. Schlosser, *Senior Vice President*
Chris Brown, *Technical Director*
Nicole Elliott, *Manager*
Rachel Faulise, *Manager*
Robert L. Barr, *Manager*

The National Geographic Society is one of the world's largest nonprofit scientific and educational organizations. Founded in 1888 to "increase and diffuse geographic knowledge," the Society's mission is to inspire people to care about the planet. It reaches more than 400 million people worldwide each month through its official journal, *National Geographic*, and other magazines; National Geographic Channel; television documentaries; music; radio; films; books; DVDs; maps; exhibitions; live events; school publishing programs; interactive media; and merchandise. National Geographic has funded more than 9,600 scientific research, conservation and exploration projects and supports an education program promoting geographic literacy. For more information, visit www.nationalgeographic.com.

For more information, please call 1-800-NGS LINE (647-5463) or write to the following address:

National Geographic Society
1145 17th Street N.W.
Washington, D.C. 20036-4688 U.S.A.

Visit us online at www.nationalgeographic.com/books

For information about special discounts for bulk purchases, please contact National Geographic Books Special Sales: ngspecsales@ngs.org

For rights or permissions inquiries, please contact National Geographic Books Subsidiary Rights: ngbookrights@ngs.org

A large and wonderful variety of stunning images like the ones in this book are available for purchase as high-quality, framable prints. Please visit our site at www.PrintsNGS.com for details.

ISBN: 978-1-4262-1173-7

The Library of Congress has cataloged the 2011 editions as follows:
Visions of Earth : beauty, majesty, wonder / foreword by Chris Johns.
 p. cm.
 ISBN 978-1-4262-0883-6 (hardback)
 ISBN: 978-1-4262-0935-2 (U.K. edition)

1. Nature photography. 2. Landscape photography.
3. Human geography. I. Johns, Chris, 1951- II. National Geographic Society (U.S.)
 TR721.V57 2011
 779'.36--dc23

 2011024278

Printed in China
13/PPS/1